Extreme Close-Up Photography and Focus Stacking

Extreme
Close-Up Photography
and Focus Stacking

Julian Cremona

CROWOOD

First published in 2014 by
The Crowood Press Ltd
Ramsbury, Marlborough
Wiltshire SN8 2HR

www.crowood.com

This impression 2017

British Library Cataloguing-in-Publication Data
A catalogue record for this book is available from the British Library.

ISBN 978 1 84797 719 9

Frontispiece: Close-up of the hind wing of a Common Blue Butterfly *Polyommatus icarus*, male, × 4.

Dedication

This book is dedicated to my bug collectors Carys, Rory, Conor and Finlay.

Acknowledgements

Much of what I have learnt over the years has been down to trial and error. In recent years a number of people that I have met have triggered ideas through conversations and given support, like John Archer-Thomson, a landscape photographer, friend and work colleague. Mike Crutchley, a retired engineer, develops great ideas, some of which brush off onto me. Often through a collective discussion, ideas are generated. Some of the super ideas people are from the Quekett Microscopy Club. In particular are Phil Greaves, Geoff Mould, Carel Sartory, Ray Sloss and 'Spike' Walker. Thanks to all of them for their thoughts and suggestions over the years. Also to James Robson of the Horniman Museum in London: always one for a bargain on eBay! My family has been a constant support, especially my four super grandchildren who show such brilliant enthusiasm for the natural world at a young age. Thanks especially to Brenda, my long-suffering wife, who has always been my greatest supporter and critic.

Graphic design and layout by www.peggyandco.ca
Printed and bound in Times Offset (M) Sdn Bhd, Malaysia.

CONTENTS

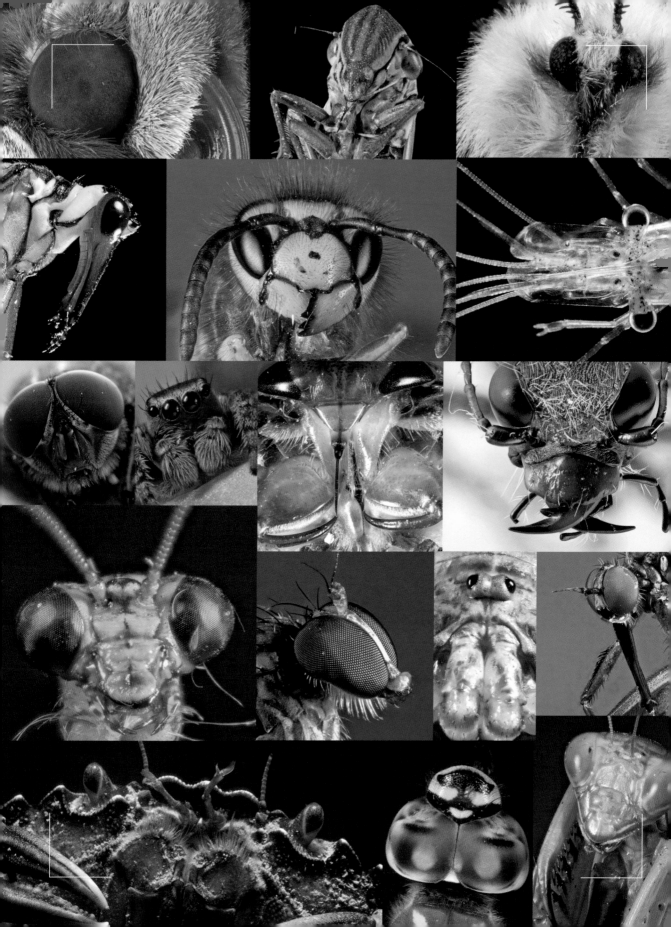

Introduction

I have always been a collector: even at the age of eight I collected any object pertaining to wildlife. By ten years of age this collecting advanced to pickling pieces and parts of bodies, such as the heart of a dead bird. By twelve I was setting butterflies and other insects on boards. The collecting had now taken on a whole new angle as I discovered the use of crushed laurel leaves to produce cyanide to 'bump off' all the invertebrates in the back garden. The collection grew during my teenage years until my parents asked me why I had to kill everything. It was for my eighteenth birthday they bought me a camera and suggested I photograph them instead. The camera was one of the most difficult to use, but a cheap, single-lens reflex model: a Russian Zenith E. Gradually, as I learnt to use the camera my collecting changed again and has continued for more than forty years. My huge invertebrate collection is now on a computer and easier to access through a database. This digital image may not appear as exciting as the tangible object and yet the thrill of capture is no less electrifying. When exploring a new location the sight of a species I have never seen before provides the same level of excitement, so that as I move in with the digital SLR I am shaking. I stop breathing as I fire the shutter to capture the creature. It will start with a general distant shot with the habitat in the background and, by slowly moving closer, just the organism is collected. That is not good enough as I need to see the detail of wings and hairs on the legs. Every invertebrate has

a personality, which the portrait photograph shows, and so the collection will not be complete until that head shot is in the bag.

Those early days with the Zenith were a struggle with minimum finance. Film was bought in bulk, cut up and loaded in the darkroom. I learnt at university to process my own, using the zoology department's darkroom at night when no-one else needed it. Most difficult was teaching myself ways of taking close-ups and getting those head shots with no money to buy equipment. Toilet rolls, poster rolls, lenses borrowed from student microscopes and slide projectors as spot lights – all were used and developed until I had vaguely presentable images. I gave many people a good deal of enjoyment as they laughed at my methods. Today I would cringe at some of the results and yet the Zenith was a superb learning tool because of the difficulty in getting good results. Every day seemed to be a 'back-to-the-drawing-board' day as I developed the film and went back to try again. Today learning is easier, with near-instant results.

There is staggering beauty in the unseen elements of nature in close-up. I never cease to be amazed as details appear in a focus-stacked image which the unaided eye could not resolve. During my life as a biologist I have learnt and been lucky enough to branch into every area of the natural world, not just terrestrial invertebrates but to extend my collection in directions I never would have thought possible as a young teenager.

◀ Fig. 0.1
Portraits of different invertebrates. Left to right, top to bottom: Elephant Hawkmoth, Froghopper, White Ermine Moth, Scorpion-fly, Wasp, Prawn, House Fly, Jumping Spider, Saucer Bug, Tiger Beetle, Mantis Fly, Dolly Fly, Harvestman, Empid Fly, Common Shore Crab, Migrant Hawker, Praying Mantis.

Embracing and developing new technologies to achieve this is ongoing. Relatively speaking, the price of equipment has never been lower, and products are more accessible with the Internet. Some new ideas can lead to a dead end and that can make people afraid of trying, concerned about getting it wrong. As has often been the case in history, most of what I have learnt has been through such mistakes. Sometimes I am pleased with particular images but typically I am not and always feel that I need to try again.

The digital vs. film debate still goes on – which is better? I suppose it depends on one's viewpoint but I would never return to film, for environmental reasons and because I spent many years in darkrooms breathing in the noxious chemicals. In addition there are the improved methods of capturing close-ups and more advanced ways of learning to improve. I hope that this book will help you develop more quickly than I did. There is no better time than now to create extreme close-ups, and the technology is straightforward. Although it would be great if a student of photography could learn everything in one go, until that becomes possible, the linear fashion of chapters building upon each other is the way this book is written. The contents show the key points; dip in and out to suit yourself. The final chapter is the one that tries to piece it all together by taking specific subject matter and looking from that perspective. The choice of organisms has been made to cover most eventualities.

Today I have a catalogue of many thousands of species, digitally stored on my hard drive, which I have collected over my life. It may not be as spectacular as a museum collection but at least I no longer need to kill species to store them. Focus stacking has been described by many who practise it as only possible when using dead specimens. Unless I find the individual already dead, I rarely use dead material. Unless stated, all photographs were taken of living specimens.

This book is approached from the perspective of a naturalist wanting a record of any organism they find. It is about attaining maximum detail and sharpness. It is a practical guide covering all aspects of how to photograph any terrestrial or aquatic subject in close-up. Where possible, captions give some information about the organism. What sets this book apart, however, is its focus on providing the most concise information available to date on focus stacking, and it will be useful for anyone interested in this topic, whether for 'macro' or any other form of photography, such as landscapes.

We look at indoor, studio photography, as well as photography in the field. The word 'studio' suggests something grand but in practice it means a table or bench where all the paraphernalia that occurs with extreme close-ups can be set up next to a mains socket. This type of photography does entail an incredible variety of bits and pieces and so storage space in the form of drawers, boxes and shelves will be needed, as well as – most essentially – a nearby computer. This all suggests close-up photography is an expensive activity but it is surprising how, with a bit of ingenuity and searching, much of what you need will be unwanted material. Old photographic and darkroom equipment that has been collecting dust may become central to the effort. Extreme close-ups can take up an inordinate amount of time and patience (my wife says I disappear for hours) but with a bit of effort, and always bearing in mind the welfare of the creatures, it is amazing what is possible on even the tightest budget. Expect a heap of frustration on the way to gaining great results.

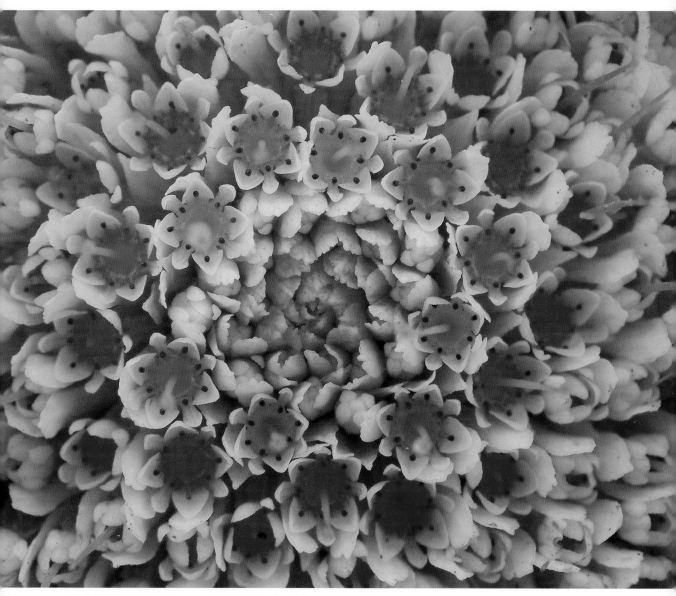

▲ Fig. 0.2
Albany Daisy, *Actinodium cunninghamii* (centre of the flower),
endemic to Western Australia. Magnification ×3, Fuji Finepix S602
bridge camera with a coupled 58mm lens.

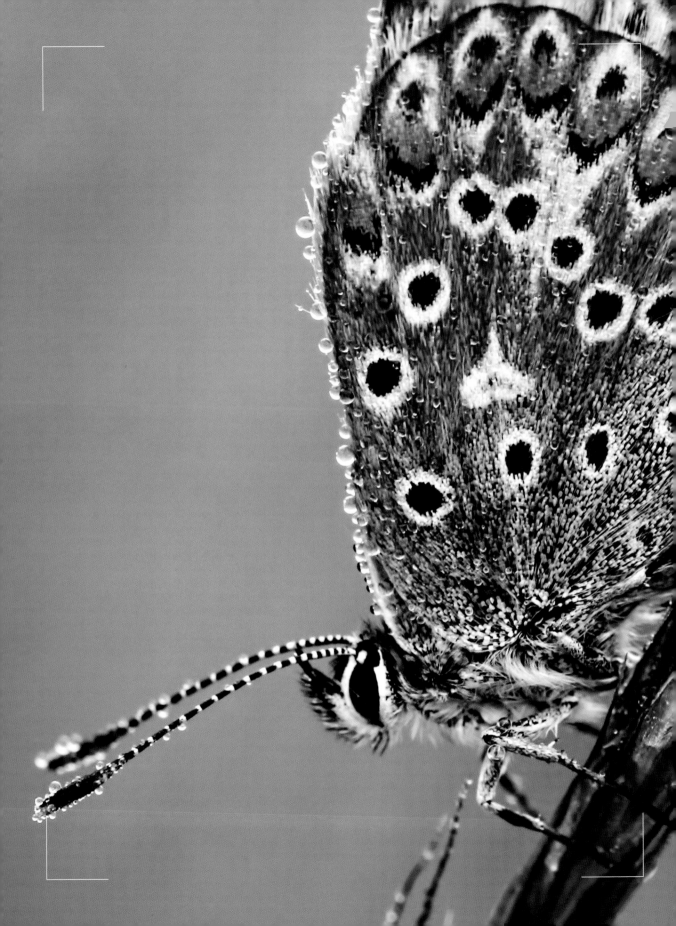

Chapter 1

What is Macro?

What makes a good photograph is very subjective but to many it is a subject or viewpoint that few others see, making the viewer look twice. The world is typically seen from between one and two metres above the ground; by moving to ground level the viewer's perception of the area changes. Alternatively, go higher: a view from the top of a hill or mountain can make a scene more interesting; aerial imagery is a whole genre of photography in itself. Getting close to living creatures will display more and more detail – almost personal elements of the subject's life not seen before – and this can make intriguing photography. A whole new micro-world waiting to be photographed. This is the world of macro-photography; making small things look bigger.

The word 'macro' has been used and abused extensively. Its meaning can be confusing, as people's perception of what 'macro' means varies widely, not least between manufacturers of lenses. Most photographers realize that a 'macro' setting will allow the user to get closer to a subject. This may be written on the side of a lens or the focusing scale. Purists would say that a macro setting on a general-purpose lens like this is not true macro, as it just provides a closer focusing facility. So what is true macro?

This was easier to answer when everyone used film, particularly the standard 35mm film like that used to produce slide transparencies. As 35mm film equivalents are still used today on digital camera lenses perhaps we can start here, too. A macro photograph of a subject is where the image is the same size as the film. For example, if the subject is a coin, once the film has been developed, it could be placed to fit exactly on top. The ratio is 1:1. Most general-purpose lenses and zooms that have a macro setting may also have a ratio nearby, typically something like 1:4 and not 1:1. This means that the image is a quarter of the size of the subject, or the subject is four times the size of the film image. With suitable equipment you could photograph a tiny flower such that the film image is twice the size of the actual subject. In this case the ratio will be 2:1. Of course, if the 35mm film transparency is projected on to a screen or made into a print the magnification is changed again. The ratio is used to refer to the *initial* imagery on the film; if the film format is different, e.g. 6cm × 6cm, then the ratio changes again. This is why attempting to define the term 'macro' can be confusing.

What about digital cameras? The principles are the same but instead of film it is the size of the sensor and the image that is projected from the lens onto that sensor. In the case of what is called a full-frame camera that size is still 35mm. For others you may need to refer to the manual or the Internet as there are a number of different sensor formats especially with compact cameras. The latter can produce excellent close-ups and appear to provide good magnification. However, it is not possible to see the original film with a digital camera; the image you see on the camera screen has been magnified to fit the screen.

◀ Fig. 1.1
Common Blue Butterfly, *Polyommatus icarus*, covered in early morning dew which renders it almost unable to fly, and therefore an easy subject for macro photography. Canon 7D with 150mm macro lens plus 21mm extension ring, 1/125th sec ƒ8 ISO 400.

To work out how your compact camera compares to true macro do the following. Switch on the macro mode, usually a flower symbol on the back of the camera. Using a metric ruler, focus as close as possible and take a photo. Make a note of the width of the scale that has been photographed, for example 26mm in the Canon G9 compact. Next you need to know the size of the sensor. The G9 has a sensor width of 7.5mm, a reasonable size by compact camera standards. To find the magnification ratio, divide 7.5 by 26, which gives a value of 0.29mm (around 0.3mm). The ratio is therefore approximately 1:3, which, despite the apparently good magnification, is not true macro. This information, although far from being essential in terms of enjoying taking close-ups, does help to put magnification into perspective; for digital there is always the extra magnification added by the camera, computer or printer.

As a guide, this book explores close-up photography predominantly within the range of ratios between 1:4 and 4:1, that is from a quarter size up to four times life size – around macro and beyond – as illustrated in Figures 1.2.1–1.2.4.

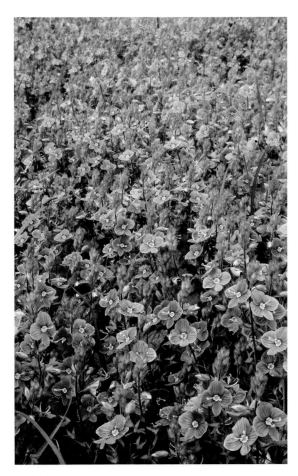

▲ Fig 1.2.1

▲▶ Figs 1.2.1, 1.2.2, 1.2.3, 1.2.4
Germander Speedwell,
Veronica chamaedrys,
photographed from
close-up through to ×4
magnification. Fuji Finepix
S602 bridge camera with
(in 1.2.4) a coupled lens and
focus stacked.

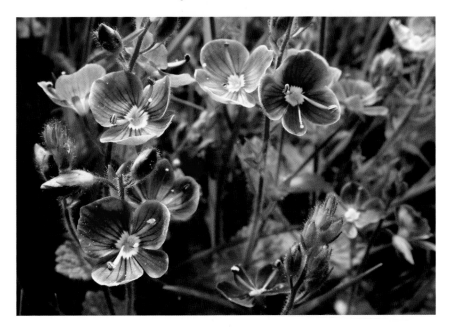

▶ Fig 1.2.2

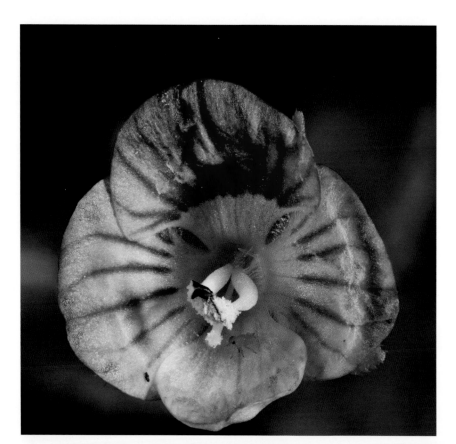

◀ Fig 1.2.3

▼ Fig 1.2.4

Chapter 2

What Camera is Best?

The saying, 'the best camera is the one you have with you', is very apt. If your digital single lens reflex camera (DSLR) is at home and an exotic insect appears in front of you then the Smartphone in your pocket is your only option. Whilst on holiday and during heavy rain a beautiful tree frog sits in the middle of the path waiting for you to take a photograph with your expensive camera but it is not waterproof. A waterproof compact is a fraction of the cost of a DSLR and so there is no excuse not to get the photo. Pentax and Olympus have been making excellent models for some years and the former with their 'microscope mode' and built-in LED lights allow for amazing extreme close-ups. So is this the best camera to use?

'You must have a DSLR for nature photography and nothing else will do' – a common statement found in magazines and elsewhere – is untrue. As with so many photographic debates the real answer is, 'it depends'. Four types of camera are discussed below, in particular their suitability for macro photography.

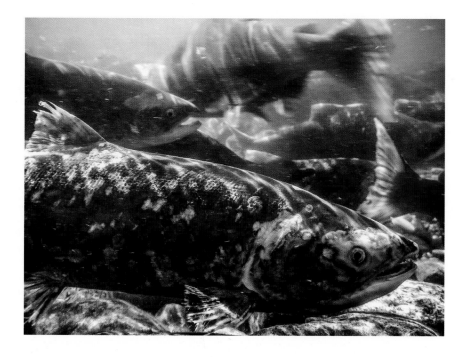

◀ Fig. 2.2
Sockeye salmon on a run in western Canada. Photographed by holding the camera at arm's length under the water amongst the fish. Pentax WG waterproof compact, on auto.

◀ Fig. 2.1
Fly Orchid, *Ophrys insectifera*, close-up of a single flower on the stem, ×1. Canon 7D with 100mm macro lens, twin macro flash, 1/250th sec ƒ14 ISO 200.

THE DIGITAL SINGLE-LENS REFLEX (DSLR)

This has to be the prime camera of choice because of quality and ease of use in taking extreme close-ups. The sensor is larger than in a compact and can produce a better image. The most expensive ones are those with full-frame (35mm wide) sensors; the others will be APS-C sensors, a size based on an alternative format, smaller than 35mm film. It is worth remembering that putting a 35mm lens on an APS-C sensor changes the focal length. The correction factor depends on the make; for example Canon multiply by 1.6 and Nikon by 1.5. So a 100mm lens becomes 160mm or 150mm respectively. The lens can be removed and substituted with a specialist one such as a macro. It will be part of a 'system' and so a wide range of accessories can be purchased, produced either by the camera manufacturer or a third party. Crucially with extreme close-ups it is possible to connect the DSLR to a computer and control the camera from there. This presents live-view on the monitor, and to do it requires software, available for DSLRs.

The DSLR will have speed on its side with a minimum of delay when focusing, often with a number of focusing points. The reflex component of the name refers to the pathway of light through the camera, via prisms and mirrors, in the main. This can lead to the key disadvantage of weight and price. Cheaper ones tend to be lighter with more basic, plastic frames. Start adding strength, durability and weatherproofing to a body and the weight and price start to soar. Another consideration is that the more expensive DSLRs, usually what is termed the enthusiast level, will have a more substantial shutter mechanism than entry-level ones. Manufacturers guarantee a minimum number of shutter actuations (the number of times the shutter is fired); this is normally 100,000 times although the shutter may

well survive for more than double that number. This may not seem an issue until you start using focus stacking techniques when five hundred actuations could be typical in an afternoon's work.

When buying a DSLR look carefully at your ability to hold not just the camera body but lens and other options like a flash. These mount up and can easily begin to exceed 2 kilograms. A day's shooting, holding this weight up to your eye soon develops strong bicep muscles. It is recommended that you use a different strap from the one that is provided with the camera. An example is the Crumpler Singapore Sling camera strap. This has a wide, padded strap, which spreads the load comfortably. Most significant, however, is that these straps quickly clip and unclip from the camera, making life less irritating when mounting the camera on tripods and optical benches to do stacking.

The ingress of dust has always been a problem with cameras that can have the lens removed. Minimize this by making sure the camera is switched off when you unclip the lens, have the lens removed for the minimum amount of time, and do it away from windy conditions. Even if you are very careful, the removal of the lens will eventually lead to dust getting onto the sensor. Whatever lens you put on the camera to take macro shots will also magnify the dust on the sensor, especially with short focal length lenses and small apertures. For this reason you will occasionally need to clean the sensor.

Although the weight produced by the reflex system is a negative issue, on the plus side there is a clear optical path to the viewfinder as well as the LCD screen on the rear. The more expensive models will have a 100% viewfinder meaning that the area you see is the area that will appear in the final photograph. Less expensive ones normally end up with more material being shown so the viewfinder may be closer to 96%. Whatever the viewfinder, the optical option is very useful as well as having the live-view on the LCD screen, found on all other cameras.

COMPACT SYSTEM CAMERAS (CSC)

This is a relatively new and developing field of cameras. First developed by Olympus and Panasonic, all the major camera manufacturers now have models available. They have the convenience of being the size and weight of a compact camera but like DSLRs they have a removable lens. Sensors vary in size between manufacturers but are bigger than compacts and some are the same as those used in DSLRs. This means that quality is very good. The main way in which these cameras differ from DSLRs is that the path of light is unhindered with a mirror, passing directly to the sensor. The lack of mirror and focal plane shutter reduces weight and size as well as reducing camera vibration. This can make them very useful to put on a microscope where weight and vibration can be a major issue. These are very positive aspects of CSCs but the downside is that with no optical path there will be no viewfinder – the image is a live-view on the LCD screen. Some do have optional Electronic View Finders (EVF) but they can take some getting used to although one good thing is that what you see is what you get. This refers to how the exposure looks as well as the area of view. To be successful the manufacturers have had to make sure that the live-view is good and focuses quickly, something that is not so good on DSLRs where live-view is a fairly new add-on. Here focusing can be tediously slow in automatic, although it is improving. The sockets present on the CSC and software available with different models will determine whether or not the camera can be attached to a computer to present live-view on a monitor and so be controlled from that computer. Currently, there are few CSCs that can be connected and this may be a potential drawback. Make sure some form of remote shutter release is available. This is most likely to be a tiny wireless remote that is quite inexpensive. There may well be a Smartphone app that can be

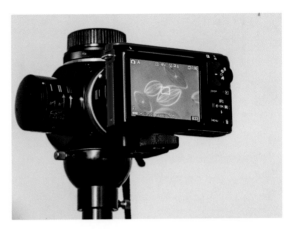

▲ Fig. 2.3
Nikon 1, Compact System Camera on a 1960s Zeiss microscope with diatoms on the live-view rear screen.

used as a wireless remote; this may be cheaper than buying a separate one.

Another possible drawback with CSCs is the limited number of lenses and other options available. However, it is possible to acquire, either from the manufacturer or third party, adapters that enable other lenses like those for DSLRs to be attached. They may not autofocus but for macro work that is not a problem.

In brief, there are three formats of CSCs available:

- The 'DSLR replacement', which looks like a miniature DSLR and functions in a similar way with an integral viewfinder;
- A rather 'retro' style taken up especially by Olympus and Fuji looking like the rangefinder cameras of decades ago; and
- The ones that look very much like a compact but with a removable lens.

BRIDGE CAMERAS

As the name suggests they bridge the gap between DSLRs and compacts. In most cases they will have a smaller sensor than the DSLR and CSC, so quality will not be as good. They do have plenty of pixels and as long as you understand their limitations they have their place. Also the lens is fixed so there is minimal chance of dust on the sensor. New models appear all the time with longer zoom lenses, over 1000mm equivalent. Along with their light weight, these cameras could be a useful substitute in situations when you really cannot carry a DSLR. They are also cheaper than a DSLR. It is a compromise as delays will occur when trying to focus with the

▶ **Figs 2.4 and 2.5**
Different sensors. Both photos were taken using the same settings, 200mm lens, ƒ8 and were focused on the white flower. The difference is that Fig. 2.4 was taken on a full-frame camera, i.e. a large sensor, whilst Fig. 2.5 was taken using a bridge camera that has a significantly smaller sensor. This shows the amount of detail that will come into focus with the bridge camera and small sensors. When enlarged there will be a slight difference in quality.

telephoto but bridge cameras can excel at macro and micro photography. Small sensors allow for good close-ups, in many cases down to 1cm/0.5in. They are criticized for their small aperture range although these are not comparable with larger sensor cameras. Importantly, they have better depth of field. Quality may not match the DSLR but it does depend on so many factors – not least the photographer and post-processing on the computer. When contemplating a bridge camera check reviews for quality and noise level at high ISO values. Cheaper models can have unacceptable noise above ISO 400 such that images are unusable.

COMPACTS AND SMARTPHONES

In this book we will not be looking at using these in any serious, extreme close-up photography. It is possible to use them but they will be hard work;

control of the image is very difficult and quality will suffer. However, a Smartphone may well be in your pocket and certain compacts, like the waterproof one mentioned before, should always be available in your bag even if it is just for emergencies. The reasons are threefold.

- **Portability:** there is never an excuse not to have a camera with you. The small sensor may not provide the best quality but it does enable the camera to reach incredibly close to a subject. Fig. 2.6 shows a fritillary butterfly laying eggs. This activity kept the butterfly sufficiently occupied for the lens of the compact to practically touch the back of it. Care needs to be exercised in keeping one's shadow off the subject at such close range. By using the LCD screen on the rear, these cameras are almost equivalent to the SLR in that what you see is what you get. Hold your arm extended and your body well back and the insect may not be disturbed.

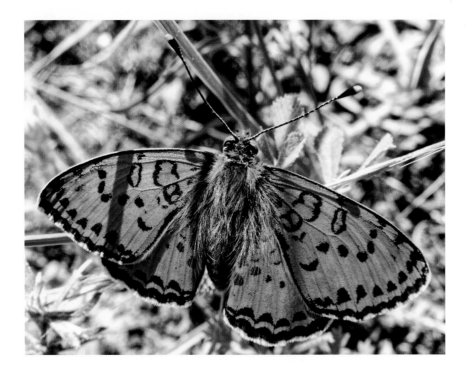

◀ **Fig. 2.6**
Fritillary Butterfly, approximately 3cm across, laying eggs. Taken with a compact camera, with arm at full extension to minimize disturbance. The camera was angled so the camera did not cast a shadow but a nearby grass has projected a long dark shadow across the left wing. Canon G15 1/80th sec ƒ8 ISO 100.

- **Small lens:** this may seem to be a disadvantage after seeing the width of some high-quality DSLR lenses, but where this wins is in the ability to place the tiny diameter over another lens such as a microscope or telescope. This is not easily possible with DSLRs or bridge cameras. Most compacts have high-quality video available and to achieve this through a microscope or telescope can be a major advantage. In fact the small diameter lens allows any lens to be placed in front. Find any suitable hand lens, such as a slide loupe used in checking slide transparencies, and this can be held over the front camera lens. Set the camera on close-up mode (usually a small picture of a flower) before holding the lens over the front. Any magnifier can be used and it is possible to buy specific ones for Smartphones. A technique called 'coupling' will be discussed in the next chapter and this can be used on compacts – although any coupled lenses will have to be held in place by hand as attachments will not be available or will be cumbersome.

- **Waterproof and 'ruggedized' models:** a little more expensive than basic compacts, these can be used underwater with no preparation required to depths in excess of 10 metres, and dropping them on concrete from a height of a metre or so is little problem. Pentax tested their initial model with a group climbing Everest to prove its durability and freeze resistance.

To summarize, it is possible to take close-ups and macro with any camera but if we want to have control over the photograph and achieve consistent and variable magnification the compact and Smartphone will not do the job and will not be considered further. For regular use and the greatest flexibility a DSLR is ideal; the others will give super results but are not so easy to control.

BEFORE STARTING

Macro and extreme close-up photography requires a good deal of trial and error. One problem of getting very close is that it is not always possible to see what you are doing, as most of the image is out of focus! This may seem bizarre but with experience the achievable outcome becomes clearer to understand. The learning process requires that you review and check your photographs regularly during a photographic session. This cannot be done accurately on the rear camera LCD screen and the review is not just about seeing an image: it will entail reading and comparing data on how the photographs were taken. This requires good image viewing software, which you may already have. Apple users probably use iPhoto. Software like Adobe Bridge in Photoshop or galleries in Lightroom can be used but take time to load and are not always flexible unless a good deal of memory is available in the computer.

Consider, especially if you are a Windows user, a free viewer download. There are plenty available. One very good, quick and simple viewer is FastStone. Designed as a viewer to make image comparisons, it takes a great deal of beating. FastStone allows the user to compare up to four images side by side with EXIF data available. Using a wheel on a mouse a simple roll back and forth can zoom in to the smallest amount of detail and compare the same area of the picture and make comparisons. EXIF data is the information recorded at the time the photo was taken and this is attached to the image. It records shutter speeds, apertures, whether the shutter was fired, as well as dates, times, and which camera and lens were used. By making comparisons and reading the data you reduce the learning time. Immediately you can see which method is achieving the best results and how you did it. This area will not be visited again during the book although reference to reviewing your photographs will be made.

Fig. 2.7
FastStone Image
Viewer version 4.8:
screenshot of the
general view. Excellent
free software.

Fig. 2.8
FastStone's
comparative view,
where up to four
separate images can
be compared side by
side along with main
EXIF data.

Fig. 2.9
FastStone's single view
with some menus,
including EXIF and
enhancements.

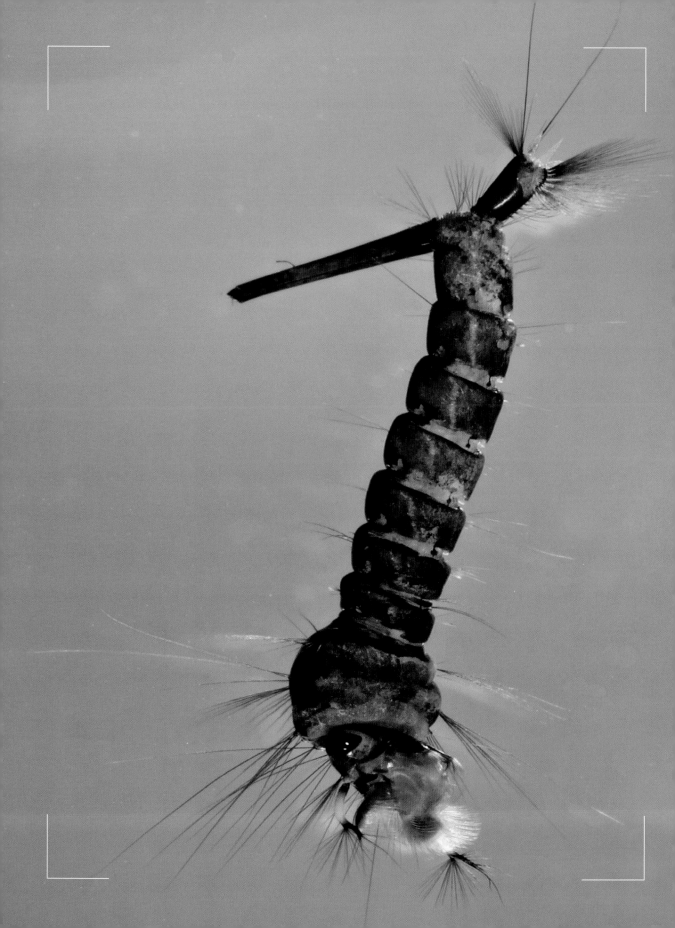

Chapter 3

Techniques for Getting Close

There are numerous ways of gaining magnification and the method you employ could depend on your camera choice. The focusing range of general lenses that you may have will reach a minimum distance of around half a metre or so. By increasing the focal length on a zoom lens you may get a closer view of the subject whilst a wider angle may get you physically close but the angle of view will become greater so the subject appears to move further away. One consideration to be aware of for all of these methods is the working distance from the end of the lens to the subject. The larger the distance the easier life can be in controlling lighting as well as disturbance. However, first we need to look at a few practicalities.

MANUAL AND AUTOMATIC FOCUSING

The autofocus function on cameras depends on contrast within a relatively small portion of the image. The closer the camera is to a subject, the less contrast will be present; consequently it becomes more difficult to focus. Even at a quarter of life-size, autofocus will not always work and so by 1:1 autofocus becomes an irritant as it hunts back and forth attempting to focus the image. Macro lenses have limiters to reduce the degree of hunting, preventing it from moving between 1:1 and infinity. With experience it soon becomes clear that for macro and close-up work it is preferable to switch off autofocus and work in manual. A number of specific lenses for extreme close-up are non-focusing anyway.

Having switched off autofocus, adjust the lens so that the level of magnification is what you require and then focus by moving the camera slowly back and forth from the subject until the image is in focus. The closer you go the more difficult it is to see whether the subject is sharp in the viewfinder. It takes practice but try not to rely on autofocus, starting from around quarter life size and going beyond macro. Practise without a tripod at first, to see how magnification and focusing works. Although, as we will see later, tripods have their place sometimes you need to be able to hand-hold the camera and creep up on specimens. Holding the camera still without camera shake is difficult. The higher the magnification the more the image will waver around and holding the subject in the screen seems impossible.

Built-in image stabilization is common in some lenses (the name for it varies between manufacturers) and in the body of Sony cameras. Stabilization is useful in most areas of photography but not especially so in macro work. At 1:1 image stabilization may give a stop advantage but should not be relied upon. Without stabilization always aim for a shutter speed similar in number to the focal length to prevent shake. As always, practise and review your performance, comparing results side by side so that your ability to hold and focus can be relied upon.

Although not a generally recommended technique, if holding the camera steady and in focus is difficult, consider switching the camera to rapid, multiple image mode. This allows between four and ten images to be taken every second. Whilst holding the camera as steady as possible, move slowly back and forth around the point of focus. By holding your finger on the shutter release a burst of up to twenty

◀ Fig. 3.1
Mosquito larva.

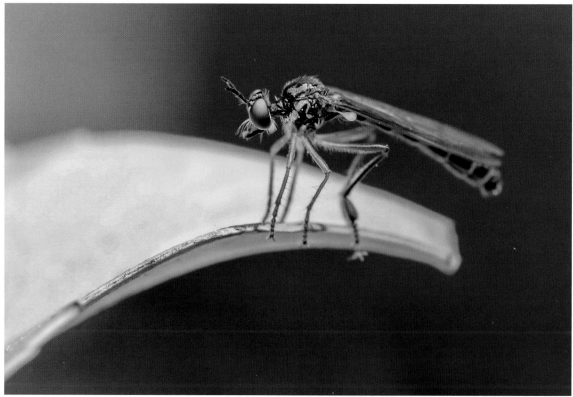

▲ Fig. 3.2

Robber Fly *Leptogaster* in dim light taken with a 150mm macro lens on an APS-C DSLR, Canon 7D, hand-held. The lens on this sensor is therefore equivalent to 240mm, based on 150mm × 1.6 correction factor. The rule of thumb is to use a shutter speed number similar to the focal length, i.e. 1/250th second. However, the lens had the image stabilizer switched on but with an allowance of 1 stop only, not the 3 stops suggested by the manufacturer. The image is sharp at 1/125th second at ƒ5.6. This subject is around life size and parts of it are not in focus. Aim to use the lowest ISO possible to ensure minimum noise interference. In this case, to achieve the exposure in the dim light the ISO was raised to 800 as noise is preferable to camera shake. Robber flies are superb hunters. Their long necks allow them to move the head around to look for prey. They do not stay still for long and hand-holding allows easier tracking of the insect.

images could be taken. Later, on the computer go through these carefully and select the ones that are in focus and delete the rest.

Of course the best way of holding a camera steady is to use a tripod or other support. Remember to switch off any image stabilization when doing so. Supports for the camera become more important the closer you get to your subject; beyond 1:1 it becomes essential. Types of support will be considered in more detail later but the immediate problem with these is that having set up the camera on a tripod, moving it to focus will be difficult. If the magnification is not too great, focusing may be adjusted on the lens but the only suitable method is a focusing

rail. Several types are available and, if you can, try them out first as they do operate differently. The rail is fixed to the tripod and the camera attached to the rail. Use a quick-release mechanism to attach the rail, as you can be sure that as soon as you have set everything up the subject will suddenly move or you need the camera elsewhere.

There are sliding rails but normally they have one or two knobs to rotate to move the camera back and forth. It is possible to use a combination of two, with the second one fixed at a right angle to the first. This allows side-to-side movement as well as back and forth. The theory is sound but in practice this combination can be unstable unless the sideways

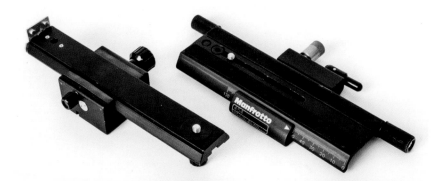

◀ Fig. 3.3
Focusing rails. On the left the rail is moved by rotating the large side knob with a smaller one for locking it in position. The other uses a knob at either end of the rail for movement.

movement is limited so the camera is not too far off to the side. The alternative is to reposition the head of the tripod, which may be easier.

There is an alternative to these manually adjusted focusing rails: an automatic rail of up to 200mm in length. The Cognisys StackShot uses a stepper motor at the end of the rail to move the camera at a very precise rate including fractions of a millimetre if required. This may seem excessive, but as we will see, in focus stacking this level of precision can be very useful especially when going beyond macro to 4:1 and more. The drawback is that it requires a 12-volt power supply. In a studio this is fine but in the field it does mean carrying a battery; this will be discussed in Chapter 6.

COUPLING LENSES

This may prove to be the easiest method for magnification, particularly if you have an array of old lenses tucked away in a drawer. One method of achieving extreme close-up is simply to turn a lens the wrong way around so that the filter end is up against the body of the camera. To hold it in place a reversing ring can be purchased and this screws into the filter mount. The main drawback is the loss of connection with the diaphragm in the lens. For most lenses this means that the aperture stops down

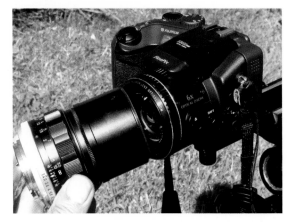

▲ Fig. 3.4
Fuji bridge camera with a Minolta 58mm f1.4 standard lens reversed and coupled onto a filter adapter produced by Fuji.

to maximum and the loss of light makes it difficult to see.

Reversing an appropriate lens over another lens that is attached to the camera is the answer. This works extremely well with bridge cameras. The attached lens has all the connections necessary to control the diaphragm and the reversed lens is acting as a magnifier. The best results are achieved with the diaphragm of the reversed lens left wide open, although it is advisable to try different conditions with the lenses. If this lens is a good-quality one the result should not show any degradation. Purists would suggest that the more glass the light has to pass through on its way to the sensor, the greater the chance of distortion. The best way is to try it and test the options yourself.

▶ Figs 3.5.1, 3.5.2, and 3.5.3
Results of the coupled Fuji bridge camera at different zoom levels: a
Scatophagid Fly, 1/200th sec ƒ11 ISO 160. At the wide position there
is heavy vignetting and limited magnification. Zooming will eliminate
the vignette and at 200mm maximum magnification is achieved,
around ×3.

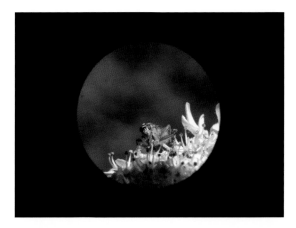

▲ Fig 3.5.1

The images on these pages show what can be
done with some quite old, second-hand equipment.
The Fuji bridge camera has a 1960s Minolta standard
lens designed for a film SLR reversed on to it. This is
a good-quality ƒ1.4 58mm lens and is heavier than
the camera itself. To hold it in place a coupling ring
is used. This is a simple ring that has a thread on
both sides. In this case the size is the same for both
filter threads of camera and lens. If one thread is
different a filter step-down or -up ring can be used.
In the first instance, when trying to find a suitable
lens, just hold the lens reversed over the end of the
camera lens. Autofocus should be switched off.
Focus by moving the camera back and forth slowing
down as it comes into focus. The bridge camera's
lens will start at wide angle producing a heavy
vignette but by zooming the focal length towards
telephoto the vignetting disappears and the magni-
fication increases. As an indication of magnification
you will need to know the focal length or 35mm
equivalent used in both cases. The aphid image was
taken with the Fuji lens zoomed to its maximum,
here equivalent to 200mm. Divide the focal length of
the reversed lens, here 58mm, and it is 3.5 times life
size. Magnification is increased further by the sensor
and printing but it shows that a bridge camera can
produce extraordinary images. That was made on
an early bridge camera from around 2002. In recent
times there has been a resurgence of bridge cameras
and the latest batch with greater zoom lens allow
magnifications beyond ×8.

▲ Fig 3.5.2

The lightweight nature of the setup means it
can easily be used in the field. Most bridge cameras
have a minimum aperture of ƒ8 or ƒ11 but due to the
smaller sensor size a surprising amount of detail
can be recorded. In the field, on a bright day with

▲ Fig 3.5.3

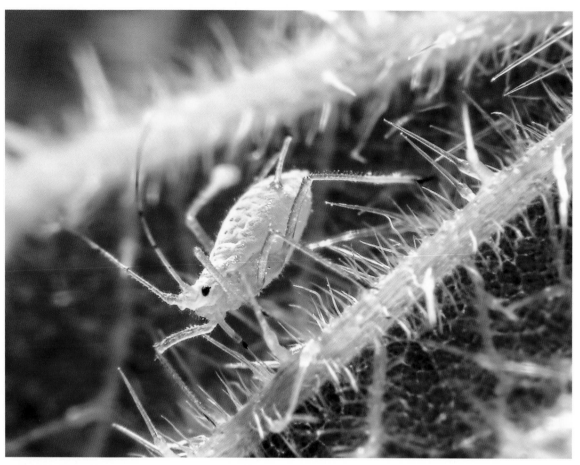

▲ Fig. 3.6
A green aphid, *Aphis*, on the underside of a stinging nettle, *Urtica dioica*. Note the detail in the sting cells and the depth of detail present. Fuji bridge camera with Minolta 58mm lens coupled. 1/200th sec *f*11 ISO 160, tripod and focusing rail.

an aperture of *f*8 the shutter speed is likely to be fast enough to prevent camera shake. Most bridge cameras have a hot shoe for attaching a flash and this is ideal for fast-moving subjects. Using the zoom the degree of magnification can be varied and if vignetting occurs cropping can be made on the computer later on. For this reason alone keep the resolution at maximum for work of this nature – cropping reduces the pixel resolution.

This technique just shows how simply and cheaply gaining magnification can be achieved and is not just for bridge cameras. This will work with any camera including a compact (except you will

need to hold the reversed lens in place as permanent coupling is difficult). If you have some old lenses try them out. If not, take your camera along to a good shop selling second-hand camera equipment. It is preferable to check out different lenses to see that they work; also that the diameter of the reversed lens is wide enough for the attached one. Old manual focus lenses work best, as later autofocus ones tend to stop down to the smallest aperture when removed from a camera although it is possible to force the diaphragm open.

This works fine on the diminutive CSCs with a 35mm lens reversed on to the standard kit zoom

▶ Fig. 3.7
Anthers and pollen of the
Scots Pine, *Pinus sylvatica*.
Fuji bridge camera with
Minolta 58mm lens coupled.
1/100th sec *f*11 ISO 160,
tripod and focusing rail.

lens. The problem with some very expensive
zoom lenses on DSLRs is that the front elements
are so wide, with filter mounts of around 77mm
or more. You may consider a cheap, second-hand
70–300mm zoom with a 58mm filter thread for the
attached lens and reverse a 50mm standard lens
on to it. Trial and error is necessary; review your
images carefully on a computer. To buy coupling
and reversing rings try specialists like SRB Griturn
[now called SRB Photographic AQ]. It is possible to
get cheap second-hand lenses on eBay, but you
cannot try them out first. If you find a bargain, check
the diameter of the front element as well as the filter
size. If the lens is an *f*1.2 or *f*1.4 it should be as good
as you can get.

MACRO LENSES

The coupling lens technique is an inexpensive way
for anyone to take good close-up images. For DSLRs
and CSCs the best and easiest way of achieving
macro, however, though significantly more expen-
sive, is with a dedicated macro lens. Most of these

only go as far as 1:1 whilst coupling can go beyond
that. Coupling also works well with macro lenses.

There are macro lenses available from the camera
manufacturers as well as excellent ones from
independent companies like Sigma and Tamron.
The quality and sharpness of lenses can be checked
online, especially by looking at the MTF charts
that are normally available on the manufacturers'
websites. As new lenses appear there are plenty of
reviews to look through and often the independent
lenses come out best. To some extent the cost will
be proportionate to an increase in the focal length.
It may be tempting to buy an inexpensive macro
based on this by getting a 50mm or 60mm lens.
These will be physically short as well as the most
lightweight. However, it comes down to working
distance (the space between the lens and the sub-
ject); within that space lighting may have to be set
up as well as the prospect of disturbing what you are
trying to photograph. Flowers will not be affected by
you being up close but there is a chance you could
cast a shadow.

Another thing to watch out for is *bokeh*, a
Japanese term that refers to the out-of-focus back-
ground. The smoothness of this depends on several

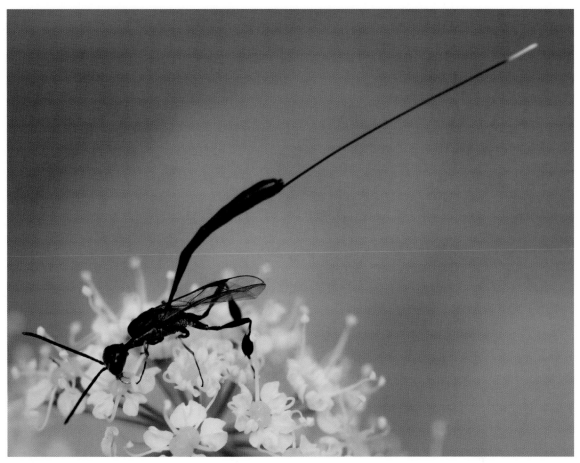

▲ Fig. 3.8
Bokeh on a Sigma 150mm macrolens. Note that despite the excellent sharpness the background that could potentially be distracting is very even. Ichneumon Wasp in a French woodland, Canon 60D with 150mm macro 1/300th sec ƒ7.1 ISO 400 natural light, hand-held. The long ovipositor is for injecting eggs into host caterpillars and is not a sting.

factors including the construction of the diaphragm and the focal length. A short focal length lens will create potentially the most distracting background, depending on what is behind the subject.

Macro lenses of 90mm to 100mm length are probably the smallest length to consider and these are seen as the standard to consider. On a non-full frame camera the 100mm will be much longer. The working distance for these lenses will vary across the focal length range and even within a focal length between manufacturers. As an approximation a

50mm macro set at 1:1 will have a working distance around 4–5cm (2in), 90mm macro is 10cm (4in) whilst a 150mm focal length gives around 18cm (7in). 180mm macros can have as much as 25cm (10 in) working distance. These are practical figures and different from those stated by manufacturers, which work on different principles. Easily disturbed creatures like insects need these larger distances and you might want to consider the 180mm macro lens. Indoors under studio conditions working with a long focal length lens may present a few problems depending on the space you have available.

There are some specialist macro lenses that do not fit the standard categories. For example Canon make a superb 65mm MP-E lens ƒ2.8–ƒ16. This is a non-focusing macro lens that starts where the others leave off. When fully retracted it starts at 1:1

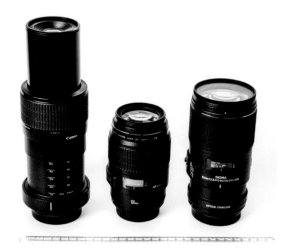

▲ Fig. 3.9
Three macro lenses shown together. From left to right, 65mm MP-E, 100mm and 150mm. Note the 65mm MP-E lens extended to maximum magnification.

▲ Fig. 3.10
Zeiss Tessovar lens on a stand with Canon 60D mounted on the top.

and steadily winds out from 10 cm (4 in) in length to 23 cm (9 in) at 1:5, i.e. ×5 life size. Between ×4 and ×5 the images become slightly soft but overall this offers an impressive array of continuous magnifications. Although designed for Canon AF mount, with third-party adapters it can be made to fit any body. Nikon have a tradition of calling their macro lenses 'micro', a throwback to when they were designed for microfilm systems.

The Infinity Probe is an excellent (if rather expensive) lens, produced by an independent manufacturer in the USA, with a variable range up to ×18 magnification. It can be purchased to fit any CSC or DSLR camera and is designed to be used in the field. There are a number of variants that can be checked out online although purchasing one in Europe can be problematic.

A number of other makes can be researched online and quite a few are no longer made and need to be hunted down via auction sites like eBay. One of these is the remarkable Zeiss Tessovar. Designed in the 1960s as a dedicated system, it can easily be converted to have a DSLR or CSC fitted. This is arranged more like a microscope, requiring a good stand, and Zeiss made a number of types. However, it can

easily be set up on a focusing rail and good optical bench. Due to the size and weight of the lens it is not really a field system but better suited to studio work. There are two or three objective lenses that can be rotated for differing magnifications and all produce a very good working distance to set up lighting. The magnification range is from around quarter life size through to six times life size or more, depending on lens and camera. Although these lenses take some finding they are remarkable and some would say the ultimate in producing extreme close-ups. Nikon owners without the Canon 65mm MP-E option (unless a third party adapter is used) have few other alternatives. Interestingly, the second-hand price of the Tessovar with stand is likely to be similar to the Canon lens. The camera mount on the Tessovar is straightforward to change using a standard T2 mount.

In addition to these primary lenses are a number of converters or extenders that can be fitted between the camera body and the macro lens. As the names suggest they convert or extend the focal length depending on their magnification, usually ×1.4 or ×2.

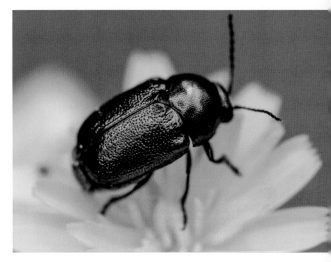

▲ Fig. 3.11
Leaf Beetle, *Cryptocephalus hypochaeridis* (just 5mm in length). Photographed using 150mm macro lens with ×1.4 Apo Tele Converter making 210mm focal length, slightly cropped. 1/750th sec ƒ8 ISO 4000. A common term for these beetles is 'hidden head', appropriate as they dive into the yellow flowers; they are widespread on Cat's Ear flowers across Europe.

▲ Fig. 3.10.1
Zeiss Tessovar with two homemade LED lights attached near the objectives fixed to a 200mm vertically arranged StackShot, with control box (top right). A Nikon DSLR mounted on top has a safe-sync adapter on the hot shoe, which allows a safe connection with the old Bowens Illumitran flash unit beneath the stage.

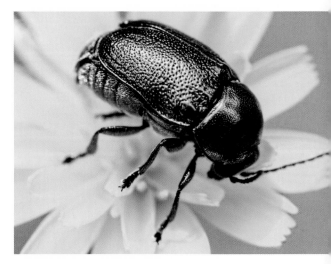

▲ Fig. 3.12
Leaf Beetle, *Cryptocephalus hypochaeridis*. 150mm macro lens with three extension tubes fitted. 1/250th sec ƒ8 ISO 4000.

A 150mm lens would become 210mm or 300mm, respectively. More to the point is that the minimum focus distance is reduced, allowing the lens to get closer to the subject. The secondary lens works by a simple case of magnification, enlarging the image as it leaves the primary lens and approaching the sensor. As such it can make a useful way of achieving extreme close-ups and the working distance is not significantly changed either. Now the downside: magnifying the image also results in magnifying any problems like distortion in the primary lens. Invariably there will be a softening of

the final photograph. To minimize this problem look to buy matched optics, that is an extender made for particular lenses. For example, Sigma manufactures EX APO extenders that only fit EX lenses. Likewise, Canon and Nikon produce extenders that only work with specific lenses. Treat general-purpose

converters with care and try to test them out first before buying.

There is another problem with using converter or extender lenses: autofocus may not operate with them connected. For macro work this is not an issue as it is best switched off anyway. Also, they do reduce the light passing through by as much as two stops. Again, this may not be a problem if flash is being used or the ISO could be increased to compensate.

Working along the same lines as extenders are a few independent companies producing what are referred to as 'macro converters'. They do work and may have a zoom capability to give variable magnification.

EXTENDING THE LENS

When light leaves the rear element of a lens it is projected as a cone of light. The sensor is rectangular and needs to fit inside the circle of light that projects onto it. If it is too large for the circle, dark corners start to appear, known as 'vignetting'. This was seen in Figures 3.5.1 and 3.5.2; here the lens needed to be zoomed to fit the sensor to the cone of light when a reversed lens was coupled. Usually the distance from the rear element to the sensor is designed to exactly take a rectangular portion of the circular image. This is why some lenses will not work with certain camera bodies, even if they are the same make.

Try removing the lens from a camera and, whilst looking through the viewfinder, watch the image as you gradually move the lens away from the body. The image slowly enlarges. In this case the sensor is moving along this projected cone of light taking a smaller and smaller portion out of the circle. This is an important method for taking extreme close-ups. Best of all it does not involve adding more glass which could increase distortion. However, just moving the lens is not ideal, as stray light gets onto the

sensor and a tube is needed to seal the light pathway to stop this from happening. A tube like a toilet roll will work but is far from perfect (it will go soggy in the rain).

Extension tubes or rings

Usually these are purchased in a group of three of varying length, such as 12mm, 21mm and 31mm. They can be used together, separately or in combinations to create different magnifications. They work best with a standard or telephoto lens with the latter providing a good working distance. They are ideal for use with macro lenses as it takes them beyond 1:1 (life size) to ×2 or ×3 magnification. In conjunction with a 65mm MP-E lens set on ×5 magnification around ×7 or ×8 will be achieved instead.

Extension tubes come as either manual or automatic. The latter has connections to ensure the diaphragm control is maintained and are the easiest option to use. The former are literally just a tube with a fitting for the camera and lens. Automatic are the most typical form on sale but check when you buy. Camera manufacturers make their own and these will be very expensive, especially as they are only rings. Independent makes abound, like Kenko, but for the cheapest look on eBay. These can be very cheap, are likely to be made of lightweight, sturdy plastic, and work well.

Bellows

During the last twenty-five years macro lenses have developed and progressed steadily to make them the most common method of choice today for gaining magnification. Prior to this, extension rings and bellows were the norm. With the rise in macro there has been a simultaneous decline in the use of bellows so that few manufacturers produce them now. New ones can be bought, however, and there are large numbers of cheap, second-hand ones available. The bellows are made from a thick and durable material but they may be damaged so look out for light leakage.

▲ Fig. 3.13
Minolta 12.5mm micro Rokkor bellows lens on a 1970s Unitor bellows unit and focusing rail.

Bellows can be used as an alternative to extension rings, and provide a continuous variation in extension instead of having to keep changing ring combinations to achieve the desired magnification. Also, bellows extend further than rings but (in the vast majority of cases) they are manual so no linkage exists with the lens diaphragm and the camera. This makes bellows more complicated to use in the field and so are better suited to a studio environment where the control is easier.

All these issues might put people off using bellows but there is a slow increase in their use, as they provide an inexpensive way of getting extreme close-ups. Their use with film is potentially complicated and more difficult but as we will see, digital photography provides a number of additional benefits. The strength of the bellows is not in the use of the standard or macro lenses you may have for use with extension rings. These lenses can be fitted and used on the bellows but are likely to become unwieldy and difficult to support; also, in many cases it is best if a lens is reversed when attached. The advantage is in the variety of specialized lenses available.

Lenses for bellows

At the time that bellows were at their peak, between the 1970s and late 1980s, manufacturers brought out a raft of accessories to go with the units. As well as different bellows, including attempts at automatic diaphragm control with dual cable releases, they came integrated with focusing rails. Some superb, special bellows lenses were also produced. These were non-focusing lenses with a minimum of glass elements present and designed with a flat lens element to maximize sharpness. During the 1980s these would have been expensive, some costing several times the camera itself. Although no longer produced they can be found second-hand and whilst some are very cheap, not surprisingly, the best ones can fetch higher – but reasonable – sums. One of these is the Minolta 12.5mm micro Rokkor bellows lens. It is more like an objective lens from a microscope complete with a manual aperture ring, $f2 – f16$. When it was available there was a series of adapters and rings to attach it to a Minolta SLR MD body. They can be a little difficult to source second-hand but other adapters are available. The roots of this lens began in microscopy and was initially developed, along side a 25mm lens, by Leitz as Photar lenses. Leitz and Minolta collaborated in the early 1970s and the micro lenses first appeared in 1981 as Rokkor lenses. The quality is variable across the aperture range and although $f16$ suggests good depth of field the sharpest detail is gained at around $f2.8$. It would have been important at the time of film to have apertures, but with digital and focus stacking the need for a diaphragm in the lens is really unnecessary. It follows, therefore, that good results can also be achieved by using a good microscope objective lens. ×2 or ×3 objective are readily available second-hand at a cost significantly lower than a bellows lens and fitting one on the front of the bellows can be as easy as making a cardboard adapter (although something a bit more substantial might be better). Blu-tack and white tack are surprisingly good at holding and supporting lenses at the front of bellows, as we will see.

Instead of using a purpose-designed bellows lens there are plenty of lenses around that were

▶ Fig. 3.15
Cranefly head photographed using the Leitz enlarging lens and 100mm of bellows extension. Aperture was wide open, 34-image stack, approximately ×7 magnification.

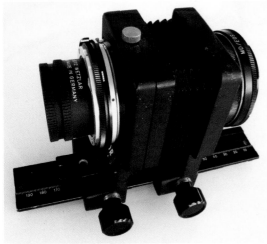

▲ Fig. 3.14
Leitz Focotar 40mm enlarger lens attached to the front of the bellows. To hold it simply in place a length of Blu-tack has been placed around the front of the bellows and the lens pushed in and secured. This temporary mount lasts extraordinarily well, although permanent fittings are available.

and professional ones had superb lenses for magnifying the film and projecting them on to paper. To do this they inherently had a flat field as they had to project a flat image from a flat negative, and they are perfect for macro work. The aperture diaphragm is manual so no linkage is necessary to the camera. The aperture ring in many since 1980 have a gap in the body of the lens where light is drawn down to illuminate the stop numbers. For macro work this gap can leak light and if the images are a bit soft or have flare it may be the result of this gap. They can easily be blocked on the outside. Enlargers were in use for many decades (and still are) and so there is a huge selection of enlarger lenses. Look out for names like Schneider, Rodenstock and Nikon. Schneider also made lenses for other names like Leitz.

The better enlarger lenses for macro are those with six elements. Some are symmetrical and have flat lens elements both front and back. Some others, like Nikon, are likely to be asymmetric. The significance of this is that it may affect which way round the lens has to be attached to the bellows. Even some symmetrical ones can benefit from being reversed but with others it makes no difference; use trial and error to find out. The well-known names are

built for a totally different function but do very well for this purpose; lenses that have no method of focusing and, typically, have to sit on some form of bellows to make them work. Enlarger lenses fit this category. Just a few decades or so ago, enlargers for amateurs and professionals were common for printing from negative film. Some of the enthusiast

easy to research online and purchase from camera dealers and auction websites. Most enlarger lenses have a 39mm screw mount and a M39 adapter is the simplest way of attaching the lens to a bellows unit. Adapter manufacturers like SRB in the UK can provide most rings and mounts as required.

A search on eBay can yield interesting lenses. A variety of odd lenses appear, referred to as ex-copier lenses – for example, an Olympus 40mm ex-copier lens with no apertures or focusing but flat field and a lens element that is wider than normal objective lenses letting in plenty of light for focusing on bellows. Some lenses you find have a small aperture and focusing can be difficult. With a price in single figures it was worth buying just to see how it performed on a bellows. It produces good quality images of two times life size at 180mm extension. The Zeiss S-Orthoplanar ƒ4/60mm lens is at the opposite end of the spectrum, commanding high prices. Designed for the semiconductor industry and for micro-documentation it produces images of a very high quality. The different lenses mentioned here are just the tip of the iceberg when it comes to 'unofficial' bellows lenses. Unthought-of half a century ago, we are now spoilt for choice and a brief look on Flickr will show the large following that enlarger and unknown lenses have for macro work.

Discussed above are some of the many types of lens that could be attached to bellows, achieving results beyond macro and at an affordable price. Quality can be exceptional. Using them will take some practice and effort, but just try any lens you think might work and it probably will. The simplicity of digital photography is that testing is easy and quick. Take the photos, review them critically with your viewing software at full screen size, adjust as necessary until the best is achieved, and delete the material you do not wish to retain. Focusing will be a problem and so a focusing rail is essential with a bellows unit. Lighting is important in this testing, as will be focus stacking, to be discussed in subsequent chapters.

UNMARKED BELLOWS LENSES

Lenses for enlargers form a neat category but there are plenty of lenses that have no particular grouping and yet are suitable to fit to a bellows unit. It is surprisingly common to find old, small lenses without a diaphragm and with no markings to suggest their origin. Testing on bellows can produce amazing results. James Robson of the Horniman Museum, a constant and innovative searcher, found such a lens that created good quality macro with an unbelievable working distance of over a metre. Some super bellows lenses, like those from Cook, were for cine cameras and can still command high prices. Unmarked ones sell for very little. It just shows that it is worth trying any lens you happen to come across.

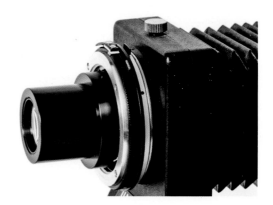

▲ Fig. 3.16
An inexpensive, ex-copier, Olympus 40mm lens on bellows.

Lens adapters

In many cases an adapter will be available some-where on the Internet to attach a lens to a standard camera mount, both DSLR and CSC. For most of the bellows photographs shown here there is an adapter to allow a modern DSLR to fit to an old bellows unit. Therefore, any lens can be attached to any camera mount. It could be that not all the functions of the lens may work, e.g. autofocus and diaphragm, particularly so with CSCs. One of the biggest issues is that the extra space caused by the adapter can prevent focusing to infinity as they can act as a small extension tube. Of course, this is not a problem for macro. These adapters are produced mainly in China and can be purchased direct or through importers via the Internet. A number of camera sup-pliers will sell them; check adverts in photography magazines. They are inexpensive and are usually fine although care should be taken when first fitting them to ensure it is a good fit. Sometimes they can be a little snug but a candle can be run up and down the adapter edge where it connects with the camera, making sure small pieces do not get detached and drop inside the camera. This will provide enough lubrication to make a smoother connection. Camera and lens manufacturers will of course not recom-mend their use but when selected and attached with caution should not be a problem. The benefits are enormous if lenses can be interchanged between camera mounts. If you have concerns over using the adapters check for reviews online.

Microscopes

Extreme close-up photography is edging into photomicrography. This is the process of photo-graphing down a microscope; it is a highly special-ized area and goes beyond the realm of this book. If you are interested in this you are strongly recom-mended to join a good microscopy group such as the Quekett Microscopy Club or Postal Microscopy Society. They have amateur and professional people who like nothing better than to help a developing

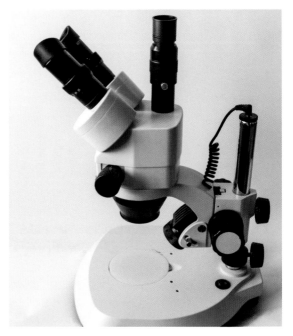

▲ Fig. 3.17
Stereo microscope for low magnifications. This is a trinocular one, the third tube is for attaching a camera. A new GX Microscope can often be found for a reasonable price on eBay.

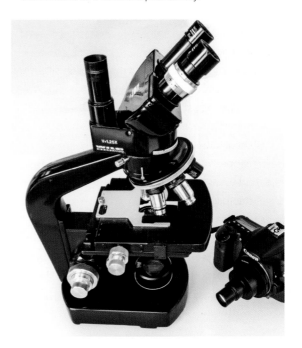

▲ Fig. 3.18
Wild M20 compound microscope, an example of a high-quality but relatively inexpensive microscope made in the 1960s. This is a trinocular one for attaching a camera – here a DSLR with adapter attached – but it could be a CSC or compact.

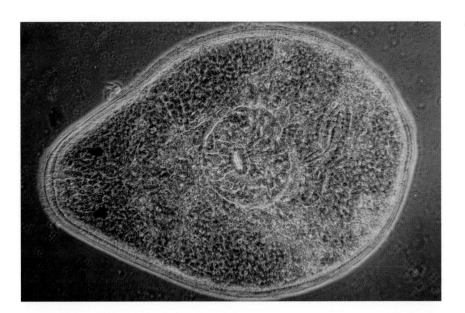

Fig. 3.19
Flatworm species from a saltmarsh, photographed on the WILD M20, phase contrast, magnified ×100, composite of four images.

microscopist of any level. Through practical meetings around the country they will include days when enthusiasts exchange and sell a wonderful array of equipment. Neither of the two is expensive to join. These super people will give you advice on what second-hand microscopes to buy, where to source them and how to use them. They have leaflets and books as well as free information downloads on virtually any subject. Purchasing second-hand microscopes does not have to be expensive and attaching a camera is fairly straightforward.

The illustrations shown here display trinocular microscopes which are ideal for photography where the third tube is for attaching the camera. However, if the microscope has only one or two eyepieces these can be used to take a photo through. A compact with a small diameter lens is ideal as it fits the eyepiece, although a slight amount of zooming in on the compact will help prevent vignetting. Many basic compacts can be difficult to attach but, like any adapter, check SRB or online. It may be possible to hold it in place with a tripod for a limited amount of use.

VIEWPOINT AND COMPOSITION

Concern over the technical side of close-ups and about whether the subject might move makes it easy to forget about composition. Picture elements, like shape, form, texture, lines and viewpoint, are just as critical in making a good photograph. The important part has to be getting the photograph before losing the specimen. When approaching a subject, take a series of shots in case it does disappear. If not you can settle down and start improving the composition. Early on, allow plenty of space so that re-composition can be completed on the computer later with cropping and rotation. Clearly, it would be better to get it right in the camera. Remember that what makes an interesting photograph for a viewer is something different; just changing the viewpoint helps. Most people will see flowers and insects straight-on so getting down below and looking up at them can make a difference. Lighting takes on a different hue at sunrise and sunset, producing richer colours.

▶ Fig. 3.20
Black-veined Moth *Siona lineata* is very translucent and a low viewpoint allows the detailed black veins to appear more effectively than if the camera had been pointing earthwards. A DSLR would be difficult and a compact was held low down below it with an extended arm. Exposure was set in manual beforehand. Only two shots were taken before it flew. Canon G15 1/500th sec ƒ6.3 ISO 1000.

TABLE OF METHODS FOR DIFFERENT MAGNIFICATIONS

	Magnification ratio	1:4	1:2	1:1	2:1	4:1
	Subject examples	Dragonflies Flowers Crabs	Butterflies Periwinkles	Small flies Small flowers	Parts of organisms Delicate seaweeds	Heads of small insects Large plankton
Suggested methods	Zoom lens	■				
	Zoom with extension tubes	■	■			
	Macro lens	■	■	■		
	Macro lens with extension tubes			■	■	
	Coupling lens			■	■	■
	Bellows with enlarger lens or similar				■	■
	Focus: auto or manual	Both	Manual	Manual	Manual only	Manual only
	Depth of field	Decreases from left to right				
	Need for extra light	Increases from left to right				

Changing the viewpoint can be aided by a vari-angled LCD screen. This can prevent the need to lie down on the ground. This is where a compact can be better than a DSLR as it can more easily be put below a subject and face skywards. With macro photography it is difficult to get everything in focus: if all else fails try to get the eyes in focus. If they are sharp the rest can be blurred and the image may still work. With the eyes out of focus there is little that can be done to improve the photograph as it is all about making eye contact, even with an insect.

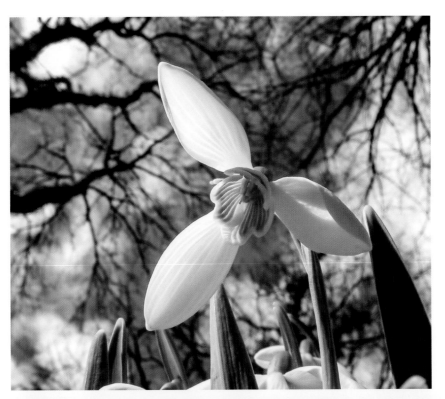

◀ Fig. 3.21
Snowdrop, *Galanthus nivalis*, in woodland. By lying the camera on the ground and shooting skywards the outline of the trees shows that it is a winter woodland and the blue contrasts well with the blue sky. Fuji S602 bridge camera, 1/60th sec ƒ11 ISO 160.

▼ Fig. 3.22
White Ermine Moth, *Spilosoma lubricipeda*, composed so that the head is off-set and looking into the picture with plenty of space in front. The single antenna helps form a frame across the top of the picture. Magnification ×2, 15-image stack.

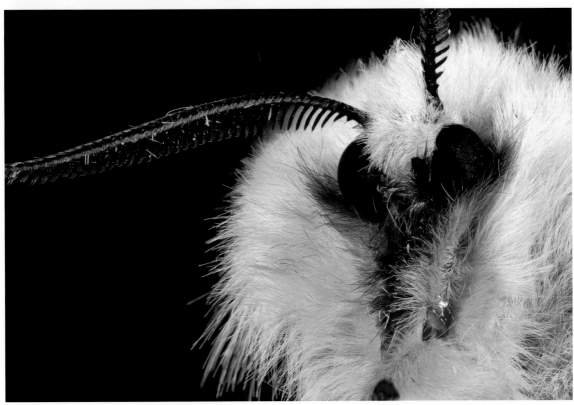

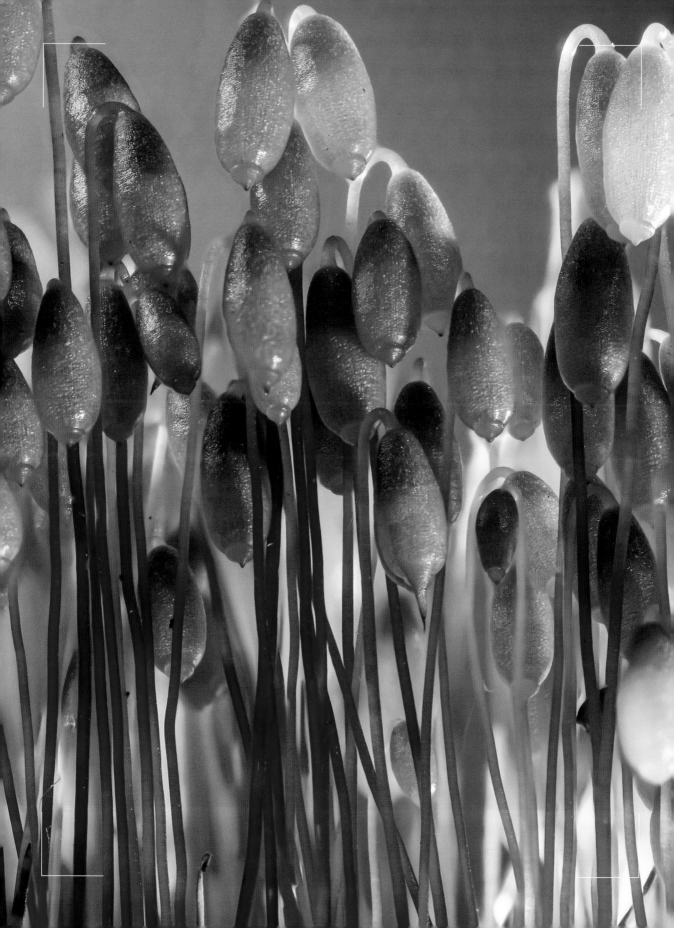

Chapter 4

Lighting and Exposure

Lighting is critical to a good photograph as the intensity, position, direction, type and number of lights can subtly or dramatically change the image. The alteration could be in the colour and contrast whilst detail may be subdued or enhanced. Of course, the amount of light will affect the camera's exposure of the image. Traditionally with film, this was about the shutter and aperture controls but with digital comes a third, more prominent issue: the sensor's level of sensitivity, which is measured as ISO. Film is inflexible with the latter but for digital cameras the ISO setting can be adjusted as easily as the other two lighting controls. This chapter looks at the impact of all of these issues on close-up photography and making the exposure.

EXPOSURE READINGS

As tempting as it may be to use a fully automatic mode on the camera, to achieve good and consistent results 'Aperture Priority' mode is the best choice. This means that you choose an aperture and the camera reciprocates with a suitable shutter speed according to the amount of light available. It is a semi-auto mode. The camera measures the light reflected off the subject, usually by an evaluative metering mode, although other methods like spot and centre-weighted will probably be available. Evaluative metering provides a good all-round method of estimating the amount of light present. However, the meter needs to know how sensitive

the sensor will be. This sensitivity is the ISO setting; as a starting point, for best quality aim for around ISO 100 to 200. The lower the number the lower the sensitivity and more light will have to be taken in by the camera, resulting in wider apertures or slower shutter speeds. High numbers, like ISO 3200, allow photos to be taken in quite dim light as these values make the sensor much more sensitive to light. The downside of high sensitivity is the increase in noise at these higher values. Noise is electrical interference on the sensor and shows up as randomly coloured pixels in the image. That could mean red pixels in a blue sky, but most crucially, images are not as clear and sharp. As with the control of apertures and shutter speeds, to provide better images, ISO needs to be carefully controlled. Avoid the auto ISO settings; digital cameras allow for quick changes in ISO and so always start low. When selecting ISO setting, be aware of the possibility of noise creeping in if you move the setting higher.

Modern cameras are good at controlling noise, and later in the book (see Chapter 8) we will be able to see how to reduce this on the computer. Like so many aspects of photography, practise regularly and discover the limits of your camera. Photograph the same subject under the same conditions but change just the ISO setting. Compare enlarged images side by side on your computer screen, find the setting where noise becomes unacceptable to you, and try to avoid going that high.

On a sunny day with the ISO set at 100 the result of metering a landscape could be a shutter speed of 1/125th of a second with the aperture of the lens

◀ Fig. 4.1
Moss spore capsules, ×2.5 magnification. Photographed indoors with a main flash behind and slight fill-in flash at the front. 26-image stack.

THE RELATIONSHIP OF SHUTTER SPEED TO APERTURE

Cameras normally show the shutter speed as whole numbers rather than as fractions, which can be confusing.

Shutter speed (in seconds)	1/1000	1/500	1/250	1/125	1/60	1/30	1/15	1/8
Aperture (shown as whole stops)	ƒ2.8	ƒ4	ƒ5.6	ƒ8	ƒ11	ƒ16	ƒ22	ƒ32

diaphragm set to ƒ8 (referred to as 'f stops'). The shutter speed is the length of time that light has on the sensor. The aperture value refers to the diameter of the hole made by the diaphragm in the lens, allowing light to pass through into the camera. The amount of natural light is fairly well fixed so if you change a value then one or both of the others would have to change. They are reciprocal and the table above shows this reciprocity.

Every time there is an increase of a whole stop, e.g. from 8 to 11, the light entering the camera is halved. Opening up a stop from ƒ8 to ƒ5.6 doubles the light, and in this example ƒ2.8 has the lens wide open, letting maximum light through the lens. Using our exposure reading example (highlighted in the table above), if the light is halved by changing the stops in Aperture Priority mode to ƒ11 there is an automatic shutter speed change. This is to 1/60th second to allow twice the amount of light on to the sensor (don't forget they are fractions) and so keep the exposure the same.

If a fast shutter speed is needed to freeze the action and you select a thousandth of a second then with the same amount of light present the lens would have to be opened up three stops to ƒ2.8 to reciprocate the amount of light entering the camera. This keeps the exposure the same. However, if you want to keep the aperture at ƒ8 the three extra stops of light could be achieved by trebling the ISO from 100 – but be careful here. Three stops would take it to ISO 800 (100 to 200 is one stop, then doubling again is 400 and the third stop is 800). The new

exposure for the same amount of light as shown in the table will now be 1/1000th second at ƒ8 at ISO 800. Above 1/1000th and below one second this reciprocity does not always function and is referred to as 'reciprocity failure'. In these situations it is easy enough to take a test exposure with a digital camera and review the result. Choice of aperture and shutter speeds will be discussed further in the next chapter; it is a fundamental process when looking at light.

FORMS OF LIGHT

Natural daylight produces the best rendition of a scene and where possible is great to use. Unfortunately, the closer you get to a subject the less light is available and the more difficult it is to control. The exposure example given above was for a general landscape scene. An insect climbing up a small plant on the ground could have several stops of light less than this, more like 1/125th sec at ƒ4. The closer you get to your subject the greater the chance that you will be in your own light; moving around the subject increases the chance of it flying away. This is where a lens with a good working distance and long focal length helps. That is not always possible when achieving extreme close-ups as this reduces the distance considerably and working indoors makes using natural light quite difficult; independent light sources become more important.

Early morning is an excellent time to approach

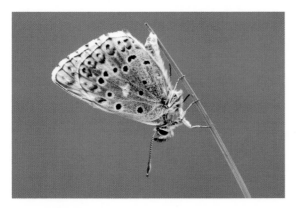

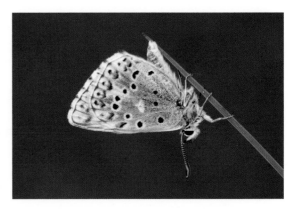

▲ Figs 4.2 and 4.3
Common Blue Butterfly, photographed early morning, at the end of a long grass stem gently moving in a breeze. To be able to use natural light Fig. 4.2 has had the ISO increased to 1600 to give a fast shutter speed of 1/250th sec at ƒ8. To bring out the dew on the wings a flash was used in Fig. 4.3, but with the shutter slowed to 1/60th sec at ISO 200. The slower shutter speed increases the risk of camera shake but ensures the background achieves a reasonable exposure. Note that the droplets of dew are not visible in just natural light. Canon 7D with 100mm macro.

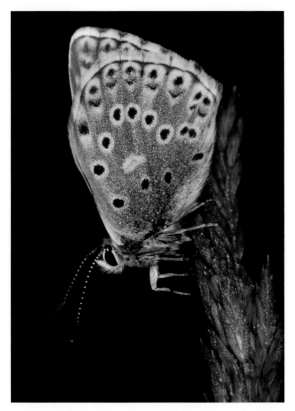

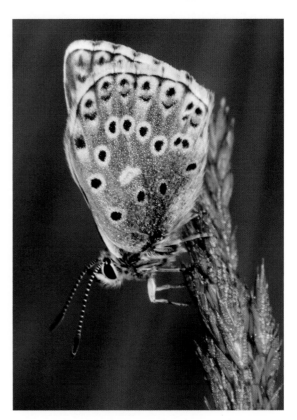

▲ Figs 4.4 and 4.5
Common Blue Butterfly, photographed early morning, at the end of a long grass stem gently moving in a breeze. For better depth of field than Fig. 4.3 the aperture was increased to ƒ16. Both images have flash, but in Fig. 4.4, ISO 200, the background has gone black due to severe under-exposure. On the right the same conditions occur except the ISO has been raised to 1000. The background now becomes correctly exposed. Canon 7D with 100mm macro, twin macro flash.

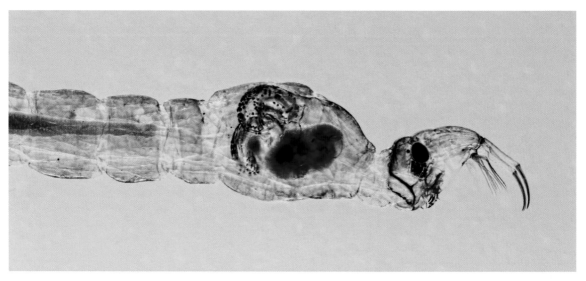

▲ Fig. 4.6

LED lighting. Live specimen of a Phantom Midge larva that lives in water. The dark rings in the body are air sacs for buoyancy and when using flash they come out black. LED lighting turns them golden and brings out more detail here and in the rest of the very transparent body. The ISO was raised to 800 so that an 8-stack image could be taken using two LED spots beneath the specimen and one to illuminate the top surface. The air bags inside the body hold the larva still in the water as it waits for prey, which is caught by the modified antennae. Magnification ×4, Canon 7D, bellows with Leitz enlarging lens held vertically.

cold-blooded creatures when they are cool and can be covered in dew. Both may prevent them moving. The colour of sunlight is good at this time but unfortunately the intensity is low. Often there is little wind around dawn and with the animals not moving a tripod is perfect. In a slight breeze, old barbecue kebab sticks can be inserted into the ground near to the stem and pegs used to gently secure the plant on which the animal is located. Another option is to increase the ISO to 800 or 1600 or higher.

Natural light can have a softening effect on the subject. This may be what is required but if you want detail, sparkle and bright colour then an electronic flashgun can be added. Beyond macro a flash is almost essential as they are so controllable and flexible. Flash can be used as the main source of light or as an extra fill-in to lift the image. In Figure 4.2 the natural light produces a pleasant, soft image of the butterfly but only when a flash is used are the drops of water covering the body visible. If the flash is the main source of light the background is more likely to be under-exposed and be black. Dark backgrounds are a matter of personal preference;

they certainly make the subject stand out. If you want a more natural effect then use the flash as a fill-in. By adjusting the ISO to be more sensitive the background will be better exposed. Alternatively check the camera and see if you can adjust the synchronization speed. Most have a shutter speed of 1/250th second but by taking it down to 1/60th second it reduces the exposure by two stops and will help expose the background. Be careful of camera shake at this speed.

Natural light is particularly difficult to use with aquatic life as this involves working with water and glass. Both absorb and reflect a good deal of light, reducing the intensity. Flash is a good portable source of bright light that works effectively in these circumstances both outdoors and indoors. Unlike natural light it can be easily repositioned. A problem with flash is that you cannot always work out where the shadow will be cast. It is simple enough to review images and adjust the position but there are times when it is useful to see the possible lighting result before firing the shutter.

▲ Fig 4.7
Using an off-camera flash. This is a bridge camera with a coupled lens attached. This is set on a focusing rail and tripod. The built-in flash would not have reached the subject; here the flash, held above the nest and lens, will simulate light from above the normal direction of natural light. Note: the flash here is an old film flash and may not be compatible with most digital cameras.

▲ Fig. 4.8
The result of the technique shown in Fig. 4.7. Red ants are moving pupae that were in a nest on the wall. The flash has frozen the action; without its use they would have been blurred.

The third form of lighting is spot lights. They are good for working indoors and with extreme close-ups. By moving them around you can check and re-check the details that are being highlighted and where any reflection occurs. In the past tungsten spots would have been used. They can still be effective today but have an inherent problem of casting a strong yellow/brown colour on the photo. This can be overcome by changing the colour temperature on the camera, and the effect may also be reduced later on the computer. Perhaps worst of all, tungsten lights tend to get hot and bulbs blow at the most inconvenient time. Microscopes often have built-in lights and older ones will be tungsten.

Far better and more flexible are LED lights, which are now commonplace. The colour temperature is more like daylight and they do not get hot in use. They have a long lifespan, are inexpensive to buy and consume minimal energy, often running on battery, and so are easily portable. One very useful property of LEDs is their even spread of light, without hotspots or shadows cast from filaments, which require diffusers to eliminate.

ELECTRONIC FLASH LIGHTING

Electronic flashguns offer powerful and flexible lighting as the main source or to boost the available light, or both. What options are there? The pop-up flash, which may be on top of your camera, is suitable only in an emergency as a light source for macro and generally should be disregarded. The flash will produce a wall of light that produces no control of texture, giving a flat, shadowless image. In extreme close-up much of the light will not reach the subject as the lens will be in the way. The only option here is an off-the-camera flash. It will be either tethered to the camera's hot-shoe by a lead, or will be wireless, depending on the camera and make. The flash can be hand-held and aimed from above or from the side to provide 3D texture. For convenience and consistency it is easier to use a flash bracket to hold the flash in place.

In Figure 4.7 a single flash is attached to a bridge camera and a coupled lens. The result (Figure 4.8)

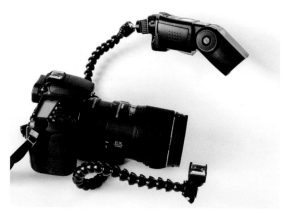

▲ Fig. 4.9
A Canon 430EX flash on an eBay twin dual-arm macro flash bracket. Two flexible arms come from a plate that fixes to the tripod mount on the camera. The second bracket is shown without a flash. The arms allow the flashes to be placed exactly where required. They are very inexpensive and support surprisingly heavy flash units.

▲ Fig. 4.10
Wimberley single flash bracket. Shown from beneath, this model has a series of secure joints to allow maximum flexibility and is being held in the middle, showing it is very rigid.

shows the movement of the ants has been arrested and the image looks natural with the light coming from above. There is strong shadow in the foreground where the ground has not been illuminated. In this instance it works because one expects the lower part of the nest to be dark and the ants to be making for that area. This could be a problem in other cases where a single flash fails to illuminate all areas of the picture. To avoid dark areas and strong shadows a second flash needs to be used to fill in the detail. A twin flash set-up is therefore the best choice and will need flash brackets or some other means of supporting the flashes. There are a limited number of good commercial brackets available. Wimberley brackets are very good, although expensive, providing a system of accessories and ultimate control. They are so rigid that the arm can be used as a handle to carry the camera. Alternatively a small selection are available from China (like those made by Meike) at inexpensive prices. Other more standard flash brackets can be modified to suit.

A huge variety of flashguns is available, starting from the camera manufacturers' own. Sigma and Nissin produce excellent models, some specifically for macro work. There are other third-party options

too, and if cost is an issue then eBay has plenty of options. This is also a place to find flash brackets. Look out for Yongnuo and small Meike flash units as these are relatively inexpensive. Two of these small units with a wireless control plus a bracket to hold them will cost half that of just one small flashgun from the camera manufacturer. They work extremely well for close-up work as they do not need to be large and powerful.

The macro flash solutions provided by the camera manufacturers are some of the most convenient macro flashes and will produce superb results but will be the most expensive option. They are the macro twin flashlights consisting of a control attached to the hot-shoe and two small flash units attached to the front of the macro lens. They can be manoeuvred to produce controlled, directional light. In addition, the power ratio between the two units can be adjusted so that one is the main light and the second a fill-in to take the edge off any strong shadow. The ring that clips to the front of the lens to hold the twin flash, as one would expect, only fits the manufacturers' macro lenses. There are third-party adapters but otherwise it will need a separate flash bracket.

Canon MX-24 macro twin-flash and Nikon twin-flash. In both cases the twin flashes are mounted on a ring that attaches to the front of the macro lens, convenient as no separate flash bracket is required. The flashes can be moved around the ring or twisted and rotated.

A pair of flash units is the flexible approach but an alternative is to use a ring flash. Designed to be fitted to the front of the macro lens, like the twin flashes they direct the light on to the subject. A single ring of light will reduce all shadow and create a flat image. The better (and more expensive) ones will have a ring split into sections so that all or just parts of the ring can be switched on and off. This produces directional side light and casts some shadow. Again look at manufacturers like Sigma, Nissin and Meike. When searching do not confuse a ring flash with LED ring flash as this will not be as bright.

On most macro flashes there are modelling lights. When switched on they provide some light to help you see and focus on the subject. In very dim light this can be beneficial as long as it does not disturb the animal. They have a habit of switching off just when you need them most and so a small LED light, particularly in a mini-studio environment, may be useful to leave on, lighting up your subject.

Using older flash units

Figure 4.7 shows a Vivitar 285 flash, which was popular in the 1980s with film SLR cameras. It is connected to a Fuji bridge camera that is digital. You will see plenty of warnings about not doing this. The trigger voltage for older electronic flashes used on film cameras was much higher than those designed for recent models. In theory, they will fry the delicate circuits of digital cameras. The current specification laid down for electronic flash is a trigger voltage of less than 24 volts. Typically they are just 6 volts;

however, flash that was around several decades ago often used voltages up to 400 volts, especially studio and mains types. The Vivitar 285 model had HV written on later models ('high voltage'). There was minimal standardization and so the only way now to find the trigger voltages is to go online and search for your model. Both Nikon and Canon say that most of their cameras can cope up to 250 volts but the latter does have a caveat that some are only 6 volts. It probably is not worth the risk on an expensive camera.

The example of the Vivitar with the Fuji bridge camera was set up and experimented upon at an early stage before the problems were fully understood. It is therefore, probably, down to luck that the Fuji did not get fried and the practice cannot be recommended. If you have an old flash and you want to use it with your camera there are a few solutions out there. What is needed is a voltage reduction circuit called a 'safe-sync' changing the trigger voltage from 400 volts to 6 volts. They are made by several manufacturers including Wein and SMDV. The safe-sync is a very small unit that slides on to the hotshoe of the camera. On top of this is another hotshoe to connect the old flash. The safe-sync should have a PC socket that takes a flash cord.

Is it worth it? The safe sync is not especially cheap and for a basic flash probably is not worth the effort. However, there are some excellent electronic flash devices that can be bought second-hand. Bowens is a manufacturer of specialist, professional flash lighting. Some years ago one of the unique

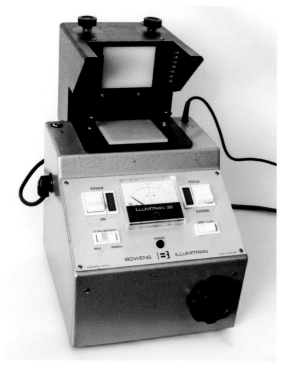

▲ **Fig. 4.12**
Bowens Illumitran 3, a commonly available, second-hand flash box. Used originally for slide copying, these make a good flash source to backlight extreme macro subjects.

DIFFUSERS

Most flash guns are supplied with some form of diffuser, either built-in or as a simple clip over the glass. Flash light can be harsh and generate strong, burnt-out reflection on shiny areas of subjects. Diffusers that come with the flash are rarely good enough for macro work. Sto-Fen make a range of diffusers that fit most flash units but are expensive and have limited ability. Several layers of clean linen (e.g. handkerchiefs) folded and secured over the flash will work well, or even cut-up plastic milk bottles. Choose a suitably clean, dry bottle and cut several similar-sized strips, including the corner curves, which can be trimmed to go around the flash and secured with gaffer tape. Test these home-made diffusers until the best result is achieved.

Diffusers do not need to be on the flash. One of the best diffusers is a ping-pong ball. With a long window cut down the ball, the opposite side of the ball has a rod or dowel stuck end-on with Araldite. Once set, the dowel can be used as a handle and be moved or held in a clip and placed over the speci-men like a hood. The subject does not have to go inside the ball. It is important that the camera lens has uninterrupted access to the specimen through the gap in the ball. The shroud of plastic needs to cover the subject from the flash so that the ball breaks up the light. The end result is a soft light with virtually no reflection and a pale background. You may consider carrying a ping-pong ball in the field with a smaller hole cut in the side. A not-too-active insect can be popped inside and if you add a gentle breath of your air to the inside they slow down. As long as you have everything ready beforehand, as soon as it starts to crawl out, another breath can be enough to make it stop for a photograph to be taken. The damselfly in Figure 4.14 lacks colour as it is an ephemeral one, meaning it has only recently emerged from the pond and colour has not fully

units they produced was the Bowens Illumitran. Within a box lies several, very controllable, flash tubes. They produce an even and diffuse beam of light at the top of the box, 80 × 80 cm. They were designed for use in slide copying with the camera attached to a bellows unit held vertically above the light where a transparency could be positioned. With a small amount of adaptation and DIY work this box can be changed to hold specimens rather than a slide transparency. Anything requiring backlighting and illumination can quickly be set up on the stage and photographed. The only problem is that it needs a PC cord socket and being mains powered will almost certainly have too high a trigger voltage (a good case for buying a safe-sync device). The Bowens Illumitran was very popular and so there are a reasonable number about both in second-hand camera dealerships and on auction sites.

PHOTOGRAPHING A WHIRLIGIG BEETLE, *GYRINUS NATATOR*

..............................

I have tried for many years to achieve a close-up of the head of this beetle. My best attempt is unfortunately with a dead specimen. Just 9mm long, the beetle lives in the surface tension of a pond, whirling around in circles very fast, catching insects that are also in the surface tension. It needs to be able to see above and below the surface and the photo in Fig. 4.15 shows the extraordinary adaptation of four compound eyes, one pair for above and one pair for looking below. Unless this was carefully focus-stacked, at this magnification it would be impossible to get all four eyes in the picture. The smooth, shiny body is well streamlined to move fast through the water.

◀ Fig. 4.13
Micro-diffuser: a ping-pong ball fixed to the end of a dowel, which acts as a handle. The ball has a wedge cut out of it so that it can be placed around a subject to prevent reflection on shiny surfaces from a pair of flashes.

▼ Fig. 4.14
Using a ping-pong ball as a diffuser. A newly emerged Blue Damselfly was carefully lifted off the vegetation in the early morning and placed through a hole into a ping-pong ball. The insect was slow to move and a gentle breath on it made it stop moving. The equipment was set up to take a 12-image stack to create this composite. Canon 7D, 65mm MP-E, ƒ8 twin macro flashes. Debris on the eyes was removed by cloning on the computer.

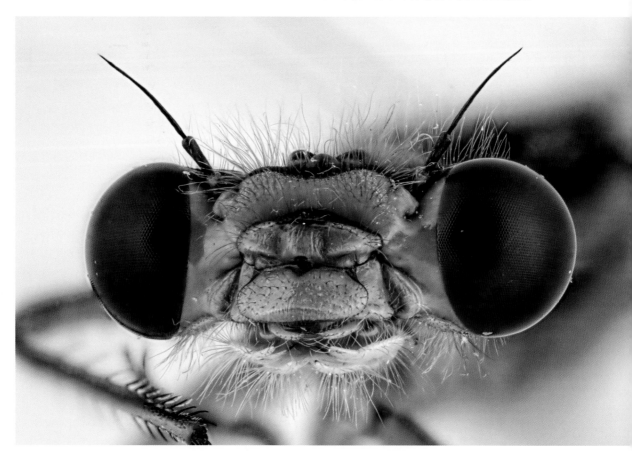

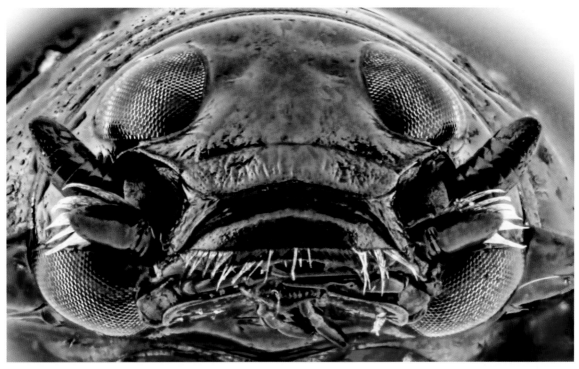

▲ Fig. 4.15
Head of a Whirligig Beetle *Gyrinus natator* using the ping-pong ball shown in Fig. 4.13. It is very shiny and produces a complete lack of any detail without the diffusion of the two flashes. Magnification ×5 magnification, 32-image stack/composite. Canon 7D 65mm MP-E, macro twin-flash.

developed. There is no reflection even on the eyes where it would be expected. The downside of strong diffusion like this example is that some detail is minimized, such as the compound eye where the individual facets are not as distinct.

Diffusion of light can also be achieved by bouncing the light off white card or other materials. For example, in the field a white bucket is quite good in which to put marine specimens to photograph. Put a small amount of clean seawater at a depth sufficient to cover a flat rock at the bottom. Place the creature on the rock so that it is just under the water. Photograph the creature by holding the camera vertically and the twin flash is adjusted so that the light is directed outwards on to the side of the bucket. The bright light will photograph the subject with diffuse light that should not show any reflections. The same technique can be used in a rockpool with a hole

cut out of the bottom of the bucket or with a short length of drain pipe.

A good look around a kitchen and the recycling bin may help to produce a number of possible diffusers. A particular favourite is a very effective diffuser made out of a small disposable bowl containing desserts for microwaving. Unlike the ping-pong ball, here the diffuser is attached to the front of the lens with the twin flashes on either side having the light diffused wherever the specimen is located.

Polystyrene is a superb diffuser. Use short lengths to break up a main flash. For example, a wedge located under a specimen could provide backlit, diffuse flash bounced onto it at a right angle (see Figure 7.7). One of the most useful diffusers you can use in the field is a polystyrene box. This doubles up as a wind break. The problem with photographing flowers, especially outdoors, is that even the slightest

◀ Fig. 4.16
Cushion Star *Asterina phylactica* photographed in a white bucket which acts as a diffuser. They are on a flat rock placed in the bottom and covered with seawater. Twin flashes are on the end of a macro lens but aimed outwards to the sides of the bucket. Cushion stars have a reflective surface and would otherwise have burnt-out white patches in the photograph, as would the water surface. This is a very rare and tiny starfish found in only a few localities in the UK. Living in large shallow rockpools it lives under stones where it lays eggs and then broods them. Canon 60D, 100mm macro, macro twin flash.

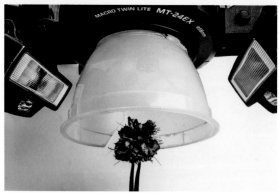

▲ Fig. 4.17
Homemade diffuser consisting of a disposable dessert bowl. The base has been removed and stuck in an old filter ring with blu-tack. This can be fitted onto the front of the macro lens. There is a V-shaped slot cut in the bowl to prevent the specimen, a liverwort, snagging on the rim. Note the results with and without the diffuser.

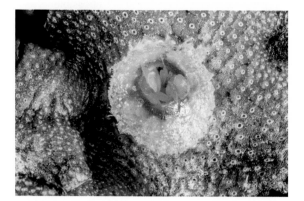

▲ Fig. 4.18.1
Marchantia liverwort receptacle without diffuser. Magnification ×5.

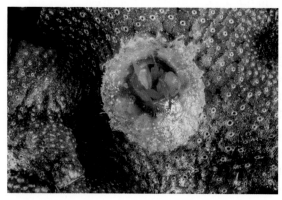

▲ Fig. 4.18.2
Marchantia liverwort receptacle with diffuser. Magnification ×5. Liverworts are an ancient group of plants and the cup-shaped receptacle contains gemmae which can asexually produce new plants. This is a very common but easily overlooked plant. The holes are for gaseous exchange.

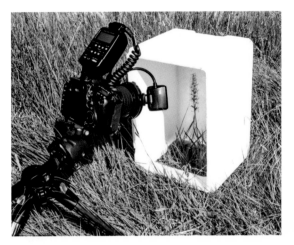

▲ Fig. 4.19
Diffuser box, made from a polystyrene veg box, used in the field, both as an enclosure to shelter from the wind and as a soft diffuser.

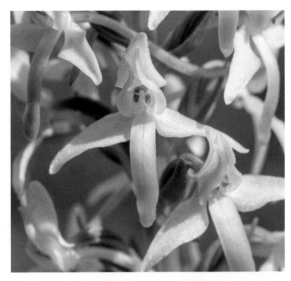

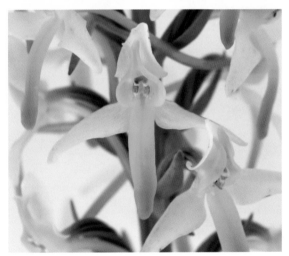

▲ Figs 4.20.1 and 4.20.2
Diffuser box: a comparison between two orchid flowers. Fig. 4.20.1 is the one taken without the box; the other was taken with the box. Both natural light. 1/250th sec ƒ11 ISO 200 and 1/500th sec ƒ11 ISO 200 respectively. Canon 7D 100mm macro.

of breezes moves the plant. For extreme close-ups this can make life very difficult. As mentioned before, clips or pegs coupled with kebab sticks or knitting needles can provide support but a wind break is better. A very easy diffusing box can be made from a large polystyrene box complete with lid that wholesalers often use for carrying broccoli. Once used they are thrown away. Pop in and have a word with a greengrocer on the high street or find a fruit and vegetable wholesaler. Usually they seem pleased to get rid of them. Approximately 40 × 30 × 30 centimetres, one of the larger sides is the lid. They are very substantial at around 3 cm thick with quite dense polystyrene. A section of one end can be cut out and with the lid off the cut end is placed over the plant, protecting it from the wind. An alternative to the box is to buy or make a small collapsible diffusion tent.

On a bright day it may seem that the light is being reduced but the sides are so effective at reflection that the exposure not only does not suffer but may actually be a stop brighter. If a flash is used, do not necessarily aim it at the plant but out towards the sides for maximum diffusion. The light bounces off the polystyrene and creates soft lighting. If matt cards are carried of different colour backgrounds

one can be placed at the back behind the flower so white is not dominant. This may distort the colour of the light slightly to give a mild cast but as long as the flash or sunlight is not reflecting off it the cast will be almost non-existent.

If the wind is particularly strong it may produce eddies that can still reach the flower. A flash will

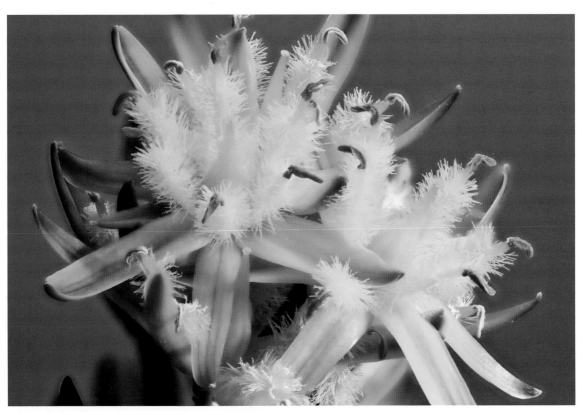

▲ **Fig. 4.21**
Bog Asphodel, *Narthecium ossifragum*. Composite image created from a 18-image stack taken in the field with a diffuser box.

help in that situation or an increase in the shutter speed/ISO. You can also use the lid to minimize these eddies. A window is cut to let the lens through and then the lid is fitted back onto the box. A flash is almost essential now but modelling lights are also needed to lighten up the interior. Using the 'Live View' mode on the rear LCD is easier than looking through the optical viewfinder. Even slight breezes can cause a problem with extreme close-ups, and the lid is almost essential when doing focus stacking. The box may be bulky but is very lightweight and surprisingly robust. In springy conditions on the surrounding vegetation the box can be blown by the wind. If you have a small camera bag or some other weight just lay this on top and it stays put.

LED LIGHTING

In recent years LED lights have become commonplace and inexpensive. They are available in a multitude of forms and although all are low voltage some are powered by battery and others by mains power. A very good starting point are the spot lights produced by a well-known, worldwide furniture store. They have a flexible neck and either a heavy base or robust clip. These spot lights contain one LED that is very bright. An individual, bare, plain LED can be purchased online through eBay and other sources at very low prices. The variety of sizes and powers is daunting. If you are happy with a bit of electrical DIY a selection of these different LEDs can be bought and wired up for use as spots. It is

DIVERSITY OF LEDS

The more you search, so the diversity of LED lighting increases to bewildering shapes, styles and brightness all at very low cost. Roger Gilroy recently sent me some photos taken with a dual-arm two-LED flexible reading light, available through numerous online retailers. For the price of a good cup of coffee this clip-on light is advertised for books but will easily clip to a macro lens hood. With the camera on a tripod the flexi arms can be adjusted to illuminate a static subject giving good directional light. New lights are appearing all the time.

▲ Fig. 4.22
Ikea Jansjo LED work lights. An example of good and suitable spot lights for macro work.

becoming common practice to replace tungsten light units in older microscopes with a 5 or 7 watt LED. They are all low voltage and so it is quite a safe procedure. To connect to the mains a transformer or LED driver is needed. Additionally, a dimmer switch can be connected in line to produce variable power. For battery usage a 12 volt 7Ah lead-acid type works well. These are like very small car batteries and, like them, can be recharged with a car battery charger. A portable studio of LED spots can be set up to be used in the field.

LED light is even and a similar colour temperature to daylight. This means that the camera's white balance can cope well with LED in automatic mode.

As well as a single LED, many light units have multiple LEDs present to create rings and strips of light. The ring is especially useful as it can be used like a ring flash or (more importantly) to create variable forms of backlight. Both types of bare LEDs are available for DIY construction, a very reasonable cost option, or as fully developed lighting.

▲ Fig. 4.23
Portable LED spots. Two bright LED bulbs, sold as replacement reversing lights, have been connected through a dimmer that acts as a switch to a battery. For the photograph the bulb wires have been shortened but otherwise this set-up is used in the field. The battery is the same one used to drive a StackShot (see Chapter 6) and even with regular use with both this and the LEDs will last for many months before needing to be recharged.

▲ **Fig. 4.24**
LED ring and flash. On the left is a mains-powered 40-LED ring light with a dimmer control. On the right is a Meike LED ring battery-powered flash.

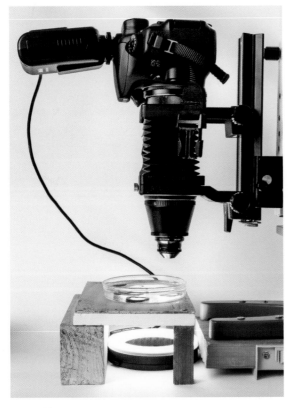

▲ **Fig. 4.25**
LED ring flash in use for backlighting set-up under a home-made stage.

DIFFUSE AND
DIRECTIONAL LIGHT

One might think that a bright sunny day has to be the best opportunity to photograph close-ups. This is not the case with, say, mosses and lichens that have very irregular surfaces. The result with strong, directional sunlight will be high contrast that leads to a lack of subtle detail. Diffuse, softened light is better as it reduces harsh shadows and mutes colour, which in mosses will be largely green. A reflector can help to send some light back onto the shadow although better still, a diffuse screen can be used to break up the light. Any material that is thin and translucent will do and it does not have to be big. Some very cheap reflectors, occasionally given away free in photographic magazines, can be thin and make ideal diffusers instead of reflecting light. Make sure they are white so the light remains neutral.

Whatever the source of light, the direction and angle at which it strikes the subject will determine the amount of shadow cast across the surface that in turn creates texture and relief. A landscape photographer will be up around dawn or just before sunset to photograph a scene when the sun is low in the sky. Vegetation, buildings and rocks cast shadow that provides a three-dimensional lift to the land. As the sun climbs in the sky less and less shadow is produced and in the middle of the day, when it is close to the perpendicular, so little shadow is present that the landscape looks flat and less interesting. The same principle applies in macro photography. If the texture and detail of the surface of a seed or an in-sect's cuticle is to be highlighted then the light needs to come from a low angle such that tiny shadows are cast along the surface giving the same relief as if it were a landscape.

▲ Fig. 4.26
Lichen photographed in strong directional sunlight from the left.
1/200th sec ƒ16.

As we have seen from a discussion of flash, posi-tioning two lights on either side of the lens is a good option. Any strong shadow cast by one of the units can be reduced by the other. This is easy enough if you have a macro flash that enables the ratios to be controlled. If the two flashes are separate units and thus there is no ratio control one will need to be diffused, with layers of linen taped over the glass, for example. As the flash is replacing the sun as the light source, try to place the main unit in a position that simulates that effect, normally from slightly above rather than the side although this will depend on the subject. Experimenting with spot lights and reflectors will help you to learn about the differences in positioning. The results can be reviewed quickly and the lighting adjusted as required. As LEDs are inexpensive, have more than two available. They can be placed at varying distances to create the different intensities of light and minimize strong shadow. In a studio set-up placing backgrounds close to the back of the subject helps to reduce dark areas. Have a selection of different colours, like blue or green, and different sizes available. Try not to get the back-ground so close that shadows are projected onto it. A spot specifically angled on to the background minimizes shadow and improves the exposure.

Reflection of light, when photographing through water and glass, is a real problem. If the camera lens and light are pointing straight onto the surface, light will bounce right back into the lens, producing a dense, pale glare distorting the subject. In this situa-tion the key is to angle the light source at around 45

▲ Fig. 4.27
Lichen photographed with a diffuser, consisting of thin translucent plastic, held across the sunlight to soften the light. 1/40th sec ƒ16. Both taken with Canon 60D, 150mm macro with a 31mm extension tube, magnification approximately ×2.

◀ Fig. 4.28
Directional light on a seed pod of Red Campion, *Silene Dioica*. Natural sunlight from above skims the surface to reveal form and texture in the seeds. Magnification ×4. Fuji 4900 bridge camera with 50mm standard lens coupled, tripod, 1/30th sec ƒ8.

▲ Fig. 4.29
Directional light on Buff-tip Moth wing, magnification ×3. A main flash on the left skims the surface at 45 degrees whilst a second on the right fills in at a ratio of 4:1, reducing strong shadow. The scales on the wing have been 'lifted' to create good texture. Canon 7D, 65mm MP-E macro, macro twin flash ƒ8, 10-image stack.

degrees to the surface. Any reflected light bounces off at 45 degrees on the other side of the surface. This principle applies to public aquaria as well. In those situations the glass can be very thick and a powerful flash gun may be necessary. The glass may give some distortion and colour shift as well. Photographing through glass is dealt with in more detail in Chapter 7.

▶ Fig. 4.29.1
Buoy Barnacle *Dosima fascicularis*. In seawater, feeding, side flashlight to show the texture of the body. Canon 30D, 100mm macro, single flash from the left.

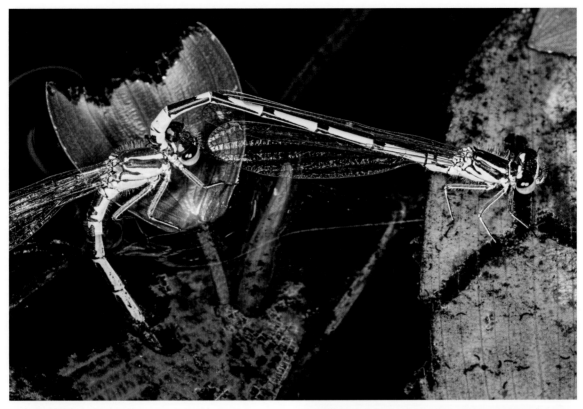

▲ Fig. 4.30
Flash and water: damselflies laying eggs into pond weed. The female is being held by the male as she descends into the dark, peaty water. One flash has been angled at the insects from the right, carefully so as not to bounce light onto the water, and a second flash on the left is held down near the water at 45 degrees to the surface to expose the weed and abdomen under the water. Canon 60D with 100mm macro 1/250th sec ƒ16.

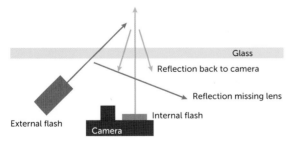

▲ Fig. 4.31
Diagram to show the path of light when it strikes glass or water. The internal flash along the same axis of the lens bounces back into the lens. An external flash at an approximately 45-degree angle will pass some light through the surface and any reflected light goes away from the camera on the right.

▲ Fig. 4.32
Developing tadpole embryo, photographed with two LED spot lights angled at 45 degrees to the surface of the water. A small sample of eggs had been taken from the pond and placed in a glass dish with pond water. Under the dish was a blue card for background. Flash and daylight produced significant reflection and so a portable LED set-up was used by the side of the pond so the eggs could be returned. Some debris has been cloned out on the computer. Magnification ×3. Canon 7D on a tripod, 65mm MP-E macro, 1/5th sec ƒ8 ISO 200 and a 7-image stack.

BACKLIGHTING

Transparent and semi-transparent subjects may show more detail or texture with light shining through from the back. This could be achieved very simply by moving to allow sunlight to pass through or holding a flash behind and out of shot of the subject.

Determining which light is best for a subject can be a matter of trial and error, especially in the field. Searching along hedgerows in summer you can find tiny bagworms attached to the underside of leaves. Backlighting produces a more natural appearance. Photographed with natural light first and then a flash separately give quite different results. Natural light gives the more pleasing image but the bagworm will be in shadow. The diffused flash exposes everything correctly but does not suggest the underside of the leaf. The ideal would be a combination of both but with insufficient sunlight a second flash could be placed above the leaf to suggest sunlight. This provides a pleasant backlight passing through the leaf with a front right flash to correctly expose the bagworm (see Figures 4.36 – 4.38).

Aquatic organisms are particularly good subjects for backlighting as they are often translucent; a top light may not be necessary. Natural light is tricky to use whilst a flash is more consistent. Figure 7.1 was taken with a single flash from beneath a dish but to get the exposure right the pre-flash facility found on DSLRs was needed. Looking through the viewfinder, hold the centre of the view over the area to be correctly exposed. With the flash on and in position a button is pressed on the camera (this varies between manufacturers and models) and a faint flash occurs. The camera's metering system has used this to correctly assess the flash exposure of the area concerned. By firing the shutter release now the correct exposure will happen. More information about working with tanks and aquatic systems is given in Chapter 7.

LEAF MINER PHOTOGRAPHY, A NEW GENRE?

Almost everywhere you look, there are leaves that have been mined, from honeysuckle bushes to low growing weeds and holly trees. An entire genre of photography could be developed using backlit leaves. A tiny moth caterpillar inside the leaf slowly works its way around the leaf eating all the cell tissue between the upper and lower epidermis so it is still protected inside. As they feed they grow and so the tunnels increase in size. Their droppings inside litter the tunnels and damaged tissue is shown up along the edge in a variety of colours – but only when backlit. Once ready to pupate the larva emerges out of the leaf to spin a cocoon. There are many different species of mining micro-moths found on a wide variety of plants.

▲ Fig. 4.33
Oak leaf miner, backlit.

▲ Fig. 4.34
The underside base of a nettle leaf in natural backlight. The bright sun has passed through the leaf to create a diffuse light, highlighting the sting cells beneath. Canon 300D 90mm macro with 50mm coupled, approximately ×2 magnification. 2 seconds at ƒ22 ISO 100.

BATTERIES

Invariably lighting will require batteries and rechargeable ones are best, both for convenience and the environment. Most rechargeable AA batteries will slowly discharge by themselves over a week or so and always need re-checking. Eneloop batteries by Sanyo are a little more expensive but totally reliable with just a small percentage discharge over a year. They are readily available online and I have now replaced all of mine with these and have never failed to have perfectly charged batteries months after they were charged.

▲ Fig. 4.35
Backlit bramble leaf miner
Stigmella sp. photographed
with a single flash behind
the leaf. There are several
individuals present in the leaf.
Canon 7D 100mm *f*16 with
430EX wireless flash.

▶ Fig. 4.36
Bagworm underneath a leaf,
natural light, ×1, 1/125th
sec *f*8. Bagworms are small
caterpillars of micro-moths.

◀ Fig. 4.37
Bagworm underneath a leaf,
flash from front right and left,
×1, 1/60th sec ƒ11.

◀ Fig. 4.38
Bagworm underneath a leaf,
flash above the leaf and
second front right, ×1, 1/60th
sec ƒ11. Canon 7D, 100mm
macro.

Chapter 5

Image Quality and Sharpness

Much was said in Chapter 2 of the varying benefits of different cameras. Speak to anyone about their camera and probably they will extol its virtues and image quality. This can be down to differing perspectives on what makes a good photograph. When making extreme close-ups there is one overriding issue that dominates quality whatever one might think, and that is sharp focus. Focusing and the point where you focus is critical. The closer you get to your subject the more difficult this becomes. This short chapter looks at how to get the best quality out of the methods you employ.

WHAT IS 'DEPTH OF FIELD' (DOF)?

When you focus your camera on a particular point there will be an area both in front and behind that point which has sharp detail. Away from those sharp areas the detail in the photograph is blurred and out of focus. The length of the in-focus area from front to back is referred to as the depth of field. Three properties will determine the length of DoF: the aperture used, the focal length of the lens, and the position of the focus point. The last of these properties actually makes less difference once past the 1:1 ratio. In fact at this magnification the real problem is, initially, just how to focus. As we have seen, the best way is to switch off autofocus and rely on manually moving the camera and lens, not even attempting to turn the focusing barrel. Bright light on the subject

▲ Fig. 5.2
Depth of field on a Greater Water Boatman, *Notonecta* sp. at ×1.5 magnification. The animal is hanging upside-down at the surface of pond water to collect air with hairs at the end of the body. At the other end of the body the head has a vicious proboscis that can stab into prey and suck blood. The eyes need to be in focus as well as the proboscis which is running backwards. It is in a tank but set back from the glass, so it was impossible for the camera to get a better angle. A 90mm macro with extension tube can just reach it. *f*32 gives the best depth of field. The focus point (arrowed) is critical to ensure the area in front of and behind that point is used for maximum DoF. Canon 30D with Tamron 90mm macro + 21mm extension tube, single flash held above.

◄ Fig. 5.1
Tiny weevil in the base of a Kidney Vetch flower, *Anthyllis vulneraria*, magnification ×4.5. Photographed exactly as found in the field. 32-image stack, Canon 7D, 65mm MP-E macro, macro twin flash on a StackShot at *f*8.

helps (macro and ring flash may have modelling lights) and a focusing rail to move the camera in small increments so you can see to focus. A hand lens can assist if you can get close without disturbance but, as we will see later, a camera linked to a computer screen with live-view is a massive bonus to assist focus. Live-view on the camera rear screen, although not as large, is very useful, especially if you can enlarge the middle portion of the image. This will distort the picture but now at pixel level you can focus more critically.

With regard to the focal length there is some variability here. The basic rule is that the longer the focal length, the smaller the depth of field. This means that if you compare a 50mm macro lens with a 150mm you would expect less detail to be sharp in the latter lens. However, for close-up work often the working distance carries a greater importance. Working distance is the length between the end of the lens barrel and the subject and is a detail often missing from technical data provided by manufacturers. The distance does vary slightly between lenses of the same focal length and we looked at this under the section on macro lenses. When using bellows lenses, whether official or not, working out the depth of field and working distance is a case of testing for yourself.

APERTURES AND SHARPNESS

The lens aperture offers the most immediate and effective control of DoF. If the aperture is wide open the DoF is at a minimum. As the diaphragm is stopped down and the aperture number becomes larger, so the DoF increases. This means that macro lenses with ƒ22 and ƒ32 have a very small aperture and maximum depth of field.

When you look through the viewfinder of a DSLR the image that you see is shown with the aperture wide open even if you have selected ƒ22. As the camera is optical it requires the light so that you can see the image. When the shutter release is fired then the camera switches the diaphragm down to the chosen aperture. The only way to see the effect of any aperture on the image will be to use a depth of field preview button, usually located at the bottom of the camera near the base of the lens. As it stops down the viewfinder goes dark as less light is now entering the optical system. For CSC and bridge cameras that have electronic viewfinders the image should show the aperture stopped down and the resulting depth of field can be seen.

The three photographs of the empty limpet shells demonstrate this phenomenon. At ƒ2.8 the aperture is large and with a minimum DoF only the central shell is clear. At ƒ8 more detail is appearing in the nearest shells to the central one but only on ƒ22 can all five be said to be clear. In all cases the top of the centre shell is the point of focus. The area in front of the focus point is not as large as the area behind. Some people look at this as one third and two thirds, in front and behind respectively. That is a very rough guide but is not always obvious. However, it shows that the central shell was not the best point to focus on; perhaps the point between the second and third shell from the front might have been better. It is about choosing the right focus point to maximize the DoF. But the reason it was done here was to show something else: the point of the middle shell, the focus point, is sharpest at ƒ8 whilst at ƒ2.8 and ƒ22 it is soft with less contrast.

We now have a dilemma. If we want the sharpest image on this lens we use ƒ8 and yet the amount that comes into focus will be significantly less than if taken on ƒ22. The 'sweet spot', as it is known, varies between lenses and is not precise. It does mean that you should test each of your lenses to find out what aperture is good to use. If possible try to use a proper lens testing chart, often given away free. Set on a tripod, take photos under the same conditions varying just the aperture, and compare the results blown up

▲ Fig. 5.3 ▲ Fig. 5.4 ▲ Fig. 5.5

▲ Figs 5.3, 5.4, 5.5
 Depth of field: five shells have been photographed with the focus
 point being the peak of the middle limpet shell. The light was kept
 constant by using diffused spot lights. Set on 'aperture priority' the
 aperture was changed between the three photos. Fig. 5.3 is ƒ2.8;
 5.4 is ƒ8; 5.5 is ƒ22. Note that the focus point is sharpest in ƒ8.
 A 60mm macro lens was used.

next to one another (remember, the FastStone Image Viewer is very good for this). You may find that the drop-off of quality is slow and gradual from ƒ8 or there may be a sudden change from, say ƒ16. Either way you should know what each of your lenses is like and then it will be easy when in the field to select the correct aperture to use.

Briefly, there are two reasons for the sharpness problem. At wide aperture the edge of the lens is used and this is not the sharpest part. A lens sweet spot is often found in the middle of the range, around ƒ8. Stopping down to very small apertures causes the light to pass through at such angles they conflict and cause distortion. If you are going to use enlarger lenses or others which you have obtained for use on a bellows it is essential to test them and find the optimal conditions. The Minolta 12.5mm micro lens discussed in Chapter 3 has a performance that peaks around ƒ2.8 and at ƒ16 is virtually unusable. If you find the results disappointing with a lens, find the sweet spot!

For extreme close-ups, depth of field is always going to be a problem. Figure 5.7 shows a single photograph of a crane-fly, which is quite a large insect. At three times magnification and an aperture of ƒ8 with a 65mm macro the actual depth of field is a distance of 0.249 millimetres (data from the manufacturer). The lens has an aperture range of ƒ2.8 to ƒ16. At ƒ16 the DoF doubles to 0.49 millimetres but that is when distortion creeps in. The crane-fly may not have much of it in focus but what is present at ƒ8 is sharp. Taking control of what is in focus in our pictures, as well as what is not, is so important in directing the viewer's attention to what we want them to see. It is always important to have the eye of the subject in focus and despite the fact that every-thing else is soft and out of focus, concentrating the attention on the eye still makes the photo work.

DoF VERSUS SHARPNESS

How do we get around this dilemma? Firstly, avoid turning the aperture down as far as it will go; having checked your lens you will know the ideal and what you might be able to get away with in the extreme cases. (Good lighting also helps sharpness.) Second, to achieve exceptional depth of field and sharpness consider taking more than one image of the subject and combining the best parts. Always use the optimum aperture; for example, with the MP-E lens composites in these chapters it is invariably between f5.6 and f8.

DISTORTION

This image was the first one I took with my new Canon 65mm MP-E lens soon after it became available. Upon viewing the first images on a computer the excitement vanished, as they all seemed soft. Using f16, the maximum aperture, I knew the DoF would be limited but thought it would do. None of the image is clear. Reproduced small, like this or on the back of the camera, it looks all right but it is not sharp. Like most lenses it is at its most sharp around f8. I test all lenses and keep the results filed away on my computer.

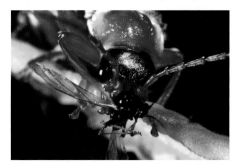

▲ Fig. 5.6
Cantharid beetle eating an aphid. Magnification ×4. Canon 30D, 65mm MP-E macro f16, macro twin flash.

▶ Fig. 5.7
Depth of field: the crane-fly *Tipula paludosa* has been photographed from the front with a Canon 65mm MP-E macro at f8 to show the depth of field, which is barely the length of one segment in the antenna. Finding a focusing point was difficult at this magnification, ×3. (See also Fig. 5.14.)

◀ Fig. 5.8
Velvet Swimming Crab, *Necora puber*, close-up of the head, with extended depth of field. This final image is made from two photographs. The main image lacked focus to the claws and so the claws were cloned in from a second photo. The crab is in a tank and the mottled effect on the seaweed at the top is due to detritus in the water. Canon 7D 100mm macro and macro twin flash. 1/250th sec, *f*14 ISO 125.

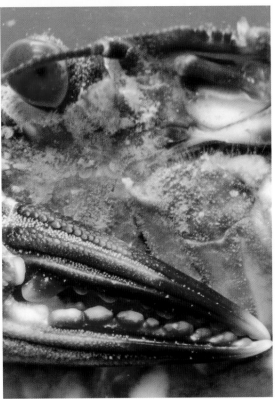

▲ Fig 5.9.1

▲ Fig 5.9.2

▲ Figs 5.9.1 and 5.9.2
Velvet Swimming Crab, *Necora puber*, part of the initial two images enlarged. Fig. 5.9.1 is the main one but the claw is out of focus, whilst in the second image the claw is clear but the eye and face are out of focus. These were hand-held and so the photos do not align but this is not a problem with cloning.

Cloning

When photographing a close-up think of taking a number of images but change the focus point. At the time, reviewing images on the rear screen does not always show up unclear areas. Of course you can enlarge the picture, but even by moving to all four corners you cannot see it all in one shot – when expanded there may be some soft spots. On a full-screen computer image, soft, out-of-focus areas can be seen and the best photo identified. Looking at the spots which are unclear, distorted, out of focus or just badly exposed, check out the other images you took at the same time. Hopefully, one will have the poor spots correctly photographed. In your image editor you need to place these two images side by side on the screen with the areas to be improved enlarged. Using the clone tool, set the clear material to be cloned and then click on the main image to add. Carefully, and taking plenty of time, begin cloning the good material on to the poor. Make sure you have zoomed in on the main image. You do not need the entire area to be cloned to be on

▲ Fig. 5.10
Freshwater Pearl Mussel, *Margaritana margaritifera*. One of eight images taken, moving to vary the position of strong reflections on the water surface.

the screen: do one section at a time then move the image before tackling the next piece. It is best to do the cloning before other enhancements like levels and tone curves unless you are cloning because of exposure issues. That is more tricky and needs the exposures brought to a similar state first.

Clearly, you can clone from as many images as you wish, taking small sections of material from files one at a time. When subjects move even just a fraction this can be the best way of constructing a sharp image.

Cloning works well and is a simple technique. There have been a few purists who argue that this is unacceptable manipulation, especially when competitions are involved. It should be treated as an enhancement rather than manipulation as the subject has not been altered in any way. The photographer is allowing the audience to see what is natural and there – it is just that the viewer would otherwise struggle to see it. If the viewer was looking at the actual crab or the mussel the eye could move back and forth and get the perspective and relevant areas in focus. We are just limited by our photographic equipment. In the case of the mussel a waterproof camera or one in a housing would have achieved an even better image but all that was available was a bridge camera!

A COMPLICATED CLONE

The Freshwater Pearl Mussel is a very rare species in Europe. It lives in fast-flowing water in upland areas and is so difficult to find that seeing this specimen meant it had to be recorded. It was between boulders in shallow flowing water and strong reflection on the surface could not be eliminated with a polarizing filter. Eight separate images were taken focused at the same point. Using my body I moved to shade the reflection as much as possible, but each shot has an area of reflection although in a different place. On the computer, starting with the best image I cloned small sections from each of the other seven photos until I had one composite. Cloning works very well and I have been using the technique for more than fifteen years.

▲ Fig. 5.11
Freshwater Pearl Mussel, *Margaritana margaritifera*. Final image cloned from eight photographs. Fuji Finepix S602 bridge camera, tripod, 1/3rd sec ƒ8.

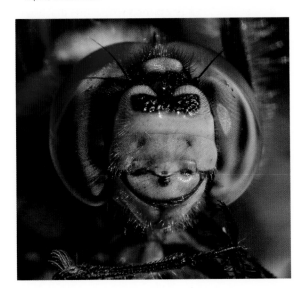

◀ Fig. 5.12
Cloning an Australian Dragonfly road accident victim. It was still alive when removed from the front of the vehicle. Two images were taken, one with the eyes in focus, the other with the central face sharp. The face of the second was cloned on to the first. Unfortunately the accident had damaged one side of the top of the head section. To reconstruct that bad part the original second image was flipped horizontally. Now the good part was reversed and then this side was cloned on top of the main image. Magnification ×2. Fuji Finepix S602 bridge camera coupled with reversed Minolta 58mm lens. Natural light, hand-held, 1/60th second, ƒ8 ISO 400.

It is interesting that even during the Victorian era there were photographers like Henry Peach Robinson who in the 1850s was creating composites made from combining multiple negatives. Having learnt the technique from his friend Oscar Reijlander, who first came up with the idea, Robinson went on to develop it further. The painstaking work involved masking and printing sections of usually between five and ten negatives where he struggled to achieve focus and exposure. Some of his most famous works have amazing front-to-back sharpness and huge tonal range. It is interesting that many other photographers of the day called his work 'fraud and deception'.

Stitching images

Sharpness and tonal range can be improved if the photograph has more pixels. This is not a simple pixel increase achieved by using software designed to bump up the pixel number. In fact it can be time-consuming to the point that gains might be outweighed by the time it takes to achieve these small differences, and this technique will not work with all material. Essentially, instead of taking a single photograph, the subject is divided up into sections and each one photographed with the optimum conditions. For example a flower could be divided up into quarters and the four parts photographed with a 20 megapixel camera. When taking the photographs an overlap of around 20 percent is allowed for so that the software can match up the images. Plenty of software can do the stitching together of the images but few can beat the free software download from Microsoft called ICE. Drop the four images into the ICE window and with nothing else to do the software finds the matches and you have your image. Allowing for the overlap your image now becomes around 60 or so megapixels. Passing this image through levels and whatever else needs to be done for enhancement, including Unsharp Mask to sharpen up the image, you can finally reduce the number of pixels back down to

around 20 megapixels if you so wish. Viewed on the computer screen or printed out, the image will have a slightly enhanced sharpness and tonal range.

Usually, this technique is done to counteract equipment limitations and especially used by some microscopists. For example, if the subject is too large when viewed down a microscope, move the subject and take a number of shots until the whole animal has been covered. Then stitch them together. Sharpness in a lens is limited by issues such as numerical aperture and the amount of internal distortion. Stitching can help. When using a bridge camera-lens coupling method, stitching is very useful to produce high quality 1:1 images. Normally the setup ensures high magnification but causes vignetting on lower ones. Stitching several high magnification ones together can give 1:1.

Stacking images

Ten years ago while many of us were cloning to improve sharpness several computer geniuses were working out how to take in-focus pixels out of similar photos and add them to create sharp composites. Originating with medical and microscope users, focus stacking has now become mainstream and straightforward. The principle is simple even if the technology is complex. Focus stacking is where a number of photographs are taken of a subject all at a slightly different focus point along an axis and then combined using software to produce a composite to achieve an unparalleled depth of field. This is applicable to almost any photographic situation but with the problems of depth of field and sharpness involved in close-up photography it has become an important technique.

The basics of focus stacking is to choose the optimum aperture, e.g. $f8$, and take a series of images from the front through to the back of a subject, with some overlap where possible. The technique does not work with hand-held cameras as the images need to be carefully aligned but this will be discussed later. In the crane-fly, focusing was first on

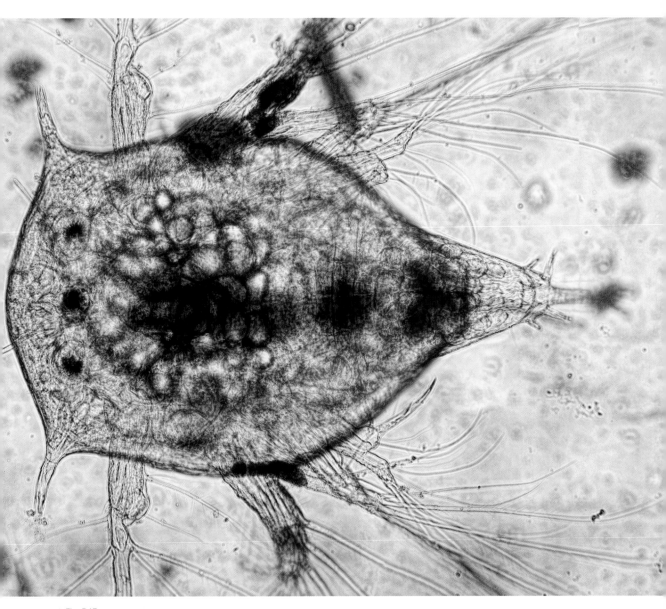

▲ Fig. 5.13

Stitching to improve quality. A barnacle larva from the plankton photographed under low magnification. Not all of the larva could be seen at any one time with the equipment and, starting at the head end, a series of four images was taken through to the tail spines. These were stitched in ICE and the result is a much sharper image. This is the original composite and has not been further enhanced, and includes a few spines that do not match up. Also the detritus that was in the water was to be cloned out later. This was a live plankton sample slowed with magnesium sulphate added to the water.

the very tip of the palps projecting from the front of the head. The shutter was released and the camera moved on a focusing rail a small amount forward, actually 0.35mm. A second photograph was taken. The camera was moved again and so on as far as the very end of the body. Thirty-four images were taken and then using software the photos were combined. This means that the pixels that are in focus are taken and combined together. The image can then be

▲ Fig. 5.14
Focus stacking a crane-fly, *Tipula paludosa*. This composite is
made from thirty-four separate images taken from front to back
and then combined in software. This is the original image with no
enhancements, showing the initial composite is very sharp. Canon
7D with 65mm MP-E macro, macro twin flash. Magnification ×2, ƒ8.
Equipment on an optical bench using a dead specimen.
(See also Fig. 5.7.)

saved and further enhanced with levels, tone curves
as required.

The alternative to moving the camera forward
in small increments is to refocus the lens. This is a
technique suitable for standard macro lenses with
magnifications up to 1:1. Focus the lens on a point
at the front of the subject and take the first image.

Then refocus slightly behind the first point allowing
for some overlap. Take the photograph and then
refocus again behind this point and so on until you
have gone beyond the subject. This can be used up
to around 1:1 but beyond that most methods will not
allow for a refocus of the lens. Beyond 1:1 it has to be
by moving small increments closer to the subject.

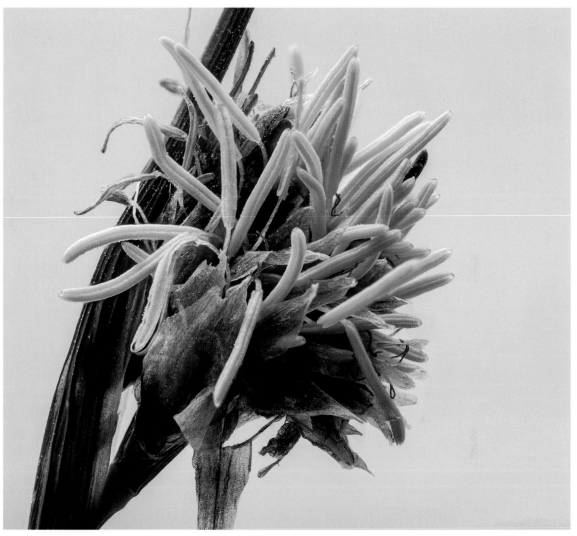

▲ Fig. 5.15
Focus stacking a flower of the common sedge, *Carex*. This is a composite of twelve images. In this case the lens was not moved but the lens barrel was turned to change the point of focus. Initially, the focus point was the front anther of the flower and a photo was taken; then the focus was adjusted to slightly behind the first one. The shutter was fired again, the focus was adjusted again, and so on. Canon 30D 100mm macro on 1:1, 1/2 sec ƒ8, ISO 100 with natural light. Tripod.

Focus stacking extreme close-ups is rewarding but requires some patience. It can be used with any of the techniques shown including coupling in bridge cameras. The next chapter looks at focus stacking in more detail.

▲ Fig. 5.16
Bee Fly frozen in flight with a combination of fast shutter speed and flash. The insect was tracked with the auto focus off and pre-focused on a set distance and magnification ratio of 1:1.5. By watching the behaviour for a while beforehand it was possible to identify the preferred flowers and to notice the fact that just before feeding the fly hovered for a second by the flower. Canon 7D 100mm macro, macro flash. 1/250th sec ƒ11, ISO 100.

FREEZING ACTION

Reference to aperture has been made numerous times whilst the shutter speed control has only been touched upon. Much of this has been down to depth of field and sharpness but the shutter speed is critical for several reasons. Blur through camera shake is one of the most annoying aspects of taking close-up photos. Exposure issues and even sharpness to some extent can be adjusted in emergencies on the computer later on but if you have camera shake there is nothing you can do. Some software purports to be able to clear up shake but it is minimal. If there is shake the only option is to bin it. Tripods are not always ideal as chasing a moving insect requires flexibility. Prevent camera shake from the offset by using a suitable shutter speed and, if in doubt, go higher. Start with a number similar to the focal length. If the lens is a 100mm macro on an APS-C DSLR then allow for the smaller sensor which means the equivalent focal length is around 150–160mm. So the shutter speed is going to be 1/160th second. With stabilization on the lens you may think this

▲ Fig. 5.17
Hawker Dragonfly, *Aeshna cyanea*. 1/800th sec at ƒ8 ISO 800 with
noise minimized by Topaz DeNoise software.

could drop by several stops which would be 1/40th second. In reality that is not going to happen without shake unless you are very stable. Better to be safe than sorry after the event – all it takes is an increase in the ISO to allow for a faster speed. Modern cameras are good at controlling noise; and a little noise is far preferable to camera shake, as noise can be reduced later.

Freezing action is often achieved through use of a flash. The pioneering work by Stephen Dalton should be reviewed if you need more information on this area. Electronic flash fires at exceptionally fast speeds and it is the flash that produces the exposure to light. Macro flashes may not have the speed of large, individual guns but they will still be in the thousandths of a second.

Chapter 6

Stacking Images

Focus stacking was introduced in the previous chapter; here we delve into the detail. The software is crucial to the success of stacking but taking the images correctly for the stack is just as important. The approach will be subtly different when collecting images in the field as opposed to indoors, and consistency is reached with automation of the photography. For a start, indoors the equipment can be linked more easily to the computer. Once the stack of images has been turned into a composite photo there may well be more work to do. These are some of the issues explored in this chapter, as well as stacking down a microscope and the welfare of your material.

STACKING SOFTWARE

If you are using recent editions of Photoshop CS then you will have the basics of creating stacked images – but it is just that: the basics. The original specialist programmes are Helicon Focus, Zerene Stacker and CombineZM but in recent years a number of others have appeared. They work using complex algorithms based on three principal methods: 'weighed average', 'depth map' and 'pyramid'. Thankfully, all the software programmes work automatically and no knowledge of how they function is required.

The software can be split largely according to whether or not they are free. Those you pay for do have a month's trial before a licence is required. Free software requires a little more perseverance and may not be so intuitive or have support. Also, free software is at the time of writing unavailable for Mac users. PhotoAcute works with both Mac and Windows and seems to have an unlimited trial period and so this may work for those with Apple OSX. There are free software stackers for Linux like ALE and MacroFusion. There are a number of good free downloads for Windows users to choose from. The original CombineZM has now been replaced by CombineZP although both are available and have many followers producing super results. TuFuse is a relatively new piece of free software and initial results seem favourable. Of the free software one that is good, intuitive and with a good set of controls is Picolay. It is not widely known about, and can be slow to use (activate the beep system to notify you that it has finished) but the results are excellent. There are many plus points, not least the ability to put the tiny, 1.8 megabyte programme on to a memory card or USB stick to run it from any computer without the need to install and change any files. This can be a useful feature when sharing a computer or when travelling. Unlike some (including some requiring a licence), it is possible to stack most file types including RAW files. It allows for stacking parameter changes and file enhancement and improvements.

◀ Fig. 6.1
Small Elephant Hawkmoth, *Deilephila porcellus*, close-up of head. Large moths are good subjects to try stacking as they make excellent models. During the day they sit still, allowing you to approach easily. Magnification ×2. 23-image stack, Canon 7D, 65mm MP-E, twin macro flash *f*8.

▶ Fig. 6.2
Picolay, free stacking
software, main screen.

▶ Fig. 6.3
Zerene Stacker stacking
software, main screen.

After you have tried programmes like Picolay it
will be worth trialling the Helicon Focus and Zerene
Stacker for comparison. They all have pros and cons
and ultimately it is down to personal preference.
Zerene has a very uncluttered layout but is not
quite so user friendly and can be 'clunky' until you
get used to it. For example, memory allocation and
control on Zerene can be a little tedious at times
and is best set on auto. Helicon has a more polished
interface and runs very quickly – up to three times
the speed of Zerene – although it is the result that is
more important than speed. Zerene may be slow but

on some delicate, hair-covered creatures it can work
better. Zerene provides two methods for stacking:
PMax (pyramid) and depth map; Helicon has three:
weighted average (A), depth map (B) and pyramid
mode (C). Using all five can provide quite different
results. Both programmes create similar images
with the depth map mode and these are usually
the most vibrant. However, if there are areas of
background that have subtle changes in tone, depth
maps invariably produce patchy blotches, which
can be removed but is a little time-consuming. On
the other hand, pyramid modes produce the better

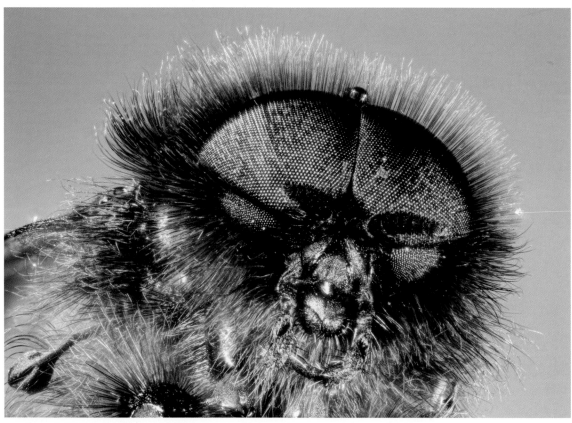

▲ Fig. 6.4
The head of a male St Mark's Fly, *Bibio marci*. A composite of a 40-image stack, this is a difficult one because of the huge number of hairs on the head. Compare the four cropped images. This one, made from Helicon method C, has been put through Lightroom and Topaz DeNoise.

detail and good backgrounds. This sounds the one to use but there can be problems here: PMap may have good detail but loses vibrancy, colour and tone. Putting this through another programme like Lightroom can help restore these but involves more work. Helicon's pyramid mode does not suffer from that problem as badly, but it is not perfect as it tends to generate strong and obvious noise in the image. Also, this mode can increase burn-out in strongly highlighted areas. (Noise is easily removed by plug-ins such as Topaz DeNoise.)

Two other points which may determine your choice of which programme to use is the way files are handled. Firstly, Helicon will work with raw files as well as JPEGs; Zerene will not. Second,

when saving the composite file at the end, Helicon gives more options. In Zerene it is just JPEG whilst Helicon gives others including TIFF. If you want to work on your file after the composite has been saved an uncompressed file like a TIFF is preferable rather than resaving compressed JPEGs. The Raw issue is not so important as Helicon makes a conversion at the start using Adobe Raw Converter (over which you have no control). When comparing composites produced from Raw or JPEG there is no clear difference. Obviously, Raw files are going to take longer to process than JPEG but do make sure that your JPEG files are large and of the highest possible quality.

▶ Fig. 6.5.1
Zerene Stacker, depth map.

▶ Fig. 6.5.2
Helicon Focus, method B
(depth map).

◀ Fig. 6.5.3
Zerene Stacker, PMax.

◀ Fig. 6.5.4
Helicon Focus, method C.
These four images are the
same section cropped
from composites made
on the 40-image stack of
the St Mark's Fly. Note the
differences: both depth maps
have blotchy backgrounds
but Helicon has lost detail
in the hairs. Both the other
two are better but the
Zerene image is flatter and
paler. These are from the
original files before any
enhancements have been
made.

CREATING THE STACK MANUALLY IN THE FIELD

The software is one thing but what would be a typical way of getting the stack of images? First we will consider a simple field sequence. On the camera is a 150mm macro with an extension tube fitted. The lens has a tripod mount in the middle and this is connected to a focusing rail on top of a tripod. A shutter release, either cable or wireless, is connected and switched on. The lens will give a reasonable working distance even with the tubes. The tubes are necessary in this instance as the subject is a tiny jumping spider, less than a centimetre in length, and will be around 2 to 3 times magnified. It is sitting on a *Verbascum* flower and the intention is to get a head shot of it looking towards the camera (see Figure 6.6).

Cool, early mornings are always good as the creatures do not move so much. The equipment needs to be already set up on the tripod, the camera switched to manual focus and the exposure set with the optimum aperture. This should have been done before seeing the subject but a quick check may be needed. If a flash is to be used, make sure that it is switched on. Moving slowly, the tripod is positioned with the focusing rail set in the middle so there is roughly equal travel forward and back. Switch on live-view so you are not too close to the subject, and carefully set the position. An adjustment may be needed on the tripod head to reset the horizontal but try to get as much of this done before moving into place. In the correct position it helps if the live-view can be magnified to get a better idea of focus.

Rotate the rail adjustment until the very leading edge of the picture is in focus. In the other hand have the shutter release ready. The moment the edge is in focus fire the shutter. Immediately move the rail forward so that a new line of depth of field is present and fire again. You may need to practise so that the rail movement is quickly followed by the shutter release. Keep this going until the furthest point has been reached and begins to go out of focus. Ideally, you want to start and finish just out of focus and there should be some overlap between the shots. In the field, with concerns that the animal will move or wind will disturb the vegetation, these are luxuries that you may not have. Often the sequence is terminated early because of movement. Expect (or hope) that a number of stacking sequences will be achieved. Until they are stacked on the computer there is a degree of guesswork.

In the example here, three stack sequences were done before the specimen departed; Figure 6.7 shows a composite that failed due to movement (without realizing at the time that it had moved). A quick look at the best image of ten images appears to show a pleasing result straight from the software; however, close inspection shows gaps in the focus. The entire duration of taking the sequence was probably 8 seconds, achievable with experience. It needs the animal to stay still for around 10 seconds. If it remains still after the sequence try going in reverse and taking more time to be more accurate with the interval distance. The first sequence is invariably done quickly but repeat several times if possible so that anomalies can be eliminated.

The diffuser box was discussed in Chapter 4. This works well to photograph stacks of flowers in the field as you are setting up a mini-studio around the subject. The box provides a fairly windproof environment, minimizing movement of the flower. Cut a small window in the lid so the lens and flashes can be inserted. It does not have to be sealed or complex: in fact it can be better to have a reasonably sized hole as moving the lens is inevitable with a subject rarely being opposite the hole. If wind becomes a problem have something to wrap gently around the equipment to block the gaps before starting the stack, e.g. teatowels, or a T-shirt. All of this is only really needed in extreme close-ups, beyond 1:1 when stacking is being done. Here the slightest movement will show up. Set everything up first and then the

▲ Fig. 6.6
Jumping spider on a *Verbascum* flower photographed in the field, early morning. 10-image stack, magnification ×2, 7D, sigma 150mm macro with 62mm of extension tubes, macro twin flash on a focusing rail and tripod, ƒ8. Jumping spiders have remarkable eyesight and articulation of the body. The strands of web just visible at the back are an essential part of its stability system when jumping, acting like a dragline.

◀ Fig. 6.7
Green-veined White butterfly *Pieris napi*, 14-image stack. Note the multiple antennae and proboscis that have moved during the sequence. Often these movements are not seen until much later when the stack is compiled. Magnification ×2. Canon 7D, 65mm MP-E macro, macro twin flash, ƒ8.

lid can be placed over the lens. This is one of the easiest ways of taking stacked images in the field when the wind is blowing. As the box is lightweight you may find yourself having to put the camera bag on top to secure it.

If you find this a good way to work in the field small holes can be made in the box at strategic points on the sides. Insert some LED bulbs through and connect them up to a battery. These can be surprisingly effective.

STACKING IN HELICON FOCUS

On return from the field the images need to be stacked. When downloading your images it is always good practice to move them into a temporary holding place where you can go and review them with your viewing software. A good workflow is to look at the different stack sequences first with a cursory check and then hold down the key that lets you move through them very quickly. Like a flick book it can give a good indication if they will align correctly or whether the subject moved. Also there are times when the exposure does not work correctly for some reason. This initial check can save time in the long run. If just one image seems to be out or incorrectly exposed, try leaving that out of the sequence. Continuing the workflow, if you have checked a sequence and it looks all right, rename the files giving them the correct sequence numbers. Have a specific folder for stacking, called Stack Processing, for example, to which you can transfer the files to stack. Having renamed them, drag and drop the sequence into the folder (which should be empty). Alternatively, you could drop all the different sequences that you have done all in one go. One at a time can be quicker and easier – it will depend on your preferred practice.

Having dropped the files into the folder, start up the software. Helicon always remembers where you last acquired files and so if you have a specific folder you never have to go searching for files. Also if you do this it just requires clicking 'run' and it starts stacking everything that is in the folder. Upon completion go back to the viewing software, remove the images and file them away somewhere else and add the new image sequence to stack. The alternative is to put all of the file sequences you have taken that need stacking into the folder. Then within Helicon Focus check off the files you want to stack, by moving down the line of thumbnails clicking the small white box to form a green tick, then click 'run'. It is essential to remember when the stack is completed and saved to uncheck the files before checking off a new sequence. This is one of the advantages of adding

▶ Fig. 6.7.1
The jumping spider stack images.

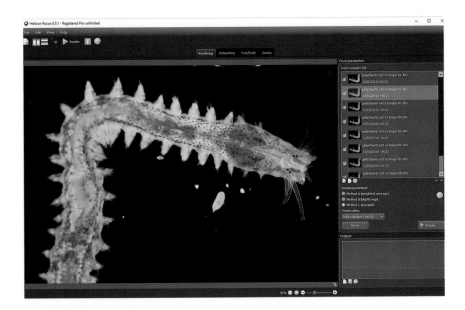

and removing file sequences as you go as it negates the need to uncheck files. To uncheck the thumbnails go to the button above the list of thumbnails, hover over the left button and 'Show Context Menu' comes up. In that menu is 'Unselect All'. Also under this menu is 'Rename Selection'. It does mean you can rename at this point rather than in your viewer.

While the stacking is progressing a bar moves down through the list of files, top right, and displays that file on the top half of the screen. Actual progress is shown down at the bottom right. The composite forms in the lower half of the screen. This arrangement can be reorganized to suit using the three options on the upper toolbar. Likewise the zoom control which is next to this can adjust the degree of magnification, or use the scroll wheel on your mouse. At the end it is useful to zoom in to check the quality of the image.

The tabs below the toolbar are fairly self-explanatory. Only the 'Files' and 'Parameters' tabs were available at the start. Parameters is important, allowing you to select the stack mode before stacking. When stacking starts you will have been automatically moved into the Parameters tab. The only control necessary in Parameters is to choose the Method

– A, B or C. By default it remains on the last one used. As stacks complete the composites appear as a list under 'Output' in bottom right. By default they are named with the date and time plus the method used. Saving is started by clicking the 'Saving' tab, which takes you to a new screen. The composite appears full screen where it can be checked more thoroughly before clicking the 'Save to Disk' button (top right). This brings up a very comprehensive list of options including a check on metadata as well as file format types.

If when checking the image it does not appear as good as you hoped – maybe there are some strange artefacts appearing or blotches instead of detail – instead of immediately saving the file, go back and redo the stack with a different method. Try all three. Even without saving, their default file name will be in the 'Output' box. Clicking on the three composites allows you to check them and determine which is the best to save. Even the best may require some further work under the 'Retouching' tab, which will be looked at in the next chapter.

Although the software can cope with huge numbers of files, theoretically many thousands, typically it will be considerably fewer than that. Once there

▶ Fig. 6.9
The Helicon Focus Save
screen reached by clicking
the right tab above the
image.

▼ Fig. 6.10
Inside the flower of a
Foxglove, *Digitalis pupurea*,
magnified ×1.5, 52-image
stack, stacked in two stages.
Canon 7D, 65mm MP-E
macro, macro twin flash, ƒ8,
with the light aimed through
the side of the flower tube,
so the inside is effectively
backlit.

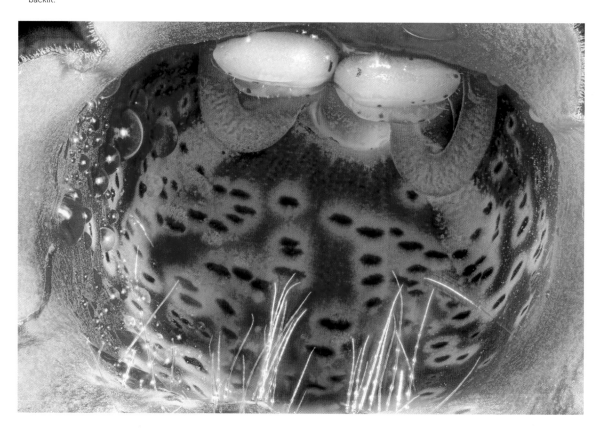

STACKING: WAITING FOR THE RESULTS

With digital cameras we are used to being able to see our images straight away. When doing stacking you see the basic building blocks but until the stack is done you really do not know if it has worked or not. With experience you get a better understanding of what will and will not work. Coming home from the field the excitement is real as to whether you have something or not. The great buzz you get from stacking is waiting for the result to appear, just as it was for photographers decades ago, waiting in the darkroom for the image to develop. Just like the faint print emerging from the developer the composite image starts to appear on the screen. Very retro!

are over 30–40 images in a stack, the image may not be as clear as when it is broken down into smaller groups to be done in two stages. The foxglove composite had 52 images so the first stack was done in six batches of eight (48) and then one stack of four. The seven composites were then stacked in the second stage. This is particularly applicable with the 'depth map' procedure.

Note that the workflow and key points of Helicon Focus are the same with Zerene and CombineZP.

The speed of stacking is down to computer memory and processor speed. Life is made a good deal easier with 16 gigabytes of RAM and an Intel Core i5 processor with the potential to run above 3 gigahertz. With this a stack can take seconds rather than minutes. For example, the foxglove 52-image stack took just 50 seconds to stack. On a computer with just 4 gigabytes and a slower processor it was closer to four minutes. If you have many stacks to do or you just need to try different stacking modes you may have to look at the specification of your computer.

CREATING THE STACK: TETHERING A COMPUTER

Although not always possible, there are many advantages to setting up a mini-indoor studio where the stacking process can be controlled more carefully. Subsequent chapters look at this in more detail but the most useful feature is to be able to connect a computer to the camera so that the former controls the action. This is quite feasible with a laptop outside but can become quite cumbersome and is only really possible in shaded spaces.

Not all cameras can be controlled from the computer and so this needs to be determined early on. Bridge cameras fall down here as well as most CSCs. DSLR should prove no problem in this sphere. The second issue is whether you have the appropriate software: once the camera is connected via USB there needs to be a software package on the computer that will automatically fire up the moment the camera is switched on. This may be on a CD that was in the box when you bought the camera. Unfortunately, some (like Nikon, for example) make you pay for it separately but need not be a problem, as third-party providers do exist. This means that the chances are there will be someone who has cracked the code and has written a programme that does the job.

Interestingly, these same computer whizzes produce third-party firmware. This is the software that runs inside the camera. Manufacturers occasionally update their firmware. This may be to improve battery life or even give faster shooting to take more frames a second. The downloaded software is put on to a memory card and when you place it in the camera it normally automatically updates the firmware. Third-party firmware may not be something you want on your expensive DSLR but you may find an older bridge camera, compact or even DSLR body that you use as a spare which could

▶ Fig. 6.11
Tethering a camera and
computer together. Here
the camera with bellows
and an Olympus copying
lens attached is set up to
photograph the seed head of
the Cleavers flower, *Galium
aparine*. Connected by USB
the laptop has the EOS utily
running with live-view of
what the camera is seeing.

▶ Fig. 6.12
Remote live-view window
showing a Cleavers
seed head magnified
approximately ×2.5. The
histogram is useful as
further adjustments to the
exposure can be made here
including 'white balance'. The
eyedropper button can select
any part of the image and set
the white balance, useful with
artificial light such as LED.
The 'zoom' button brings a
second preview window with
a further magnification of ×10
so that very fine adjustments
can be made. The white
rectangle can be moved to
any part of the picture for
a more accurate exposure,
rather like spot metering.
Wherever it remains when
the shutter fires is where
the exposure reading will be
taken.

do with a firmware update. There are old compacts
that with third-party firmware take them from a
basic point and shoot to a fully controllable aperture
priority camera. A search on the web will reveal what
is available for your old camera and it may be worth
trying out.

One very good software package for Nikon users
is ControlMyNikon. It is not free but is remarkably
good value for money and many that use it say it is
as good if not better than Nikon's own, which costs
four or five times as much.

◀ Fig. 6.13
Remote live-view window. As for Fig. 6.12 except the spot meter reading has been moved and the difference can be seen both in the window and the histogram. This gives very precise control over exposure.

◀ Fig. 6.14
Helicon Remote software. Available for any camera that is tethered, this software is free and gives superb control. It is also intuitive to use but may not have every function of the camera. Below the histogram are the controls for organizing stacks.

Image Data Suite and EOS Utility are the free software packages that come with Sony and Canon DSLRs. Pentax has available for some cameras 'Remote Assistant' utility although for some later models it does not always work. Pentax users could try the free utility PK_Tether. However, Helicon software now has a utility that was once built into the stacking software but is now a separate free download called Helicon Remote. It works with most cameras and is excellent.

Why tether a camera to a computer? Imagine live-view on the back of your camera's LCD screen blown up to the size of your computer monitor. Second, vibration of the equipment when taking extreme close-ups can be a real problem and the best bit about control from the computer is that you do not have to touch the camera to change anything. All the controls are at the click of a mouse. Even the electronic flash settings can be changed to produce more saturated images. Test firing, colour balance

or depth of field – all can be controlled separately. With the live image now magnified focusing is so much easier. Exposure readings can be taken from different parts of the view by moving an exposure spot around the screen. Once you get used to where the controls are now located it is a very useful tool.

Most importantly, as well as offering greater control, the image arrives instantly on the computer for viewing and checking. In the Preferences menu, set up the images to be downloaded straight into your stacking folder. If your stacking software is running in the background, just click 'run' and the composite will be produced. Review this in full screen and if some tweaks need to be made these can be quickly done and the stack re-run, all just a few minutes after running the previous one.

If you use Helicon Remote it has a stack organizing menu, particularly if the lens is autofocus. Make sure the camera has this switched on; then by clicking the blue arrows you will see the live-view change as it shifts the focus point back and forth. Once you have found the nearest point click the A button and this will be locked. Next, refocus to find the furthest point. Finding this, click B to lock it. The alternative is to type in the number of shots or the intervals. These will automatically appear if you find and lock A and B. Click the 'Start Shooting' button at the top and the software takes over the running completely and downloads the photos. At the end click the Helicon Focus button to begin the stack. For a free programme it is remarkably good.

Tethering a Compact System Camera to a computer is more complex and down to the manufacturer and model. New models are appearing with Wi-Fi connectivity, as are DSLRs. This gives an alternative way of connecting camera and computer. For example, Panasonic have created an app for Android and Apple iOS which can be downloaded for free, called Image App. This can be used with wireless models like the G6 and provide access to a wide range of camera settings and controls. Remote live-view on a smartphone or tablet is a tremendous

STACKING WORKFLOW

When spending time stacking I would have three programmes running on my tethered laptop: EOS Utility with the live-view active; FastStone Image Viewer with the stacking folder open; and Helicon Focus. I use them in that order, setting up the shot looking at the live-view, and then as the images start to appear in the stacking folder I watch them arrive in the Viewer checking they are all right. The moment it is finished Helicon is run and the image saved. The files can be renamed in Helicon Focus. Going back to the Viewer I move the now renamed files into another folder for sorting later. The folder is now empty for the next stack, the EOS Utility appears again ready to set up another sequence or re-run. If the stacking in Helicon is going to be a long one (you soon get an idea of how long it will take) I might open up the live-view window and start thinking of any tweaks or changes at that stage.

advantage. You can move AF points around the frame just like the DSLR utilities to change metering zones, white balance and other settings, and even review the shots afterwards and use the geotagging facilities of the smart device. This 'smart' way of using Wi-Fi connectivity is likely to grow with more DSLR models now appearing with it. Apps are already available as remote triggers and so it is no surprise that control apps are arriving too. For some excellent CSC cameras this is the lifeline they need for stacking remotely. With their small, lightweight, mirror-less, relatively vibration-free use they are set for ideal stacking, particularly with coupled lenses or using a third-party adapter to connect a lens like the 65mm MP-E.

There is no doubt that tethering a computer revolutionizes how you view and administer stacking and close-ups. However, like all improvements and evolution, other things are affected. The biggest

problem is that the camera is driving the live-view even if it is not appearing on the back of the camera. The level of the energy in the battery is shown on the screen and you will need to keep an eye on it as it can quickly drain. Depending on what you are doing, expect only an hour or so of tethered activity. One way to extend the session would be to switch off the live-view while stacking is in progress. If you find you are regularly wanting to tether your camera to the computer, you could buy a mains adapter for the camera. These usually need to be ordered from a camera retailer and consist of a dummy battery to provide the connections; this is attached via a long cable to a small transformer box and the mains power. They are a very good investment as it saves the worry about whether the batteries will last the session or not.

USING STACKSHOT

If you have used Helicon Remote and focus stacking the results should be consistent but for non-focusing lenses there are few other options than having to employ a focusing rail. It can be more difficult to be consistent especially with the increase in magnification. The set-up with the bellows and Olympus lens is a case in point. Even blown up on the screen it can be tricky to get the interval right when rotating the knob on the side of the rail. Some rails have finer, more precise control but they cannot beat the StackShot, a focusing rail with a stepper motor driving the camera. If you are planning to do a good deal of close-ups and stacking it is worth investing in one of these.

It is made by Cognisys in the USA; ordering it is straightforward but you will have to pay import duty. However, everything can be supplied including very good support. The StackShot makes stacking very consistent. It may not have the speed and flexibility in the field to produce a stack like the example of the

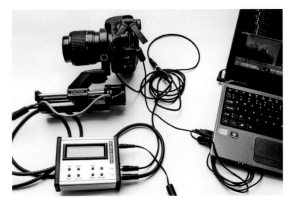

▲ Fig. 6.15
StackShot showing the connections between the rail and box, camera and box, and camera and computer. The cable leaving the photo is a mains lead for the control box via an adapter.

jumping spider seen earlier (Fig. 6.7.1). With experience that was completed in under ten seconds before it moved. All you can really do with StackShot is hit the 'Abort' button. StackShot is nevertheless a superb piece of precision equipment. Mount the camera on the top of the rail. The rail is connected via cables through to a control box. If you are tethered to a computer and using Helicon Remote the box can be connected by USB to the computer where all the settings can then be adjusted so you do not have to disturb anything. Buttons on the control box or in Helicon Remote can move the camera back and forth along the rail. The camera and box need to be connected to each other so the camera can be automatically triggered. Finally the camera is connected via USB to the computer so the files download using any utilities.

The process of using the StackShot is similar to the manual rail. In fact, using the 'Fwd' and 'Back' buttons on the control box you can move the rail precisely back and forth, firing the shutter as you go (just like a manual rail) to do a stack. There are times when advancing the camera and taking the stacks needs to be done that way. However, the big advantage of the StackShot is that the process can be fully automated. There are different modes but start with 'Auto-Distance' on the control box. To scroll through the options use the 'Up' and 'Down' buttons.

INTERVALS FOR STACKING WITH THE CANON 65MM MP-E MACRO LENS

This is a rough guide for many lenses at these magnifications. The values give reasonable overlap.

Magnification	Interval Distance (mm)
×1	0.5
×2	0.4
×3	0.24
×4	0.15
×4.5	0.12
×5	0.08
×5 +62mm extension tubes	0.03

Using 'Select', you now need to move the arrow down to the next level which is to set the interval between shots. Again, use Up and Down to change the distance. This interval depends on the lens and magnification you intend to use. It is a matter of trial and error, so initially always make a note of what you are doing before reviewing the images and keep this safe. As a guide, the table below gives an indication but this is with the Canon 65mm MP-E lens. This is one of the few lenses that gives easy and consistent magnifications. Although a Canon mount was used here, third-party adapters are available to fit any camera mount (DSLR or CSC).

Having set the interval distance, use Select again to move to the third action. As in the Helicon Remote's method you need to find the first point to start the stack and the end point to finish. The control box should read, 'Select Start Pos': this is where you now move the camera to the first edge of the picture where you want to start. Pushing the Fwd and Back buttons, adjust this until you are satisfied it is slightly out of focus in front of the shot. Now push Up or Down, it does not matter which. This confirms you have set the starting point. Now move forward to find the end position. Keep watching the live screen until the last part has just gone out of

SOFT LENSES

The Canon 65mm MP-E lens, like many other lenses near their limits, can soften and distort at times. When set between ×4.5 and ×5 magnification this lens goes a little soft, which may be why Canon stopped at that magnification. It is not a major problem but some already soft subjects (like the Pansy flower) need all the help they can get to be sharp. The trick here is to reset the lens to a sharper magnification like ×3 and add an extension tube or two to increase the magnification. This softening only shows up when the final composite is enlarged and it was when that was done I decided to go back and take the Pansy again with the extension tubes.

focus. Push the Up or Down button a third time to confirm. It now reads 'Up/Down to start'. Pushing one of those buttons begins the stack. If, however, you need to change the setting because it was not right or the subject has moved, hit the Select button instead and it takes you down to 'Change Settings'. Push Up/Down to restart entering the settings.

Once all is set stand back as you push the Up/Down to set the equipment going. StackShot takes over completely, firing the shutter and moving the camera forward the set interval, waiting a second to prevent vibration before firing the shutter again; it then advances, and so on. Upon finishing it resets itself back at the beginning. The images should have downloaded onto the computer and the images can be stacked to check they are all right. If not and you need to run the stack again without adjusting the settings you can hit Up/Down and it will do the sequence again. Otherwise, use Select to make changes.

Before setting StackShot running it may be worth doing a test shot and checking the exposure is correct. Also, look around the edge for any stray

▲ Fig. 6.16
The centre of a Pansy, *Viola*, magnification ×5. A 56-image stack
taken at 0.06mm intervals in the studio with a StackShot. The macro
twin flashes were fixed on a Meike bracket and not attached to
the camera, which would cause them to move and cast different
shadow. Canon 7D, 65mm MP-E macro with extension tubes,
macro twin flash, ƒ8.

material you were not expecting; perhaps you will
have to reset the stack. If all is well, delete that file
and commence the stack. One message that you
might see pop up when running the stack is that
there is a significant variation in light through the
stack. Small amounts are unlikely to give much of
a problem but over 25%, odd patches can appear.
This is often the case with large stacks of images if
the light is attached to the focusing rail or StackShot.
This means that the light is travelling down the

subject causing variable shadows. Typically this will
be with a ring flash or twin flashes attached to the
lens. If this occurs it may be better to mount them
off the lens and rail so they do not move.

Another problem that can occur with some utili-
ties (not normally with Helicon Remote) is that when
the stack starts being photographed and live-view
is still active the shutter may not fire. The StackShot
goes through the motions of advancing and stop-
ping, but no shutters are released. This is solved by

closing the live-view window just prior to hitting the Up/Down button to start the stack. This saves battery power on the camera as well.

In addition to the Auto Distance mode there are the following modes:

1. Total Distance mode, where you set the distance and the number of steps;
2. Distance Steps mode, where you set the number of steps and the interval distance;
3. Continuous and Auto Step modes, where it runs until you stop it; and
4. Full manual mode.

The recent versions of both Helicon software and Zerene Stacker are designed to work seamlessly with the StackShot.

Using StackShot in the field

You may have to be well organized to use StackShot in the field but there is no reason not to. The small 12-volt lead acid battery we used in running the LEDs works well to power the control box and focusing rail. The battery should be connected by a fairly long lead to the control box as the latter is likely to be picked up and moved around. The two lower ports will have the connection to the stepper motor on the rail, and the other is the trigger for the camera. Although a laptop could be used it can become too cumbersome and that part of the process is eliminated. Focusing is done using, preferably, the rear live-view on the LCD screen of the camera but failing that through the optical viewfinder. While looking at these the box is held up near to the camera so that the forward and back buttons can be operated whilst watching the front edge of the picture till it becomes sharp. Set the start position and then move to the back position. It may seem like the long trailing leads could be shortened but you do need to be free to move everything around. Before you set it running make sure something covers the back of the viewfinder. They tend to leak light and change the exposure. In the picture with

▲ Fig. 6.17
StackShot being used in the field. Instead of mains the control box is being powered by the lead acid battery that we saw earlier for LED lighting. Here the red lead replaces the mains lead. The green backdrop is actually a sheet of green plastic (bought as a chopping board). Here it is giving some protection from a slight breeze whilst taking the stack. The white flower is a butterfly orchid, on which some eggs have been laid. (See Fig. 6.18.)

this set-up the viewfinder is pointing up to the sky and could alter the exposure by two stops. If nothing else is available hold your hand close to the camera to cover the window without actually touching the camera.

While the stack is being taken vibration is one of the biggest problems in the field. You will be tempted to do substantially bigger stacks than with a manual rail because the StackShot is so competent. With the photography taking a good deal longer, there is a great chance of the subject moving. Unlike the jumping spider we saw earlier, they will probably move before the stack is complete. More likely a sudden gentle breeze will move a flower slightly. Thinking about this before you set up, look around for material in sheltered positions. A wind break may be all that is needed or try using a light box that all but surrounds the subject. If all else fails carry a few old wooden kebab sticks in the bag and these can be pushed into the ground nearby. Using pegs or clips from the stick try to secure the stem of the plant to prevent movement of the plant as much as possible.

Another concern is that the camera has gained a fair amount of height above the head of the

◀ **Fig. 6.18**
StackShot in the field. Unknown insect eggs on a flower of a butterfly orchid. Magnification ×3; 22-image stack. Three different sequences were attempted and this was the one with least movement. Canon 7D with 65mm MP-E macro, macro twin flash with StackShot. *f*8.

◀ **Fig. 6.19**
A selection of images from an outdoor stack that went wrong due to changing light conditions. Scorpion Fly, magnification ×1. Canon 7D, 150mm macro, StackShot.

tripod. You need a very secure head to do the job but inevitably there will be a tiny degree of play and movement, which will be magnified. When the rail moves forward, even by just 0.24mm, the sudden stop causes a very slight movement. Time is needed to let the vibration stop before the photo is taken. Two seconds is fine and this should be set in the configuration when outdoors. Indoors, this time lag

between end of movement and firing the shutter can be less, around half to one second.

As if this was not enough to put you off working outdoors there is the possibility of light changes. There is a distinct attraction to using natural daylight. If the light is even and there is no risk of a cloud going over, that is fine – but even a slight change in light intensity will cause one or more

▲ Fig. 6.20
StackShot in use on a rocky seashore – a rather hostile environment because of the salt spray. Many species here can only be stacked on the shore as they are glued to the rock. The bag is used to carry all the StackShot equipment including the battery which is kept wrapped in protective plastic film.

SALT AND WATER

One of the biggest problems working in the field near water, especially the sea, is that as you look for subjects and move things around so your hands get wet – or at least damp. In no time water splashes seem to be on everything. I always have a few old tea-towels in the bag which I use regularly to dry my hands before touching any equipment. Use one for the first wipe and a second, drier one for the final clean. (It is through many years of bad experiences that this can be stated.) Salt is a real problem and its effects should not be underestimated when working with photographic equipment. Have some re-sealable plastic bags to put things in or lay things upon. If there is any sand about it soon enters focusing mechanisms. A filter to protect the end element of the lens is useful, and you should take a blower brush with a lens cloth to remove any debris from the camera.

images in the stack to have a slight difference. Flash provides more consistency but it is more time-consuming to balance with the daylight. Flash also helps to freeze some vibration caused by the equipment.

The images, of course, are on the memory card and it is not so easy to check for vibration as it is when indoors with a laptop. This means it is worth repeating the stack a number of times. The photo of the strange set of eggs from an insect, probably a moth or butterfly, was repeated five times with a few adjustments. All but one were successful. When reviewed at the time they looked fine but once enlarged a number of images were out of alignment. The odd one image can just be deleted and the chances are the stack will still work.

Working on a seashore requires care and protection of equipment, primarily from salt spray. It is very

rewarding as there are a huge number of subjects to photograph without the need to go far. Many can only be taken on site as they are glued to the rock. Using natural light produces good results especially as flash can reflect from wet surfaces. Watch out for the consistency of sunlight, as mentioned above. Carrying everything in a water-tight bag and wrapped in zip-lock polythene bags is a good idea. You may choose to go only on days when the wind is at a minimum as once the automatic rail is out on the tripod it is exposed to the elements. The StackShot, as most photographic gear, was never designed with salt spray in mind. A careful wipe down on return home can also help. Using stacked images collected in the field are all the more exciting as the chances are that others have not seen the life there in the same way. They are original.

◀ Fig. 6.21
Acorn Barnacle *Chthamalis stellata*, 45-image stack taken in the seashore set-up. This shot would be impossible unless the StackShot was used remotely. Magnification x3. Note the small brown skin stuck on the edge of the main barnacle. This is a shed pupal case of a non-biting midge *Clunio marinus* that lives exclusively on rocky shores. A true and unusual marine insect. Canon 7D, 65mm MP-E macro, daylight 1/20th sec *f*8.

STACKING UNDER
A MICROSCOPE

Once the principles of stacking are understood it is possible to stack in most situations where increase in depth of field is required. There is probably no-where more appropriate than under a microscope, which is really just optics in a tube on a focusing rail. There are two adjustments to move the rail in the form of the coarse and fine adjustments. Once in approximate focus use the latter to find the area at the top of the subject in focus and make sure you have enough fine movement to reach the bottom. To commence the stacking, start at one side of the focus range, adjusting the fine focus just a slight amount before firing the shutter. Keep repeating this until you have reached the end.

The type of microscope you are using affects how straightforward it is to gauge the distance to move the fine adjustment. A trinocular (as the name suggests) has three tubes to look down. The camera is on a separate section whilst at the front will be the pair of eyepieces for you to look down. While you are looking at the specimen the light has been directed up to eyepieces. To take a photograph the light path has to be changed, usually by rotating a knob part way down the microscope. The light now enters the camera but the eyepieces go black. In some microscopes the control goes three ways, this third allowing light to both camera and eyepiece. With the light split it will not be as bright in the camera. Also, depending on how the microscope has been set up, the system may not be 'par focal': this means that when the specimen is in focus through the eyepiece it is also in focus in the camera. This is

▶ Fig. 6.22
The marine planktonic crustacean *Evadne*, a close relative of *Daphnia* found in freshwater. 9-image stack, live under ×60 magnification, Wild M20 microscope. Using a compact camera, Pentax W60.

▶ Fig. 6.23
Tardigrade species. This one was washed out of a moss and photographed on a Zeiss Photomic with phase contrast, magnified ×100, composite of 5 images. Tardigrades, commonly called waterbears, are abundant and widespread, associated with water. With eight legs and segmented bodies they are an *extremophile*, able to cope with virtually anything thrown at them including living in space, deep oceans and hot temperatures.

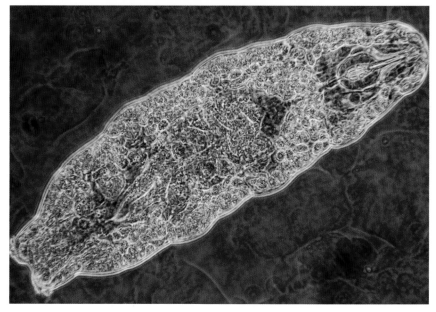

not always the case, especially if you have bought an inexpensive third-party adapter to fit the camera to the microscope. If the camera is fitted to the eyepiece of a monocular or binocular then you do not have the chance to look down the microscope at the same time and you will therefore need to look at the live-view screen.

If the camera has a flip-out screen that you can angle towards you and enlarge live-view then it may be possible to stack using that view. The best way of course is to connect the camera to a computer and view it live on the large screen. The enlargement makes it easier to judge the distance to move the fine adjustment and it does not matter if the camera is not par focal with the eyepieces.

Fig. 6.24
Salad Burnet, *Sanguisorba minor*, female flower. Helicon Focus, using Method B.

Fig. 6.25
Salad Burnet, *Sanguisorba minor*, female flower. Helicon Focus, using Method C.

There is no commercially available StackShot system for the microscope but if you want a similar arrangement a stepper motor can be purchased from Cognisys and fitted to the fine adjustment of the microscope so that it can be fully controlled from the computer.

Stacking is an impressive technique when mastered. However, rarely is a composite perfect and the software has some superb retouching tools. These and other software solutions are dealt with in Chapter 8 as before then we need to elaborate on better support and control of both equipment and specimens, especially if the latter are aquatic.

Chapter 7

Supporting Material

The title for this chapter is intentionally ambiguous as it covers a number of support aspects. Initially, one needs to think about how the camera equipment is supported to provide vibration-free conditions. Support is also about the subject: not just how to hold it in front of the lens but giving the correct environment and keeping animals alive, which ensures natural photographs. This is never more important than when dealing with aquatic species and this chapter looks in depth at photographing both marine and freshwater creatures. Preventing movement is at the heart of stacking but this does not mean it has to be dead – just contained in some way. Slowing down organisms does not have to harm them. A number of other supporting materials are discussed as well.

SUPPORTING THE CAMERA

Stability is the key to good close-up photography. This may be achieved through stabilization on the camera or lens. Increasing ISO and shutter speeds has been discussed so that shake can be avoided. For fieldwork and general close-ups these may be sufficient, but successful stacking requires more than just stability – there must be no movement at all. A tripod is the best way of achieving this, but a careful choice is essential. To begin with it needs to get very close to the ground when field stacking. For decades the tripod of choice for macro photographers has been the range of Benbo units. They can take some getting used to as they operate differently from other tripods. The three legs and arm operate around a single bolt, which when released causes everything to flop apart. Moving all the legs and arm into the approximate position, the bolt is locked and everything goes rigid. Models range from the lightweight Trekkers up to full-sized, very solid tripods weighing in at quite a few kilograms. These are especially good but you will need a Sherpa as well to carry it for you in the field for any distance. The Trekker is lightweight but not ideal for a heavy DSLR with all the stacking equipment. Ultimately, it is down to the head, normally purchased separately, which holds the camera. They will be weight listed, so make sure you have one that greatly exceeds the weight you are likely to use. Smaller, lightweight tripods are fine with compact system cameras and bridge cameras.

Most other well-known manufacturers like Manfrotto, Gitzo and Gioto make tripods that get close to the ground. They may not be as flexible as the Benbo but catches at the top of the legs allow them to go flat to the ground. Central columns come out and go cross-wise through the top so that the head and camera can touch the ground. Carbon fibre is lightweight and strong and will shave a significant amount of weight off the equivalent aluminium models. The head alone can weigh 0.5 kilograms and you may want to look at lightweight magnesium ones. The tripod used in the diffuser box photographs (see Figs 4.19 and 6.17) show a

◀ Fig. 7.1
Freshwater Shrimp, *Gammarus pulex*, with limbs covered in stalked ciliates. Backlit with black background. If the subject had not been backlit the ciliates would not have shown up. These are single-celled creatures that are just using the crustacean as a substrate for attachment. The water had been filtered and the shrimp had gone through several rinses in clean water to remove detritus. Material that still entered the dish has been cloned out on the computer. Canon 7D, 100mm macro with single flash from beneath. 1/250th sec at *f*11 ISO 125. The flash has frozen the action, not the shutter speed.

▲ Fig. 7.2
Benbo tripods including the smaller Trekker model. Both can reach
very low angles.

▲ Fig. 7.3
Optical bench. This DIY model is providing stable support for a
camera and focusing rail. The latter is attached to a metal plate
bolted to the base of an old Prior microscope. That is useful, as
it can move the camera 90 degrees into the vertical. The piece
of wood under the back is acting as a wedge so that if there is a
slight incline the wedge holds it steady in position. The Canon EOS
camera is attached through an adapter to a Minolta MD mount
bellows unit fitted with an Olympus 40mm copier lens.

carbon fibre Manfrotto fitted with a magnesium ball
and socket rated at 12 kilograms. This regularly has
to hold 3.5 kilograms of StackShot equipment and
is very rigid. Heads from one manufacturer can be
fitted to different tripods of other manufacturers,
but do check for compatibility. Gitzo make a very
lightweight ball-and-socket type. Quick-release
plates are useful as well as having a spare plate. If
you have everything set up and a different subject
appears nearby it can be useful to unclip the camera
and (hand-holding it) chase the other before coming
back and re-attaching the equipment exactly as you
left it.

One of the most annoying aspects of using a
tripod with a mini tower of equipment like focus-
ing rails and lenses on tripod mounts is that when
you lock everything into place by tightening all the
knobs, you let go to find that there has been a tiny
shift in position. This is typical when the camera
is set at an angle and even the best tripods have
an almost imperceptible movement. With magni-
fication that slight movement will be enough for
the composition to change significantly and will
constantly have to be allowed for.

This potential problem coupled with the difficul-
ties of working with tripods in small rooms and on
tables implies that an alternative would be better.
The grand-sounding name 'optical bench' belies
the fact that this is just a solid structure that can

sit on a table and not fall over or vibrate. The one
shown here is homemade, from wood and the base
of an old microscope. The microscope part simply
provides a fulcrum so that it can be moved through
90 degrees for vertical use. This is a simple horizon-
tal or vertical support for a table-top stacking system
and is more effective and flexible than a tripod. With
better DIY skills and knowledge of metalwork quite
sophisticated benches can be constructed, some
with up-and-down or side-to-side movement.
Whatever design you develop to suit your needs it
needs to be fairly heavy, rigid and be able to connect
standard screw-fitting focusing rails.

If both horizontal and vertical movement cannot
be achieved in one bench then go for separates.
Vertical is more of a DIY challenge but you could
obtain and adapt a standard copying stand. Probably
the cheapest option is an ex-enlarger from a dark-
room. Some, like the Durst models, had a separate
bar that replaced the enlarger with a camera.

OPTICAL BENCHES
AND MACROSCOPES

When you are doing fine macro-photography all you want is stability; hence the idea of a simple optical bench. The term I have used is not a photographic one but is used in Physics – a table holding your moveable optics and light in a line. Developing one yourself is simple enough: it is, after all, just a rigid stand. I have taken it a little further as I wanted to move it into the vertical as well. 'Macroscope' is the name given to a camera that is mounted vertically almost like a microscope and is a stage in that direction. There are commercially available macroscopes but these include the optics and can be very expensive, e.g. Leica Macroscopes. Like a microscope they have a stage and sub-stage lighting. Figures 4.25 and 7.5 are simple macroscopes. It is possible to set up complex microscope lighting techniques like Rheinberg, which here has been simulated using simple blue backgrounds. Help with macroscopes and lighting would be available from groups like the Quekett Microscopy Club.

SUPPORTING SPECIMENS
WITH A STAGE

Once the optical bench is available you need to be able to support the specimens at the height of the lens. A basic stage can be constructed out of wood or metal. The one shown in Fig. 7.4 is just two lengths of solid timber acting like runners on either side of a flat piece of plywood or MDF to make the platform, here painted black to reduce any reflection. If the upper stage extends beyond the side runners it provides a lip, for attaching LED lighting clips. The subject can be held on the stage, which can be moved backwards, forwards and from side to side. The optical bench may be solid but it is not very flexible in terms of up and down movement. The subject does not need to be as firm as the camera and so it is in its support that such movement can be made. One option is to use a small jack. They have various names like Lab Jack and Scissor Jack but essentially they perform the same function; a knob at the side raises and lowers the subject.

The bench and stage may look very basic but they are simply providing practical supports. When aligning the specimen with the lens on the optical bench, although you could look through the viewfinder or live-view on the rear screen, viewing it on a computer screen is much easier. The stage and jack can be manoeuvred until the subject is approximately in position; then use the focusing rail.

A little more complicated is a stage for vertical use if you need backlighting. Really this just needs to be a thin piece of plywood with a hole cut in the middle supported by legs. It can be useful to have a few different-sized holes (3–6cm/1–2in diameter) to accommodate glass dishes and glass microscope slides.

A base of an old microscope was used in the optical bench. Bases of other microscopes can be used as the stage. Redundant and old bases with or without optics can be found at very reasonable

▲ Fig. 7.4
Optical bench with a positioning stage. The stage is separate from the bench and can move about with the subject on top to help place it in position. The wooden stage has two LED lights clipped to it for front and back lights. The specimen is located in a small observation cell on top of a Lab Jack which can be raised and lowered using the knob at the back. Fine adjustments are made with the Lab Jack whilst watching the image on a live-view window on the computer. As well as small cells the jack can move substantial aquarium tanks.

▲ Fig. 7.5
Vertically arranged optical bench over a simple stage to provide backlighting. The optical bench has been raised up on a previous stage to give height. A petri dish is on the stage with top and bottom illumination.

prices on eBay or through microscope groups who have fairs where parts are exchanged or sold. Schools and universities on occasions may be getting rid of old microscopes that are worth very little. They can be converted into useful stands that work well for stacking. For example, some bases have a stage that can be adjusted (rather than the optical column) for focusing; this gives an opportunity to stack by moving the specimen instead of the camera. Microscope stages have quite narrow holes, usually less than 2 centimetres, and so are better for the higher magnifications. Microscopes can have elaborate mechanical stages attached to them, to move a slide back and forth and from side to side. The simplest form is to have a couple of clips which can grip the slide and move it around the stage. Slightly more refined is when the entire stage can move. With a little bit of ingenuity and DIY skill, mechanical stages could be incorporated onto the stages as useful guides for stacking. It can be the moving of the specimen, even at quite low magnifications, that can become a little awkward at times particularly when you are holding the specimen and watching the computer screen.

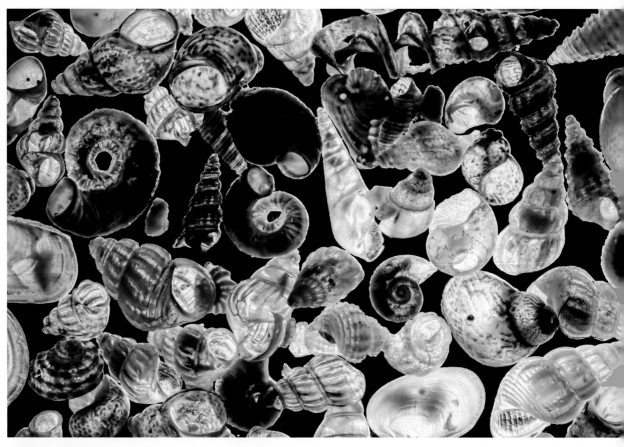

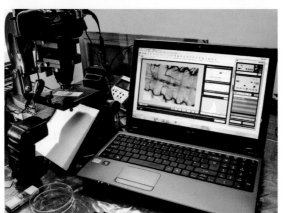

▲ Fig. 7.6
Majorcan sand photographed using the vertical setup on an optical bench. Magnification x2.5, 24-image stack using StackShot. To show the detail in the tiny shells the sample was backlit using flash beneath the stage. Canon 7D, 65mm macro, twin macro flash beneath stage.

▲ Fig. 7.7
Vertical arrangement over a stage made from an old microscope base. This means that the base can be racked up and down using the fine focus and is suitable for creating stacks. Here the camera is set on the abdomen of a mayfly on a slide and the breathing tubes are visible on the live-view screen. The wedge of polystyrene acts as a diffuser for the single flash gun that will work wirelessly to produce a backlight. The flash is ideal to arrest movement. Off screen there is an LED spot creating a light also onto the polystyrene and is giving constant illumination for setting up subjects.

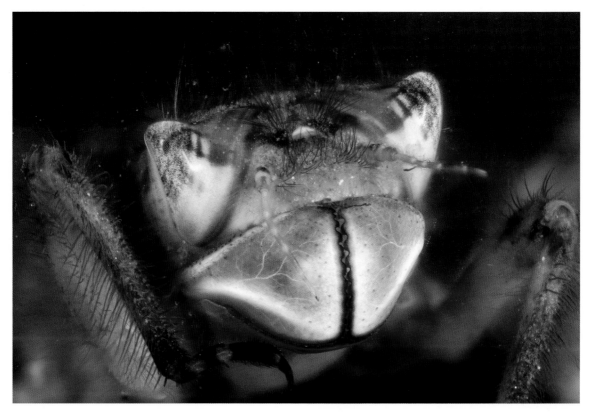

▲ Fig. 7.8
Nymph of a Darter Dragonfly *Sympetrum striolatum*.
Magnification ×2. A 24-image stack of its head taken using an
observation tank. The composite shows detail of the mask under
the head including the tracheal (breathing) tubes. Canon 7D, 65mm
MP-E macro, twin macro flash ƒ8.

OBSERVATION CELLS

In Figure 7.4 the specimen on the jack was in a very
small observation cell. As the name suggests, these
are enclosures within which the animal can be
placed to photograph. There are numerous possible
styles and sizes and after a fairly short time you
should have built up a range of these from just a few
centimetres/inches to quite sizeable tanks for small
fish. However, the aim is to make something that the
organism will be in for a short time, not necessarily
designed for it to move around freely. Small glass
aquarium tanks are fine but if they have too much
breadth the organism will be too far away from the
front glass for a close-up. Also if you make it too
much like home they will disappear and hide away

from the camera. It is important that the quality of
the glass is good and that all surfaces are cleaned
before use. Perspex tanks are good when they are
fresh but they easily become scratched over time.

If you already have an aquarium tank that suits
you could buy a piece of glass to fit inside the tank
as a divider. Like an invisible wall, it can be moved
forward to limit movement of the creature moving
it closer to the front glass, with the rest of the tank
providing a good backdrop. The glass divider will
keep the subject(s) within the zone of the lens.

Making your own cells is very straightforward.
For the larger cells use glass cut and purchased from
a glazier, giving them dimensions and the number
of sheets. The front sheet for the larger tanks can be
20cm × 15cm/8in × 6in. Try for some smaller ones
half that size as well. The quality and thickness of

▲ Fig. 7.9
Making observation tanks with glass and silicone sealant.

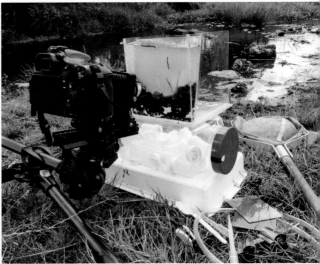

▲ Fig. 7.10
Observation tank in use in the field. In a studio the lab jack works well to move the tank into position. In the field it is a matter of using props and flexibility in the tripod to get the adjustment right.

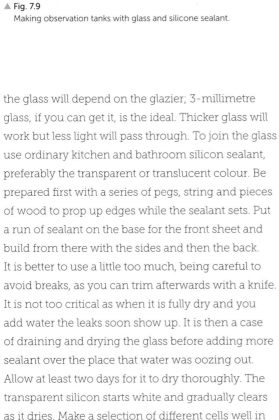

the glass will depend on the glazier; 3-millimetre glass, if you can get it, is the ideal. Thicker glass will work but less light will pass through. To join the glass use ordinary kitchen and bathroom silicon sealant, preferably the transparent or translucent colour. Be prepared first with a series of pegs, string and pieces of wood to prop up edges while the sealant sets. Put a run of sealant on the base for the front sheet and build from there with the sides and then the back. It is better to use a little too much, being careful to avoid breaks, as you can trim afterwards with a knife. It is not too critical as when it is fully dry and you add water the leaks soon show up. It is then a case of draining and drying the glass before adding more sealant over the place that water was oozing out. Allow at least two days for it to dry thoroughly. The transparent silicon starts white and gradually clears as it dries. Make a selection of different cells well in advance of using them. The solvent needs to have completely evaporated before adding aquatic life, preferably a week or so. Rinse it in water a few times before use.

The rear glass is placed at a slight angle for several reasons. An animal is kept near the front so that the light to and from the subject has a minimum of water to pass through, less distortion and a clearer, brighter image. Secondly, it can help with avoiding reflection. If the rear glass were parallel with the front sheet any flash could reflect badly. Light needs to be set up at 45 degrees to the front or be held over the top, shining down on the subject, or both. Check for reflection with test shots. A third reason is that the 'V' in the cell does help life that lives under stones and rocks. It seems that some creatures like crabs feel more at home if they can find slight pressure on the top and bottom of the body; it gives security. If seaweed and other material is placed in the cell the crabs typically manoeuvre themselves into a position with the head up and the body slightly wedged in the middle of the glass. This is away from the edges where the sealant would show. It is surprising how many aquatic organisms do this and then are perfectly positioned for photography. Of course, the position they get into will be the opposite way around to the one you want! Photographing through

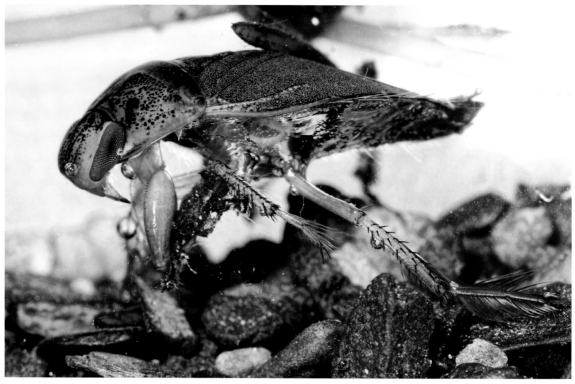

▲ Fig. 7.11
Saucer Bug, *Ilyocoris cimicoides*, life size. This freshwater bug has been placed in filtered rain water, in an observation cell, so there are low amounts of detritus and what is present could be cloned out on the computer along with the air bubble stuck to the head. Canon 60D, 100mm macro, twin flash with one above right.

the back glass is fine but stacking may be a problem as the lens, depending on your optical bench or tripod, cannot reach the glass. Also, the flash is not so easy to position.

Try not to handle the creatures too much. It is tempting to keep repositioning them, but a very occasional nudge with a paint brush is enough. Do try to set up the cell with other material such as contrasting seaweeds. Some soft greens like the sea lettuce can easily be placed nearby and help with backgrounds. Alternatively, use background cards of different colours. Place these behind the glass but not so close that they make the rear glass perform like a mirror. From aquarists you can buy gravels but it is far better to collect some from the streams and seashores near where the creatures live. Build up a collection and wash them well before use. This is because they have detritus on them that enters the water once in the cell. Also, when you have finished your photographic session, empty the cell and rinse the gravel before drying it. Store in a jar with a lid so dust cannot settle, or that will be in the water next time you set up the cell. Plastic sweet jars work well, filling them just half way or less so that any moisture still on them can evaporate.

Add fine gravel in the bottom of the cell to a depth in the V of glass dependent on the approximate size of the animal to be photographed. For example, if a 2cm/1in long dragonfly nymph is the subject and a straight-on close-up of the face is required you need to make sure that it can turn to face outwards to the glass. The V needs to be filled to around the 2 centimetre width mark. Alternatively, if you want side-on shots then make it less than 2cm/1in so that it is less likely to be able to turn. If it wants to it will rotate happily further up the glass

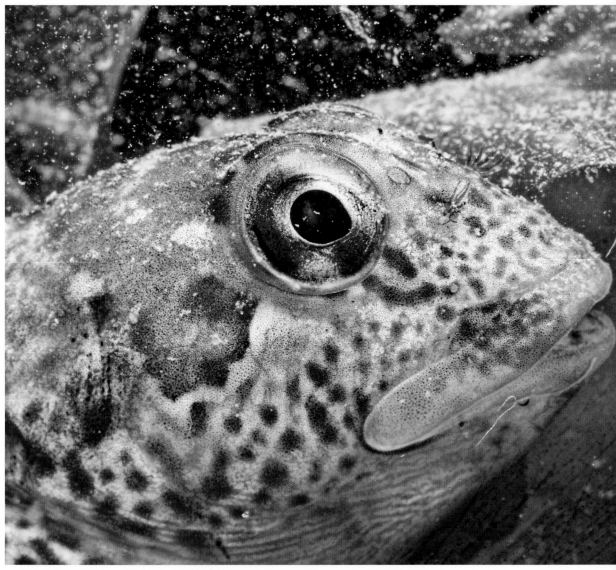

▲ Fig. 7.12
Blenny or Shanny, *Blennius pholis*, head close-up, taken using an observation cell. Magnification ×1. Note that the water has a high level of detritus, making it look grainy. Canon 30D, 100mm macro, top flash 1/125th sec ƒ16 ISO 100.

so you are not actually preventing it from moving – rather encouraging it to stay put.

Before adding water it is best to filter it first. If you take pond water or seawater and just pour it into the tank there will be a tremendous number of tiny particles of organic matter, and floating detritus. It is not immediately apparent but a flash will make it stand out like a snow storm. Thinking in advance, use collected rainwater that has been filtered rather than carrying litres of pond water back. The water needs to be relatively fresh or, if necessary, stored in dark bottles away from the light. If you have filtered water standing for weeks some form of algae will be growing in it and forming detritus even though it

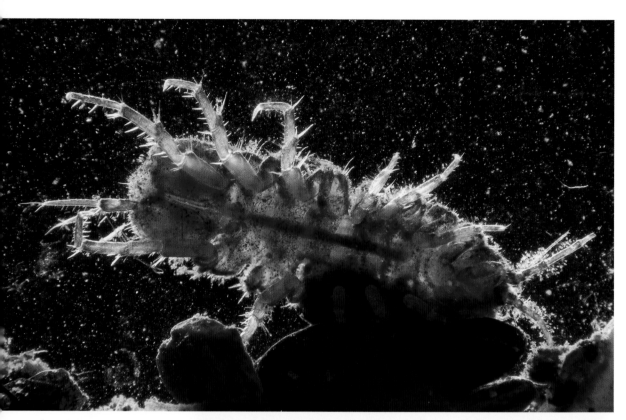

▲ Fig. 7.13

▲▶ **Figs 7.13 and 7.14**
Water Hoglouse, *Asellus aquaticus*, photographed in a small observation cell. Illuminated with a flash behind and the other with a flash from above. Magnification ×2. Fuji S602 bridge camera with Minolta 58mm lens coupled, Vivitar 285 flash.

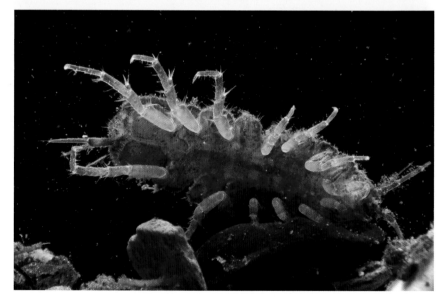

▲ Fig. 7.14

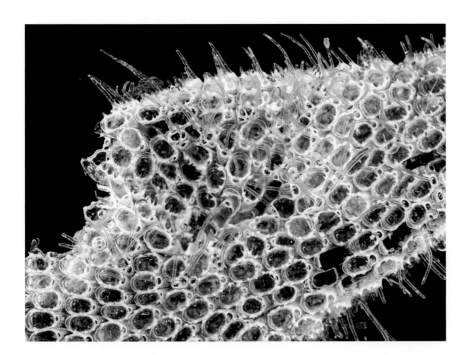

◀ Fig. 7.15
Sea Mat or Bryozoa. This small colony has been placed in filtered water within an observation cell. There is minimal detritus. The individuals feed by flicking small tentacles but introduction of a small amount of Epsom salts is enough to slow action down so a stack can be taken. 7-image stack, Canon 7D, 65mm MP-E macro, twin macro flash, ƒ8.

was filtered. Filter-bags of 5 microns mesh size can be obtained from aquarists and online stores. Hold the bag over your receptacle and pour in the water, then wash the filter. If you can find filters with a finer mesh it will be even better. Before putting a creature in the filtered water it could do with a bath in filtered water first as it will introduce detritus. Gently lift it into a beaker or small dish of filtered water for a few minutes and as it swims around it should shed detritus (even numerous baths will not eradicate all detritus). Minimize the disturbance to the specimen: the less you stress the creature the sooner it settles down in the cell of clean water. Once it is in the water you may be extremely lucky and the specimen may slow down and wait to be photographed. Normally it does not, and may need half an hour. During this time keep watching the behaviour – soon it will be possible to predict where it will go and how long it will stay quiet.

Another small trick you can do with the gravel is not to have it level. Incline a slight slope down towards the glass at the front and increase the amount of gravel at the sides. This creates a kind of well in the middle. Active swimmers will not be affected but others prefer to be at the lowest point and stay down at the bottom of the U-shaped well.

While you wait for the creatures to settle down it is time to set up the photographic equipment. Keep an eye on the cell as some insect types and crustaceans are good at escaping. Somewhere nearby have a large plastic bowl or aquarium with water in it so as soon as you have finished with the organism return it to clean water. For marine and river creatures a 'bubbler' should be added. This is a small pump that pumps air into the water to keep it oxygenated. The cells rarely produce respiratory problems for creatures, in fact it is the reverse. With all the glass and lighting oxygen bubbles form on the glass. Water that was filtered and has been standing in the dark should be all right for a while but if you used tap water bubbles come out of solution very rapidly on to the glass. Keep a fine paint brush handy and if bubbles start to appear at any time gently wipe them away with the brush.

Much of the above has concentrated on aquatic life but the cells can just as easily be used for terrestrial invertebrates. On top of the gravel place some compacted soil covered in mosses to

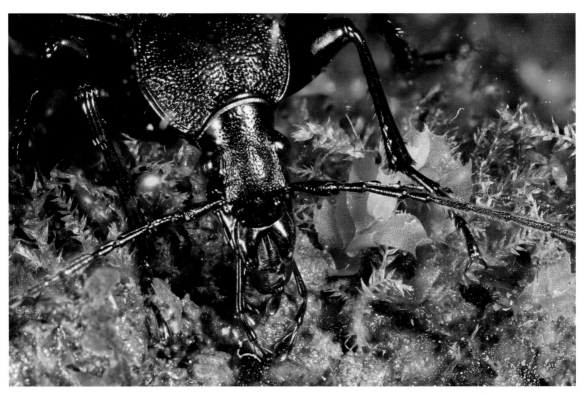

▲ Fig. 7.16
Head of the Snail Beetle, *Cychrus caraboides*, magnification ×2. 32-image stack using an observation cell set up for terrestrial life. The beetle took just five minutes to become settled and several stacks could be made. There is some debris on the inside of the glass where the beetle tried to climb the side during the five minutes. This can be cleaned with a brush but it would have disturbed the beetle. Canon 7D, 65mm macro, twin macro flash, ƒ8.

produce a U-shape well like aquatic life. Adding your creatures into the cell might initially cause them to start burrowing but the gravel normally deters them from trying to go deep. For those creatures that you expect to burrow, keep the soil to a minimum above the gravel.

Large observation cells are not always appropriate and other cells may be better. Instead of using thick glass from a glazier try to get hold of some old photographic plates. There is a surprising number around. They vary from 4 × 4cm up to 10 × 8cm, and larger, and the quality of the thin glass is very good. To remove the exposed gelatine, it may seem drastic, but pour boiling water over the emulsion. They do not crack as you might expect but the emulsion bubbles up and peels off. Once cleaned they can

be turned into observation cells by sandwiching a U-shaped length of silicon between two plates. The gap between the glass will be just a few millimetres or more depending on how much silicon you add. Have a variety available so that you can choose the cell size according to the organism concerned. As with the other cells they need time to dry and release all the solvent. It takes much longer with the sandwich type of cell, up to two weeks. Silicon gives a very good seal but the narrow gap will make cleaning difficult. The sealant can be cut, the glass cleaned and then re-sealed.

A simple alternative is to use a short length of plastic tubing clipped flat and tight by bulldog clips or similar. In fact any tubing or even suitable electrical cord can be used. Once the style has been

▲ Fig. 7.17
Narrow, flat, observation cell made from two photographic plates, cleaned of the emulsion, sandwiched together by a U-shape of silicon sealant. The well is filled with filtered water and the animal introduced. The crocodile clip holders are widely available in hobby shops and are useful to hold many things, including a background cloth.

▲ Fig. 7.18
Sea slug, *Rostanga rubra*, magnification ×1.

▲ Fig. 7.19
Case made by a marine insect larva, *Clunio* sp. on a filament of *Cladophora* weed, magnification ×3 (14-image stack).

▲ Fig. 7.20
Small caddis-fly larva in its case, magnification ×1, photographed in the narrow observation cell. The cell makes it difficult for animals to twist and move around. This keeps them flat to the front glass and if the camera lens is at 90 degrees it will ensure the best depth of field. Sea slug and caddis fly: Canon 30D, 100mm macro, *Clunio* Canon 7D, 65mm macro. All twin macro flash.

▲ Fig. 7.21
Selection of background cards and material. Only fairly small sizes are needed and so a collection of various colours and sizes can be collected from junk mail, publications and material off-cuts.

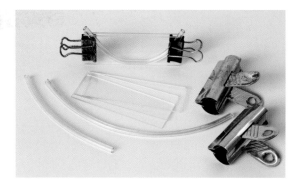

▲ Fig. 7.22
Observation cells made from microscope slides and other glass using plastic tubing and clips.

▲ Fig. 7.23
'Tack-Tanks': observation cells made from blu-tack or white tack squashed between microscope slides for temporary use.

tried and tested the sizes can be as big or small as you like. Using microscope slides works very well, too. Attaching the clip can require a good deal of dexterity but with care should not leak and comes apart easily for cleaning. However, the simplest of all methods of making very small tanks (and this is ideal in the field) is to use blu-tack or white tack. Take a length of the tack and roll it between your fingers until you have a sausage shape a bit longer than the microscope slide. Form a U-shape and sandwich the two slides together. Make sure they are squashed tight. Using another piece of blu-tack or white tack in a ball, stick this onto a post or rock and then push the two upright slides into the ball so that it is anchored and will not move. Using a pipette, add a drop of water and introduce the specimen. The tack-tank works extremely well with very small aquatic species. They are only temporary and after a while they can start to leak, so have some water handy and keep topping up with the pipette.

▲ Fig. 7.24.1
'Tack-Tank': an observation cell in use in the field.

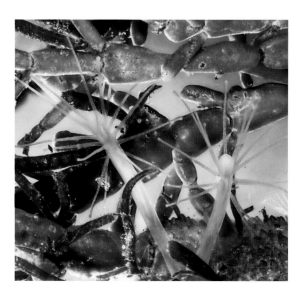

▶ Fig. 7.24.2
Hydroids *Clava* species on *Corallina* weed taken in a seashore set-up 'Tack-Tank'. Magnification ×4.

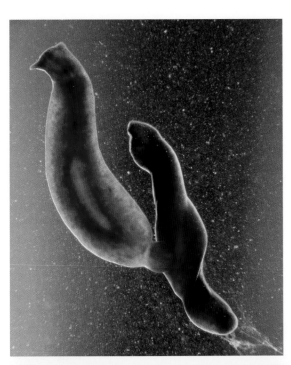

Fig. 7.25
Pair of flatworms. These primitive organisms are found in freshwater and were placed in a temporary tack-tank with the movement arrested by a single flash from behind. Detritus is evident as well as the slime left behind on the glass. The first flatworm has a pinch in the rear section where it has been damaged and replicated itself. Magnification ×2. Fuji S602 bridge camera with Minolta 58mm lens coupled. 1/250th sec F11 Vivitar 285 flash, ISO 200.

Fig. 7.26
Stonefly larva from freshwater stream. This is a young stage in a stonefly's development and was taken with a tack-tank. A small section of white tack is visible, as well as detritus. Using filtered water in the field is not so easy and so these have water straight from the pond. Magnification ×2. Canon 30D, 100mm macro with 31mm extension tube. Single flash.

▲ Fig. 7.27
Bryozoan colony in a tack-tank on a seashore with blue card
background held behind. The bryozoans started to filter feed just a
few minutes after being placed in the tank. Magnification ×2. Canon
30D 100mm macro with extension tubes, flash from above and
front, 1/250th sec at ƒ18 ISO 100.

TANKS FOR
BACKLIGHTING

Although the observation tanks can be used to
backlight subjects, more often you want a top view
and those tanks will not work. For aquatic life a
centimetre or more in size, a small glass pen or tank
can be made from strips of glass and silicon sealant
constructed on a length of glass. The thickness is
immaterial as the light from the subject to the cam-
era will not be passing through the glass. The base
or holding glass needs to be at least 5mm/0.25in
for safety reasons. This glass will span around
60cm/24in in length and 10cm/4in wide, hence the
need for reasonable thickness. A wooden frame can
be made to suspend it 20cm/8in or so above the
table or other supports. The small glass pens or tanks

SUPPORT ACCESSORIES

Support for stacking and close-ups comes in a variety of additional small, assorted items, ideally kept in a small toolbox. A plastic white spoon is good for moving aquatic creatures from dishes to tanks. Have different-sized ones including small teaspoons and plastic Chinese soup spoons (large capacity). The white background helps you to see the specimen more clearly. Other useful tools include very fine stainless steel forceps and reverse-action forceps or tweezers – squeezing them causes them to open; let go and they clamp shut – useful for holding subjects up for photographing, supporting them in crocodile clip holders (called 'helping hands'). A selection of fine paint brushes, mounted needles, a sharp knife, a pair of small scissors, plenty of blu-tack or white tack, clips and pins are just a few of the things you will find helpful.

▼ Fig. 7.28
Tanks for backlighting. Here glass strips have been attached by sealant to form a dish to hold water onto a long length of 5mm glass. A wooden support has been made to hold it clear of a flash gun, offset. The lens and camera are above with a blue background below.

are constructed from strips of glass of varying sizes such as 4cm × 10cm/2in × 4in. Even microscope slides make suitable glass to construct small tanks. You could try small glass dishes laid on the glass but it is amazing how many minute scratches they have. Also the glass base can be distorted and all these things affect the light passing through.

To use the tanks one or two electronic flash guns are placed at an angle to one side beneath the glass. The flash is directed at the underside of the glass where the subject is located but the flash guns are themselves out of the way. The light should hit the glass at around 45 degrees and not cause reflection. Beneath the specimen, laid on the frame or table can be a suitable background of coloured card or cloth. Blue works well. If it does not show up then it could be down to the exposure, or the background may need to be moved higher. Try to use filtered water and a washed specimen to reduce detritus and then track the animal as it swims around from above with the camera. The chances are that it will swim to the edge (a behavioural phenomenon called *thigmotaxis*). Animals typically like being at an edge, which is not very photogenic. With a paintbrush gently move it into the centre and it will give you a short time before it realizes it is back in the middle and swims off again. Be ready with the camera, take a number of photos and select the best on the computer. Cameras using TTL metering (all modern DSLRs) should use the pre-flash to help with the exposure, taking this off the centre of the animal. Most translucent aquatic species can provide superb images with back light. Those less transparent may need a touch of top light as well. The back light helps to give detail along the edges of the body and limbs as well as internal structures.

For smaller specimens the tanks are just too large and the subjects will probably need to be stacked. Then it is back to the vertical mounted stacking equipment with lighting under a stage. To hold the specimen go for glass dishes or glass plates, even microscope slides, that have different sized washers

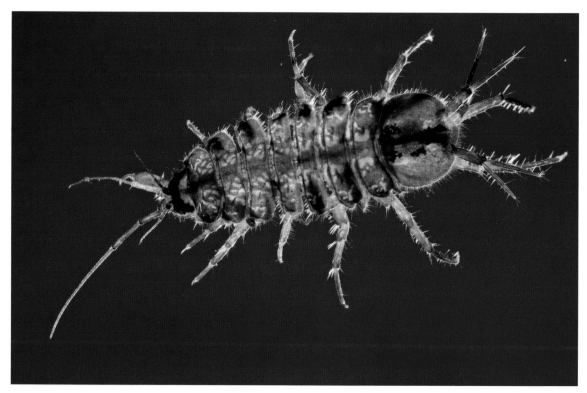

▲ Fig. 7.29
Water Hoglouse, *Asellus aquaticus*, photographed backlit with a
blue/green background. Life-size, cropped. Canon 7D, 100mm
macro with single flash from beneath. 1/250th sec ƒ14 ISO 125.

glued with Araldite to them. These are standard
washers from hardware stores or old ones that have
been cleaned. You now have a small well within
which the specimen can be placed. It is usually
unnecessary to cover the washer and specimen
but if they thrash about (e.g. phantom midge larvae
that we saw under LED lighting, Fig. 4.6), then a
microscope cover slip can be placed on top. The
only problem with this is that it could restrict oxygen
diffusion into the water and so if you have to add
cover-slips remove these after a short while to re-
oxygenate the water.

Movement of aquatic material can be a problem
if stacking is going to be the only option to get
a clear image. There are standard techniques to
slow creatures down like Epsom salts (magnesium
sulphate crystals) and magnesium chloride. Make
up a solution first and then add the creature to the
solution. Diluted glycerine or glycerol works quite
well but again, make up the solution first. Try differ-
ing concentrations until the right result is achieved.
Epsom salts works with marine life but not glycerol
as with the latter the concentration of seawater will
be incorrect and is likely to kill the animal. A sub-
stance that works very well is wallpaper paste, pref-
erably not with fungicide. These cellulose powders
are easily available and can be made up with both
freshwater and seawater. Follow the instructions
on the packet for concentrations typical for most
wallpaper. Place the made-up paste into the well and
then add the specimen in a small amount of water.
With a needle gently mix the animal into the paste.
It may sound harsh on the creature, but as long as
they are not in the mix for more than fifteen minutes
or so and on removal they are put back into clean
water, they swim off with no apparent problems. All

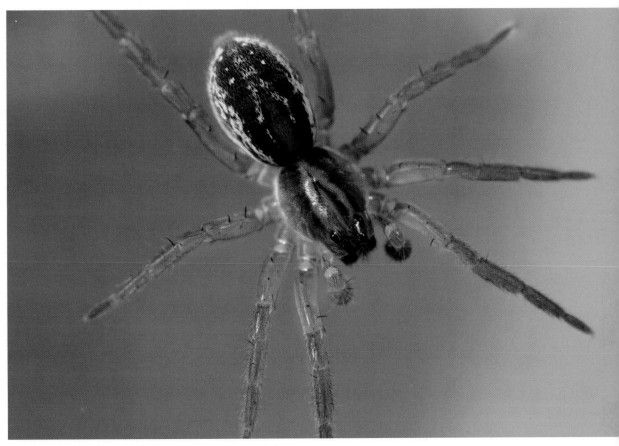

▲ Fig. 7.30
Pirate Spider, *Pirata piraticus*, photographed in a backlit dish but
with a second flash above. The spider lives next to water and runs
over the water using the surface tension. The flash from beneath
has created a slight gradient of blue. A stack was out of the question
as it moved too much on the water and so the depth of field is
limited but focusing on the eye has produced a useable photo,
magnification ×1.5. Canon 60D, 65mm MP-E macro, two flash guns,
1/250th sec ƒ8 ISO 100.

the creatures that have been through this procedure
in the author's experience have always continued on
their development – including to adulthood – with
no problems. Flash and LED lighting has no effect
on them either but tungsten is too hot and heats the
wells up too much.

PUBLIC AQUARIA

Using a public aquarium can be the answer to some
difficult tank situations. Make sure the aquarium
allows photography and flash. Most do but there
may be some restrictions on certain species.
Cephalopods, like octopus, have very advanced eye-
sight, some might say equally as good as ours, and
react badly to flash so it should be avoided. Aquaria
tend to be dark places but increasing the ISO is one

▶ Figs 7.31 and 7.32
Meniscus Midge, *Dixa* sp.,
larva and pupa from a pond.
The pupa here developed
from the larva and was
photographed in a studio
using the washers in the
dish with the camera held
vertically. To prevent them
moving too much so they
could be stacked the well
was first filled with wallpaper
paste. In the pupa shot the
texture of the glue can just
be made out. The glue has no
effect on them and the pupa
went on to emerge into an
adult. Magnification ×5. Larva
is an 8-image stack; the pupa
a 7-image stack. Canon 7D,
65mm twin macro flash.

▲ Fig. 7.32.1
Glass petri dish with three
different washers glued
to the bottom to create
wells for observing animals.
The meniscus midge was
photographed using this.

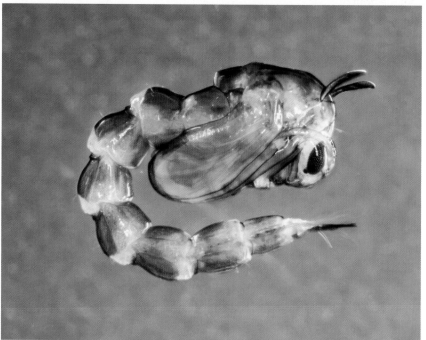

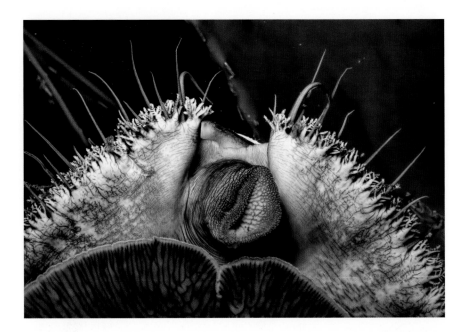

Fig. 7.33
Head of an Abalone or
Paua shell *Haliotis* sp. on
glass, in a public aquarium
at Portobello. Canon 60D,
100mm macro near life-size,
single Canon 430EX flash,
held above the camera and at
45 degrees to the glass. F11.

way around it. Flash will not pass through thick
aquarium glass and deep water very well. Also, the
subject will be quite distorted. Using a macro lens,
aim to go for species in smaller tanks and near to the
glass. Holding the flash at 45 degrees to the glass and
with the front of the lens as close to the glass as pos-
sible should result in good images. Tripods are not
usually allowed in the public areas as they become a
trip hazard and so stacking is a very limited option.
In small, not so busy aquaria, it may be possible after
asking permission. Species like jellyfish and other
swimming animals can only really be photographed
in public aquaria.

MATERIAL AND WELFARE

Using the techniques in this chapter should enable
most creatures to be photographed and stacked
alive, whether they are terrestrial, in freshwater or
marine. There are tanks and cells that can be taken
into the field and used or brought back for careful
photography in a studio. By being prepared, keeping
all of them alive is possible by using aerators for wa-
ter or by keeping land creatures in suitably dark con-
ditions; for example, ground beetles will be happy in
a box with moss before returning them to the field.
Dead creatures rarely make good photographs as
they take on strange attitudes and shapes with their
legs. The eyes soon dull and show lack of life. In
Chapter 9, various creatures will be considered and
how to handle them. When you are out and about
looking for material you will come across organisms
that are dead or dying and they might offer the best
opportunity to carry out stacking. Road accident
victims are common on a journey: keep a check on
the front of vehicles and see what has been caught.

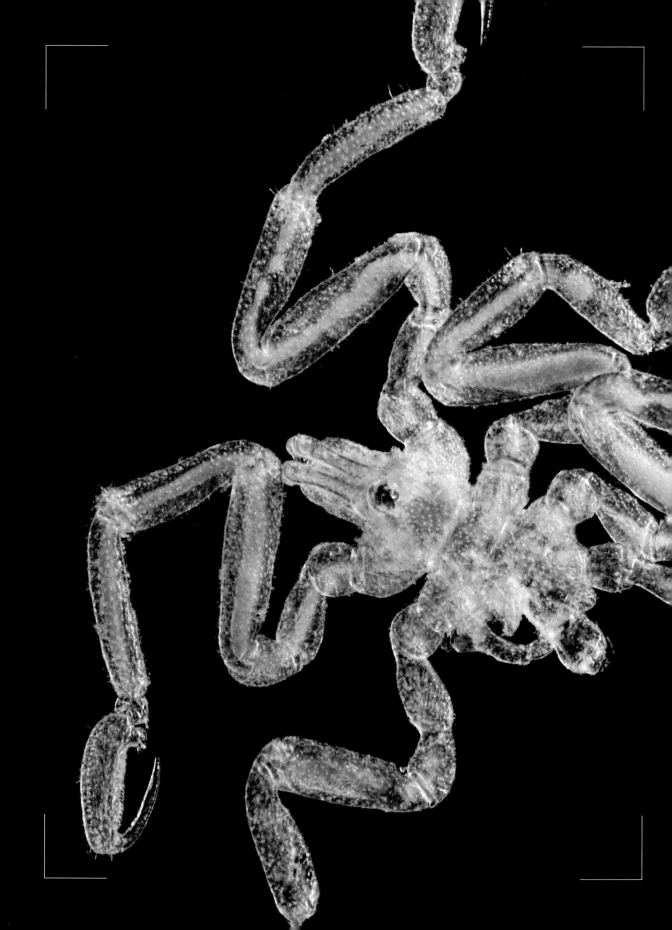

Chapter 8

Improving Stacked Images

Stacking images can produce some superb composites with stunning depth of field that just a decade ago could only be dreamt about. The software that combines these images together has become more sophisticated over recent years with complex algorithms at their heart. Unfortunately, it is not always the case that the composite emerges without some strange anomaly or artefact (see below). As the combination process works so each method can produce problematic issues from blurs and smears to reduced tones and high noise. Some of these programmes have retouching tools that we can look at here. Other issues can be improved with different software packages so that most problems produced in the stacking can be dealt with.

◀ Fig. 8.1

Sea Spider *Anoplodactylus* sp. With their very long legs sea spiders are difficult to photograph as they are tiny, around 1–2mm in length, often tie themselves in knots, and need stacking to achieve maximum clarity. The animal shown here was placed on a cavity slide flooded with sea water and covered in a large coverslip, then photographed with the camera vertical. This kept the specimen as flat to the camera as possible. 6-image stack composite with retouching as the legs moved. Magnification ×5. Canon 7D, 65mm macro with extension ring, twin macro flash ƒ8.

STACKING ARTEFACTS: IMPROVING HALOS

Whatever software is used for stacking large numbers of images, strange artefacts can appear more often than not. One cause of this is that large stacks of images create enlarged, out-of-focus areas that reduce in size gradually as they become sharper and in focus. The composite image then has the sharp edge with a blur nearby. This may be most noticeable with depth map methods, the most commonly found. The example used here is a rounded beetle photographed from front to back. The first image of the stack shows a sharp head with the back of the insect out of focus and a large blur. The last image has a blurred front and sharp back. Notice how the blurred areas tend to be larger.

This raises an important fact that because out-of-focus areas become enlarged allow for this in the setting up of stacked images. Depending on the subject and the final composite the image can end up being cropped automatically by as much as ten percent. The problem can be seen in these two images of the ladybird where the edge on the right has been clipped. Ensure that you allow plenty of space around the edge of the field of view. If you only get one attempt at a stack before the organism goes it is better to start further out and then repeat the stack closer up. In the first instance depth of field is better anyway and should require fewer images to make the composite.

▶ **Fig. 8.2**
First image from a 30-image
stack, Orange Ladybird
Halyzia 16-guttata.

▶ **Fig. 8.3**
Last image from a 30-image
stack, Orange Ladybird.

Once stacked the blurred areas, like the back, can produce pale halos, especially if the background is dark. Also, subtle areas of similar colour can lose contrast and definition when overlaid with enlarged blurred areas. Figure 8.4 shows a composite of a stack which has been set wide with reduced magnification to allow for the edges to be clear of being clipped. Cropping can always be done later. The halo around the back of the ladybird can be clearly seen although the lack of clarity in the thorax markings is not so obvious.

Stacking software has various ways of dealing with these artefacts but, depending on the severity, be prepared to take some time to eradicate them. It is worth saving the initial composite and reviewing to see if and where the artefacts are located. It is not

◀ Fig. 8.4
Orange Ladybird. Original composite of 28-stack image. Magnification ×3.5. Canon 7D, 65mm MP-E lens, twin macro flash.

▲ Fig. 8.5
Enlarged area of the Orange Ladybird from the rear section, showing halo effect.

▲ Fig. 8.6
Screenshot of the Helicon Focus retouching tab after the composite photograph, in the lower half, has been made. The image displayed at the top is one of the files from the stack, depending on which has been clicked.

always possible to see this in the stacking software. The output files are retained during the session so at any stage you can call them up and look at retouching. So before closing the software start work on the composites you have identified that need some work. Of course, if you find later that your stack has problems it takes little time to go back and restack it.

Here we will follow the Helicon software but Zerene is similar.

Use the zoom slider control to get in close, looking for abnormalities. Just by clicking somewhere in the wedge it will enlarge or go wide. Alternatively if you have a scroll mouse just roll the wheel in and out. When you find an artefact click the tab option 'Retouching'.

▲ Fig. 8.7

Orange Ladybird *Halyzia 16-guttata*, retouched and cropped. It is easy to presume that all ladybirds eat aphids. The Orange Ladybird is an exception, eating mildew, typically off leaves of sycamore with which it is associated. Mildew has minimal nutrients and so growth and development is slow. Consumption of aphids in other ladybirds produces rapid development in two weeks from egg to adult. Mildew grows especially well where there are aphids sucking sap and releasing it over leaves, creating a sticky, moist condition for the fungus to grow. It can be speculated that this species is perhaps one of the earlier forms of ladybird with other, mutant forms, moving on to eat the more nutritious aphids. This extreme close-up shows mouthparts quite different to other, carnivorous types. Canon 7D, 65mm MPE macro, ƒ8, twin macro-flash, 28-image stack.

Using the zoom function, further enlarge the area to be worked on, in this case, the rear halo. Retouching methods use a form of clone tool. In the lower part of the screen is the stacked, composite image and the upper section displays one of the images that was used in the stacking process. All the files used in the stack are displayed in the top right. To change the displayed file click on a new one, working through them until the one nearest the photo in the area to be worked on appears. In the example here file number 16 shows the sharp edge of the beetle's back. It is now possible to clone the clear and sharp area to the composite image below.

The mouse cursor is in two parts. Initially, the one on the upper image is a circle and the lower one a green dot (centre) and 4 arrowed corners. Clicking the mouse copies the pixels into the area designated within the lower cursor. Carefully moving the mouse with the left button held down will continue to clone material from the top image. Unlike in, say Photoshop, where the user determines the clone position, here everything is automated to correspond between images.

In the Parameters menu, to the right, the size of the clone area can be adjusted along with hardness, sensitivity and brightness. A range of Undo buttons

▲ Fig. 8.8
Eyebright Flower, *Euphrasia* sp. Depth map composite showing
excessive halos around the white edge against a black background
and also in upper left area.

are at the top along with Reset. Care is needed not to keep moving into new areas without checking to see if there is another file with a clearer set of pixels. Periodically click on another file close to the previous one. This may need zooming out to check the level of focus but with just a limited amount of practice it becomes easy to see and determine the approximate position of a file in the stacking sequence. The halo removal is straightforward. Areas sloping away, like the thorax in this ladybird, require more work as four or five different files may have to be used to gain sufficient clarity. Starting at the front of the composite the thorax area was added, small spots at a time from different files. By the end we see much more detail present in the thoracic area, bringing in material that could be easily overlooked.

Other strange halos can appear in what appears to be uniform toned background, especially when using the depth map stacking method. Even small, out-of-focus areas can yield gradient halos. This time, instead of looking for a file that has the area sharp, you are looking for one that can produce an even tone across the area to clone out the halos. This requires more care and may still need several files- worth of cloning as sharp edges may be obscured by soft blurs. Sometimes the halos can be so major that short of hours of careful retouching it will not work. This is why it is worth trying different stacking methods at the same time and then comparing the composites. When subjects have a relatively uniform colouring, such as white flowers, the halos can be worst when the exposure is not quite right, particu- larly with over-exposure.

WHICH STACKING METHOD IS BEST?

I invariably end up trying several methods to find the best one. Pyramid is generally better but I prefer the colour depth in depth maps. On occasions they all have good and bad sections so it is difficult to make the decision of which to use. In those cases I will open up both in my photo editor (I actually use Corel Photopaint, which comes with CorelDraw) side by side on the screen. Taking the best as my master I then clone good parts off the other. Make sure the first clone is set at exactly the correct matching point and then moving around the picture you will not have to reset it. This all can get tricky if all three methods have advantages and disadvantages but by working on one at a time the result can be a huge improvement. Figure 9.24 was done this way.

Copies of the retouched composite image can be saved and checked in full screen to see progress and any areas that have been missed. Go back and keep working on the retouching until a final, pleasing image is produced. Only then should the software be closed down and the other copies deleted.

The final image probably needs some further work in a photo-editor, for example to adjust levels, tone curve and unsharp mask. You may find that the clone tool needs to be employed again to remove detritus in aquatic photos. We will look at these issues later in the chapter.

STACKING ARTEFACTS: IMPROVING SUBJECT MOVEMENT

There are other occasions when this retouching can be used, especially artefacts caused by subject movement. Focus stacking is a straightforward process when working with subjects that remain motionless. Some people feel that subjects have to be dead to be photographed. This is not the case. With time and patience movement can be mini-mized in an image and we have seen that the use of substances like wallpaper paste can slow aquatic species. Even without using such methods there are ways around some movement. As an example of this, sea spiders are one group of many organisms that hardly ever stay still but their movement is slow.

Despite being left for some time in the observa-tion cell, with seaweed as a backdrop, the *Achelia* would not stay still. When movement was gauged minimal a sequence of photographs was taken to make a stack. The shutter was released rapidly and at the same time slight manual adjustment was made to the focus distance on a focusing rail. The images were reviewed in a viewer and the best ones stacked. As can be seen from the result an 'extra leg' has appeared in the composite where the sea spider moved. This image was then retouched in the software. Each leg was tackled separately with the image zoomed in to show close detail. By clicking on the separate images in the top left panel the best image with the clearest leg was chosen and then cloned, making sure that the dark background was cloned as well to remove the extra leg. It may not be possible to clone an entire leg from one file but by starting at the tip and working down the leg, selecting a new file as you go, continue until it is all in focus. Obviously this will only work along a leg for so long before it has moved position too much. So be prepared to have some sections out of focus, choosing the file that depicts the best material. It can

◀ Fig. 8.9
Sea Spider, *Achelia* sp. Original composite of 7-image stack. Subject movement has formed extra layers to the legs as three have moved forward as the seven photographs were taken. Magnification ×5.

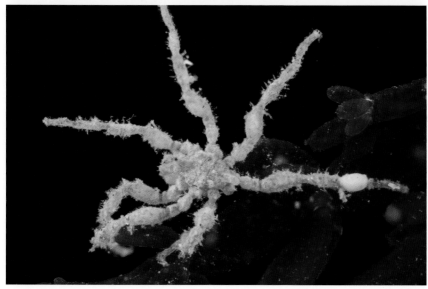

◀ Fig. 8.10
Sea Spider, *Achelia* sp. Magnification ×5. Same composite after retouching in Helicon software followed by detritus and bubbles removal with cloning in photo-editing software. Sea spiders are not true spiders although they have been classified in the Arachnida for many years. Now they have their own class, Pycnognidaea, alongside Insects and Crustaceans. They are very common in rockpools amongst seaweed although difficult to see; thought to be largely carnivorous. Canon 7D, 65mm MP-E macro, twin macro flash *f*8.

be time consuming but the results are worth it. You do need to be zoomed in close and do check different files regularly to identify the best sections. As all things, it improves with practice.

It is better to spend time on a living specimen and have a natural shot rather than killing the organism or affecting it in any way to keep it still. In some cases 'repair' work on a leg or other part of the body can be done later by using the clone tool in photo-editing software.

This concept can be taken further to include quite active species. Figure 8.11 shows the larva of a black fly, *Simulium* species. A very difficult subject as, only 4 millimetres long, this aquatic midge larva lives in fast-flowing water and moves a great deal by attaching to the substrate by the end of the abdomen and waving the body for feeding. To reduce movement the animal has been placed in a small observation

▶ Fig. 8.11
Black Fly, *Simulium* sp. larva, a biting midge. This is the best composite from eight stacked images. Compare this to the final result, Fig. 8.12. Note the overlapping images and detritus plus the edge of the observation cell. Magnification ×4. Canon 7D, 65mm MP-E, twin macro flash, ƒ8.

▶ Fig. 8.12
Black Fly larva, *Simulium* sp., final composite after retouching and removal of detritus with cloning. With a worldwide distribution the tiny biting adults can become a pest. In West Africa the flies are a vector for a parasitic worm causing River Blindness. Found in fast-moving water, larvae attach the end of the abdomen to a substrate so they do not drift. If they do become detached a rapid spinning of a silk thread can become a lifeline. They feed on detritus.

◀ Fig. 8.11.1
A range of photographs taken of the Black Fly larva to be reviewed like a flick book using the best to create the composite.

GRAPHICS TABLETS

When focus stacking, to improve backgrounds and edges you invariably find yourself doing some very fine cloning. Removal of detritus in water is one of the most common uses, along with artefacts that may appear with enhancements, like using 'Clarity' on even-toned backgrounds. Although you may have a good quality mouse that gives accurate tracking, a graphics tablet like the Wacom Bamboo series can make life a good deal easier. Here you hold a pen instead of the mouse although I always have both in operation at the same time. I use an A5 size rather than a larger tablet as it saves space and restricts the amount of tracking across the desk.

tank of sandwiched photo plates and silicon. Despite being 'rinsed' in clean water there is a good deal of detritus, the food of the larva, but that is the least of the problems as the midge larvae never stay still.

The camera and lens for a four times magnification was mounted on a StackShot auto rail. The auto rail was just used to move the camera with the back and forward controls. Connected to a computer all focusing was achieved by moving the camera and observing the computer screen. The shutter was released manually by clicking the screen. Once the subject settled on the glass the head tended to move as it fed. By watching the image the camera was simultaneously refocused and shots taken. This way movement can be monitored. If the larva moves completely out of alignment the 'stack' can be stopped. This is a quick way to take a sequence: focus, fire, refocus, fire and so on. The collection of images then need to be checked in a viewer. Using it like a flick book, hold the button down so you see the images full screen but flicking through quickly. It may take a little while to narrow down a suitable stack but eventually you should have ones that

match as well as possible. The images are stacked knowing they are likely to be slightly askew. Using the retouching tab they can be touched up with the relevant image as accurately as possible, like the sea spider previously. A clone tool can then be used to make a final trim and possible reconstruction. For the Black Fly larva there was a tiny notch of abdomen missing and so a small piece was cloned from another part of the body. Detritus is quite natural and it is down to the individual as to whether it is cloned out or not.

TIFF files take up a greater space than the compressed JPEG format. The final image of the Black Fly, which with cropping became a 12 megapixel photograph, had a file size of almost 70 megabytes. When doing many stacks it is tempting to go for the small file size of JPEG. However, if the composite requires work in other programmes, save it as an uncompressed TIFF file and then when it is repeated, saved, and worked on it will not lose any detail. This can always be converted to a JPEG once all enhancements are complete.

FURTHER ENHANCEMENTS

Focus stacking should not be rushed but inevitably, when working with wild, live animals, speed is often crucial. There is so much to think about when running a stack that normal issues that you take for granted get forgotten, like checking the exposure. It is not unusual to get back to the computer from the field and find that the images are dark. The stacking software works well even if the stack is three or four stops too dark or a few stops too light. Run the stack as it is rather than trying to amend all the images first, and then work on a TIFF copy to enhance the composite. Software for enhancements is a personal choice. Adobe Photoshop Lightroom is a popular programme and has all the key features of its expensive stable-mate. Alternatives include Elements, Paint Shop Pro, and many others. Among the free downloads are IrfanView, Paint, Google Picasa, GIMP and even Gimpshop which works in a similar way to Photoshop. FastStone Image Viewer, mentioned earlier as a first class viewing and organizing programme, has some good enhancement features like Levels, Tone Curves, Clone and Healing as well as noise reduction. Heliconsoft, the company that produces the stacking software, has a free Helicon Filter programme with numerous enhancement features.

Insects by their very nature tend to be covered in dust and dirt – which is why they are often seen cleaning themselves. Once you start magnifying anything it is incredible how much debris is on them. One could argue that this is so natural it should be left, but it can also detract from the detail. Some organisms can be cleaned beforehand with a soft brush gently run over the surface. In many cases it will be virtually impossible to see. There are people who work on creatures that are dead and this also applies when finding accident victims: clean them in small ultrasound machines that can be used to

◀ Fig. 8.13
European Praying Mantis,
Mantis religiosa. 24-image
stack, magnification ×1.5. The
stacks were several stops too
dark and this is the original
composite. Zerene Stacker
used for the composite.
Canon 7D, 100mm macro
with extension tube, twin
macro flash.

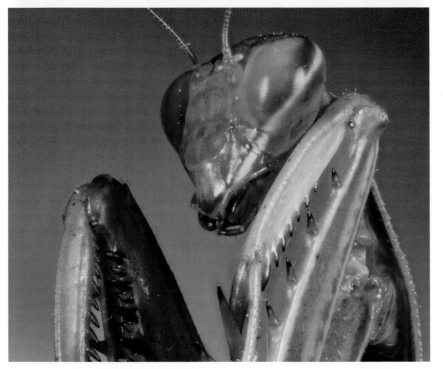

◀ Fig. 8.14
European Praying Mantis
Mantis religiosa. Using Adobe
Lightroom the image has
been developed to expand
the exposure until it was
correctly exposed. Shadow
detail was increased with the
Shadow slider along with a
little Clarity control. Tone
Curve line was raised to
brighten shadow a little more,
Unsharp Mask and some of
the butterfly scales on the
nearest eye were removed.
Also the image was cropped
so that it was more balanced,
looking into the frame.

▶ Fig. 8.15
Horse-fly, *Tabanus* sp. Close-
up of head, magnification
×3. There is something about
looking into the eyes of a
horse-fly. They can be quite
beautiful, with each species
being different and worth
making a collection. This is
a relatively clean specimen,
28-image stack.

▶ Fig. 8.16
Horse-fly *Tabanus* sp. Close-
up of head, magnification ×3.
50-image stack of a very dirty
specimen.

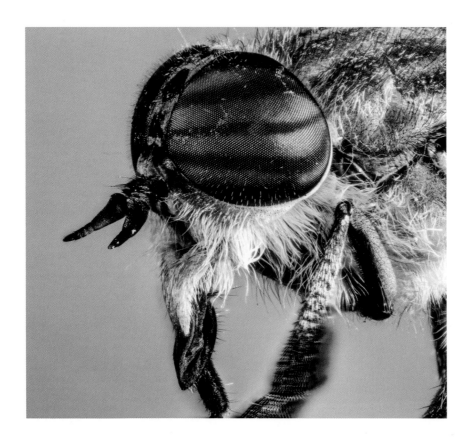

◀ Fig. 8.16.1
Horse-fly *Tabanus* sp., side view of the dirty specimen where it does not appear so bad. During the stack it has moved its leg.

clean jewellery. Apparently, it works well! However, be prepared for a degree of clean-up later on with the clone or healing tool.

Pyramid methods generate noise, especially in Helicon. Much of the time this is invisible until enlarged. In some cases it can be very intrusive. Most editing software has good noise reduction but Topaz DeNoise leads the way with the greatest range of options available. Other options are available, such as Wavelet Denoise.

Topaz Labs is a company that makes plug-ins to be used in many of the programmes listed above. Once installed the plug-in is then available in one of the menus. The actual position varies but with Lightroom it is under Photo. For some, like Lightroom, an additional, but free, piece of software is needed called Fusion Express. When the plug-in is activated within the host programme it appears in its own window. Denoise is very effective on any image in reducing grain and noise without affecting the rest of the image. Use this first before adjusting other controls. The plug-in called Detail is excellent for bringing some of the more subtle aspects of composites alive, especially when some of the methods soften the image. It can give better detail than sharpening and provides a texture to the image. Detail hosts an array of different controls and the layers of detail can be built up by enhancing shadow and highlight detail separately.

▶ Fig. 8.17
Noise. Part of the back
of a Spotted Fritillary
Melitaea didyma caterpillar.
34-image stack composite,
magnification ×3.

▲ Fig. 8.18.1

▲ Fig. 8.18.2

▲ Figs 8.18.1 and 8.18.2
Enlargement of part of the caterpillar's back to show the high level
of noise produced in the pyramid stacking. The second image is the
same but after noise reduction in Topaz DeNoise 5.

▶ Fig. 8.19
Jewel Chafer *Hoplia caerulea*. Magnification ×2, 28-image stack.
The composite had a leg retouched in Helicon (Method C), a touch
of Lightroom, Topaz DeNoise and Topaz Detail. The scales on the
body show up well. The chafer is found mainly in the south of
Europe on flowers by rivers. It will spend long periods sitting very
still and is comparatively easy to stack in the field. Canon 7D, 65mm
MP-E macro, twin macro flash *f*8.

STORAGE AND FILING

There is no doubt that focus stacking generates an inordinate number of files, particularly when using automatic kit like StackShot. Coming home from a day in the field my wife might ask if I took many photos. Six hundred is not unusual. Then they have to be stacked, probably using two methods, and then sorted. After a while experience tells you whether a composite can be retouched, so be ruthless and delete those that do not work. People often delete stacks once the composite has been produced. Having put so much time and effort into taking the stacks I keep them stored and backed up. Using an external hard drive I store all the stack images there, rather than cluttering up my main computer. I also have a second, old external drive which occasionally backs up those original stack files. Stacks I produced some years ago

have been restacked using new software versions, three or four years later, and have produced quite different and better results. All the original composites I keep in a special folder on my main computer, sub-divided into main group categories like Insect, Crustacean, Flowers, and so on. These originals, using Lightroom, are then worked on to produce an exported final copy that is filed under my usual biological classification system. All of these composites and copies would be backed up regularly onto other external drives, one of which is not next to the computer in the house. It is so important to establish a good filing and storage/ back-up system. Only when your normal system fails and you lose material do you realize how essential this is. Hard disks are the weakest link so have as many as possible.

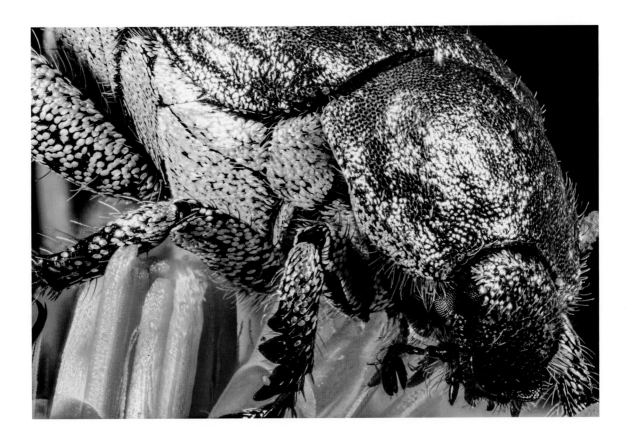

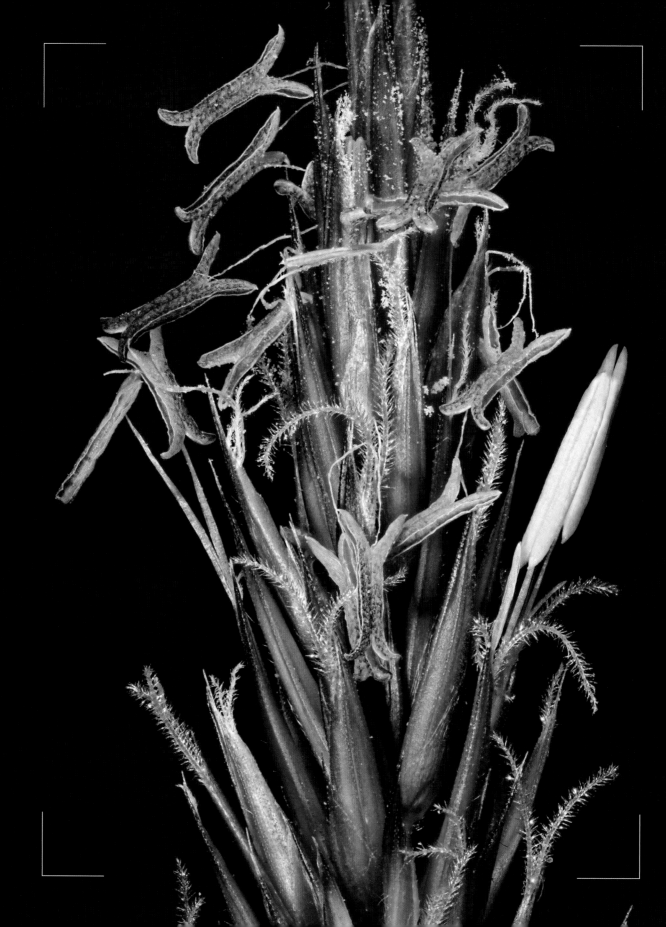

Chapter 9
Working on Projects

Having scrutinized cameras, equipment, lights, software and a plethora of other aspects of taking close-ups you may be feeling bewildered about how to move forward. This chapter, instead of looking at specific photographic kit, works from the perspective of the final result: the subject matter. Here we look at a cross-section of possible material that you could work on. With each topic we can then assess why it is worthwhile looking at this category and how to set about tackling some extreme close-ups. Initially, there will be a description of what could be achieved followed by a suggested procedure. Some of the basics will be common to all projects and once mentioned will not be repeated in subsequent ones.

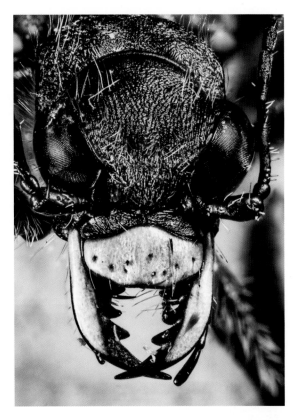

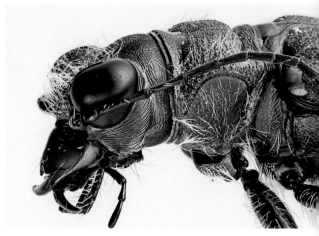

▶ **Figs 9.1.1 and 9.1.2**
Green Tiger Beetle *Cicindela campestris*. Keep a look out for specimens and have a container handy. This small but aggressive ground carnivore has massive jaws relative to its body and this one was with other dead ones in a strange crime scene! Crumbs of food are still on the jaws. They do not have pigment but rely on interference of light on the cuticle to create the beautiful iridescence, here photographed using diffuse light in a ping-pong ball.

◀ **Fig. 9.1**
Grass flower *Anthoxanthum odoratum* with developing stamens and stigmas. Magnification ×1, 22-image stack. Canon 7D, 65mm MP-E macro, twin macro flash.

Project 1

GRASS FLOWER

Understanding the subject

Except perhaps by hay-fever sufferers, grass flowers are very easily overlooked and yet they have stunning diversity and beauty. I wanted to take a close-up of the flower spike to show the developing stamens as well as the delicacy of the trailing, hairy stigmas that collect the pollen. Being wind-pollinated the stamens have to expand to hang loosely outside of the spike and that means they will move freely in the slightest of wind movement. Magnification would be 1:1 but to show everything crisp and sharp it needed stacking at $f8$. Outdoor shots, even with the grass held with a peg, had produced a composite with the same stamen blown into different positions. The grass needed to be set up indoors within a controlled environment.

Method

A small selection of developing grass spikes was picked from the garden, the cut stems placed in water and the container kept in a warm, sunny room. The flower spikes were checked over several days with a hand lens until one showed both male and female parts together. The camera with macro lens set to 1:1 magnification was on a focusing rail, attached to an optical bench, but at this magnification a tripod would have been fine. I connected the camera to a laptop by the USB cable and switched on so that I could use software to see the subject with live-view. A twin macro flash was placed in position, one unit either side of the lens. A pair of flashes would have been just as good. A background of dark grey/black was selected so the delicate white strands would show up and this was placed behind where the subject would be placed. The flower was cut carefully, to minimize pollen grain loss, with scissors to leave a small amount of stem. The stem

▲ Fig. 9.2
Enlargement of the anther of Fig. 9.1 requiring retouching from the original files to eradicate the ghosting, where a gentle movement of the stamen had occurred.

was then clamped in a crocodile clip support and checked with a hand lens to ensure the most photogenic area of the flower would be visible. Finally, as the last part of the set-up, the grass was moved into an approximate position.

Using the live-view on the laptop screen the subject is adjusted so that it is in the correct position. This means moving the grass vertically upwards and a Lab Jack makes this easy. Otherwise, some other way of raising it to the desired height is required. Initially, I wanted a portrait format and the axis of the flower needed to be vertical. The macro lens is connected to the optical bench by a tripod support. By slackening off the knob at the side of the support the lens with camera is rotated through 90 degrees and so a portrait format is possible. The focusing

▲ Fig. 9.3
Grass flower. A landscape view of the same flower.

rail was adjusted so that part of the subject was in focus. A test shot is taken, which immediately downloads via the USB cable into the folder that I had set in preferences. FastStone Image Viewer is already running and set to review anything arriving in that stack folder. The test shot is checked full screen for exposure and composition issues. Leave your viewer open for the duration of the work so that regular checks can be made. Although most of the subject is out of focus you are looking for unwanted reflections, blown highlights and parts that are likely to move out of shot as the focusing rail is adjusted. Sometimes this can only be determined after the first stack is generated.

Once your test shot looks all right take the rail back, watching the screen until the subject is just out of focus. Begin taking the stack of images, moving the camera forward and giving a short period between shots for the subject to settle. Just the gentle movement of an arm can cause a slight circulation of the air and move the stamens. My stacking software has the dedicated folder as default and one click starts the stacking process. As there is a good deal of black and some pale parts to the flower I use Method C pyramid in Helicon Focus. I like to check the final composite full screen to see if all is well. The problem is that only once the composite has been made can you really see where everything is positioned. In the first grass composite several of the stamens at the back were cut in half and after a reposition, retaken. Five different composites were made including landscape and portrait

▶ Fig. 9.4
Sedge Flower, *Carex* sp. A
close relative of grasses but
with a triangular section to
the stem. This is the male part
showing the anthers pushing
up and out. Some are already
splitting to release pollen.

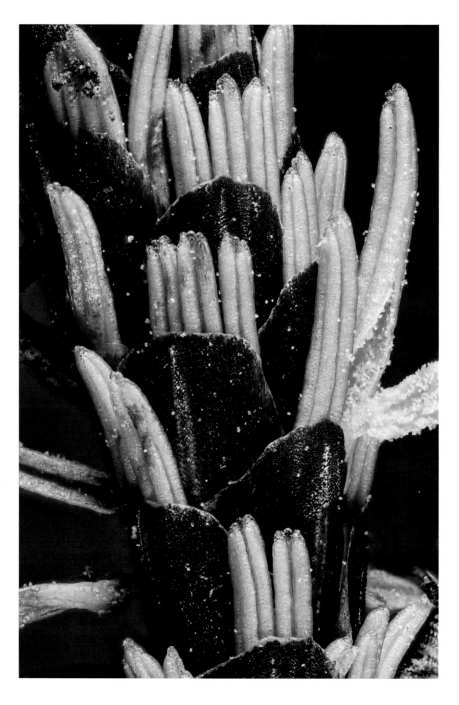

formats, two different views and one repeat after it was realized that one small area at the base was not captured in focus, i.e. not enough images in the stack. The final portrait composite needed a retouch in the stacking software as a stamen had moved position and appeared as a double image. The stack was generated with twenty-two JPEG images and the composite saved as a TIFF for further processing. Images shown here are the original files without any post-processing as all that was needed was a small lift in the shadow detail and slight sharpening.

Project 2

BUTTERFLIES

Understanding the subject

Butterflies have become scarcer than half a century ago and although it is possible to photograph them on a chance meeting some planning will help. Visiting flowers like *Buddleia*, often called the butterfly plant, increases the chance of finding insects and they can be preoccupied while feeding. They need the sun, like many insects, to warm muscles that allow them to fly. In the middle of a sunny day in summer they are active and whilst that makes them more visible it also makes them difficult to creep up on. To have butterflies that model perfectly and allow you to take your time and move around them needs an early start, soon after dawn. Usually they will have dew over their surface. Muscles will be cold. Depending on the sun it can take several hours for the moisture to evaporate and for the insect to become warm enough to move, let alone fly. Initially they will be with their wings closed hanging on to stems of grasses and plants but as they begin to warm up so wings will open and the body manoeuvred to yield maximum exposure to the sun. It is at these times that they are at their best to photograph.

Method

Firstly, identify a suitable habitat, like grass downland or meadows rich in flowers and insects, typically in June and July. Research online to find natural reserves or areas suggested by wildlife blogs. To make life easier on the day you may want to consider camping near your chosen habitat if at all possible. An hour or so after dawn, walk slowly through the dew-covered grasses with your back to the rising sun as insects will be orientating towards it for warmth. Look carefully where you tread but also sweep your eyes from left to right, from the base to the top of flowers and grasses. It can take a little while to get your eye in but once you start seeing them get down to their level. Something to lie on is almost essential as it will be wet. Around dawn there is often no wind, in which case a tripod is perfect. If not, consider raising the ISO to prevent camera shake. Although sunny mornings are best, overcast ones can be almost as productive as the insects take longer to warm up. Dull days will definitely need a higher ISO. I will often use a burst of flash to bring out better colour detail. For stacking the flash will almost be essential as even the slightest movement will be magnified. If you do not want the background to be black with a flash the exposure needs to be balanced by increasing the ISO. Sometimes I drop the shutter speed but really only do this if you are using a tripod as camera shake could still occur. Parts of the image will be sharp but moving areas will be blurred. Large ISO increases will increase noise and if it is intrusive look at software reduction later, even using plug-ins like Topaz DeNoise.

I look for interesting positions that the insects have taken up, like sitting on orchids. These are places where they have been all night and even an hour or so after dawn they will not move for long periods. Also these perches are more rigid than the end of grass. Move carefully because disturbance makes them more likely to just let go of the plant and drop to the ground. Initially they start with their wings closed over them and as they warm the wings open. This will be before they fly but as long as you are ready with tripod and camera equipment you can set up a stack. Depending on the weather you may have ten minutes or more while the wings are wide open. Blue butterflies, possibly because they are smaller, will warm up more quickly than the fritillaries. The stack will work best if the insect is stable and you may need some method of stabilizing the vegetation, like kebab sticks, or think of using a polystyrene box diffuser.

▶ Fig. 9.5
Fritillary Butterfly on
Pyramidal Orchid, two hours
after dawn. Having found
the butterfly like this it did
not move for more than the
thirty minutes I was with
it, allowing me to move
carefully around it to take
close-ups from different
angles. Canon 60D, 150mm
macro 1/200th sec ƒ12.

As well as butterflies many other insects and
organisms can be dealt with soon after dawn.
Dragonflies will be emerging at the edge of ponds.
Others will be sitting covered in dew waiting for the
sun as will hoverflies and beetles that visit flower
heads.

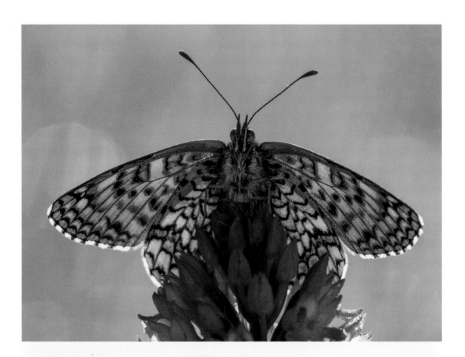

Fig. 9.6
Same Fritillary Butterfly on Pyramidal Orchid, backlit by the rising sun. Canon 60D, 150mm macro 1/200th sec ƒ8.

Fig. 9.7
Same Fritillary Butterfly on Pyramidal Orchid, close-up of the rear wing edge against the flower. Magnification ×1.5. Canon 60D, 150mm macro with an extension tube 1/100th sec ƒ8.

▲ Fig. 9.8.1
Black-veined White Butterfly, *Aporia crataegi*, covered in dew shortly
after dawn, France. Canon 60D 100mm macro, twin macro flash
1/60th sec ƒ11 ISO 400.

▲ Fig. 9.8.2
Scarce Swallowtail Butterfly, *Iphiclides podalirius*. Several hours after
dawn the dew had evaporated but it was still easily approached
as it started to feed. France. Canon 7D, 100mm macro with small
extension tube, twin macro flash 1/250th *f*14 ISO 640.

Project 3

NIGHT FLYING MOTHS

Understanding the subject

This project may sound like the butterflies project above, but moths are quite different both biologically and as subjects. Additionally, compared to the number of butterflies there are many more species of large moth, almost nine hundred in the UK alone. Day flying moths can be treated rather like the butterflies in that they will be found early morning in a similar way, like burnet moths. The main point about night flying moths is that by day their behaviour is primarily to sit still and wait for nightfall. This means they can be the perfect subjects for stacking. You may be lucky to find the odd moth doing this but to obtain the material you need a moth trap. As we know moths are attracted to lights but especially ultra-violet light. A range of traps is available, both in terms of the style for capturing the moth (usually named after the entomologist who designed it) and the type of light. The style can affect the ability to catch the moths, but portability is also an important consideration. The Robinson model is large whilst the Heath is more portable. More depends on where you intend to use it. The best light is that produced by a mercury-vapour (MV) lamp and they are very bright, large bulbs, connected to the mains. Actinic tubes, like the ones used in commercial kitchens to attract and kill insects, give off UV light and can be run off car batteries. One of the most recent innovations is the Goodden GemLight, an ultra-violet LED. Set in a small black box, it runs from rechargeable AA batteries and can be set up anywhere.

You will need to think of the neighbours: the large mains ones give out tremendous light and so even at home you may wish to use a battery-based one. The GemLight is very mild but does produce better results in southern Europe and warmer areas than northern regions. UV can damage eyes so be careful

▲ Fig. 9.9
Robinson moth trap, set up on the mains electricity, early morning after a warm, humid night – a good time for trapping. The StackShot is set up ready. Here a stack of a moth on the outside is taken first before opening up the trap.

not to look directly at it or wear special glasses. The GemLight can be just left and sensors switch it on and off according to ambient light. When it is sufficiently dark it switches itself on and then off at dawn. Mains traps need a timer switch. Instead of a trap you may consider a large white sheet spread out over bushes or hanging over a wall with a bright light reflecting on it.

Moth traps will need some investment, both financially but also in researching the moths' welfare. One morning I was up a little late to go and check the trap only to find a pair of jackdaws breakfasting on moths. When emptying a trap it seems obvious to let go the ones you do not want but they will not go far and birds will soon come down and eat them. You should get a proper guide on using the trap correctly (as well as considering your own welfare). One of the best is a Moth Recorder's Handbook, a free download from the British Butterfly Conservation website.

Method

One of the best things is camping, setting up the moth trap nearby and then waking up to an exciting catch in an area you do not know. At home you soon get to know what species are about. Inside the

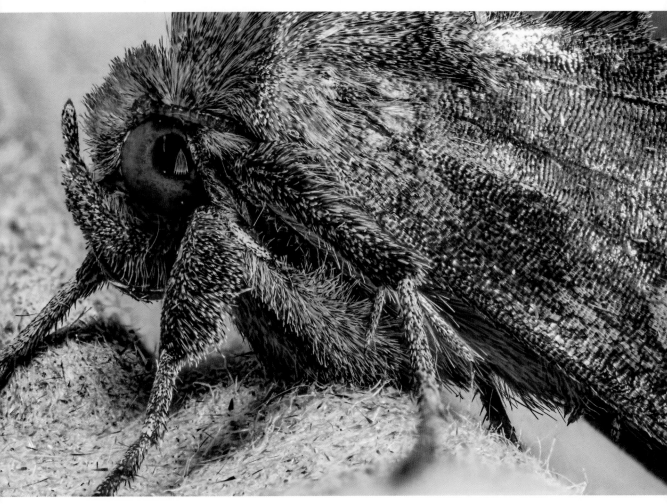

▲ Fig. 9.10
Head of Burnished Brass Moth, *Diachrysia chrysitis*, magnification ×2, 22-image stack. Specimen was on the egg box inside, carefully moved out and taken with StackShot, Canon 7D, 65mm MP-E macro with twin macro flash *f*8.

trap box are placed old egg boxes or foam with holes and pits. The moths drop down into the box and find a depression to sit in. To expand the practicality of the trap, lay it on top of an old white sheet and there will be plenty of moths on this in the morning. I also leave sticks and twigs on the sheet. If you are lucky some moths will be found sitting on these, waiting to be photographed. On checking the trap, first there will be moths on the outside which may be photographed without disturbing them before looking inside. Upon opening the trap some may

escape but generally the larger ones sit tight and the boxes can be withdrawn. Try to gently transfer them to sticks – another reason to leave these nearby – or other substrates on which to photograph them. Many moths will happily sit where you place them as long as you do not disturb them too much and will not move while a stack is being taken. You may think that, unlike the early morning with the butterflies, you can have a lie in. If you want the moths outside the trap this needs to be done within a few hours of dawn as they will either fly away or be eaten by birds. While my back was turned photographing the Burnished Brass in this section a blackbird ran in and started grabbing the moths off the sheet.

▶ Fig. 9.11
Wing of Burnished Brass
Moth, *Diachrysia chrysitis*,
magnification ×2, 18-image
stack.

▶ Fig. 9.12
Head of Gold Spot, *Plusia
festucae*, magnification ×2,
18-image stack.

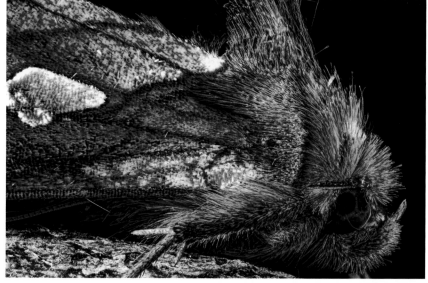

Try to have all the photographic equipment set up ready the night before. Around the moth trap at home I will have mains electricity to plug in the StackShot and use the large Benbo tripod. The long arm on the Benbo makes it easier to get the camera in close to twigs and areas of the trap. Looking at a moth I will decided whether I want the whole or part of the body and guess roughly the magnification required, setting this on the lens or bellows. Moving the tripod, the camera lens is positioned as near enough as possible. The camera is near to the central position on the focusing rail so it can be moved back and forward. Do not be caught out with it at the end of the rail. I switch on the live-view so that I can reposition the head of the tripod. Using a manual rail or the control on the StackShot the lens is moved to focus. Focus first on the nearest edge and then quickly to the back to try and check the distance and

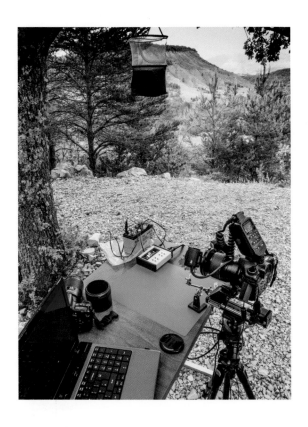

Remote moth-trapping in France using a Moonlander Moth Trap and a Gem Light, hanging in a tree behind. A camp table has been laid out in the shade for StackShot, battery and laptop.

whether everything you want will be positioned and composed how you like. Then begin the stacking photos either manually or with the StackShot. I switch off the live-view before starting an auto stack but it obviously needs to be left on for the manual.

If you repeat a stack sequence, especially with some of the moths, it can be a little tricky later to identify when one sequence stops and the next starts. If this is likely before the next stack take a photo as a marker. This could be a quick switch to manual exposure so you get an over exposed image.

I have the Robinson trap on decking when at home as it provides height and increases the spread of light. The problem with stacking on it is the flexing and vibration you will get. This means when stacking I cannot afford to move. While stacking you can expect the moths which will be flying around to land on your equipment, occasionally in the middle of the lens. Some large catches run into many hundreds of moths and if you start stacking an insect on

▼ Fig. 9.14
Pine Lappet Moth, *Dendrlimus pini*, from the Moonlander. Stacked on the camp table as shown. Magnification ×3, 24-image stack.

▶ Fig. 9.15
Oak Hawkmoth *Marumba quercus*, found on the outside of the Moonlander and moved to an oak tree nearby. Hawkmoths cannot normally fly immediately and need time to warm up. If they start a violent vibration of the body and wings, they are warming their muscles ready for flight. 12-image stack. Canon 7D, 150mm macro, using a change in focusing rather than using a focusing rail.

the egg box there is a chance another will move and disturb the one you are working on.

For remote moth trapping I use a Moonlander Trap with a GemLight. This will not produce the large catches of the Robinson which is on the mains but will bring in interesting species. It collapses down to minimal space and can be taken in a suitcase when flying. When camping I will normally set up the trap and have a table nearby with all the stacking equipment ready including a battery for the StackShot. With care the insects are moved onto leaves or other material to bring to the table for stacking.

ROCKPOOLS

Understanding the subject

When the tide drops across a seashore the seaweeds collapse on to the rocks as they have no support. Animals may have a choice of either escaping with the tide or having to do the best they can on the rocks. The creatures living here need the water and so one option is to live in a depression that stays filled with water after the tide has gone. The organisms may be specialized to live here or some may dip in just while the tide is out. Either way it is a good source of material to photograph as biodiversity is likely to be higher here than just outside the pool. The pools near the top of the beach will not be very good as debris collects and decays in the water, plus fresh water runs off the cliff to dilute the seawater. Expect small zones to build up in the pools. There will be seaweeds specialized to live around the edge, fringe weeds, which rarely dry out as long as the pool is not too shallow. A number of fringe weeds may be present and one, *Corallina*, is a bright to pale pink, hard to the touch and jointed. Being hard many animals attach to it and call it home. The fringe weeds may become prolific and thick lower down the shore where they mix with a variety of other species. Essentially, biodiversity increases the lower you are on the shore and these fringe weeds are an endless source of material in which to look for small specimens.

Check online or in local shops for tide information so that you can plan to go down to the shore when the tide is going out. Make sure you know when the tide is returning as photography can be all consuming and as you lose track of time the water may be cutting you off from your exit. Do not just look at the times of the high and low tide but see how low it will go. Spring tides will be better than neap tides as the latter may only go just over

half way down. However, the middle seashore has more than enough material to keep you occupied. Although the phrase 'spring tide' suggests seasons, seashores can be visited at any time of the year to find material. In the depth of winter when little else is about, a rockpool will still have plenty of interesting species.

Methods

There is plenty that can be done on the seashore but if you are able to return back home with some small samples then even more delicate stacking can be achieved. As well as your camera gear you need a bucket and some small tubes or bottles; also a small glass dish, some forceps and a pipette/eyedropper. If you intend to do stacking on site then a small selection of observation tanks will be useful – carrying large ones onto the shore is not very practical. If you are able to set up a small base and camping table near your vehicle larger material can be brought back there to photograph. Just expect sightseers to arrive! Also useful to take with you is an empty plastic bottle around 2 litres in size to collect seawater. A filter to clean the water would be perfect.

When collecting a sample take only small quantities. From the rockpool start by taking a little *Corallina* and put it in the small dish with seawater. To pick the weed put your fingers right down at the base, where it is attached to the rock, and squeezing just there, not higher up the seaweed otherwise you will squash the animals on it. Using the forceps and maybe a needle, start teasing the strands of weed apart. Using a hand lens have a look to see if there is anything on the pink *Corallina*. Many species can encrust onto it whilst those crawling over the surface may have dropped into the water. This is how the sea spiders were taken and photographed in the previous chapter.

I would have set up a small observation cell and the stacking equipment before this and now could transfer anything that has appeared in the dish into the cell. If it is a hard specimen like the *Corallina*

▲ Fig. 9.16
Snakeslock Sea Anemone, *Anemonia viridis*, in a rockpool. The green colour is an alga living inside the tissues and as long as it is exposed to light can photosynthesize, making food for both it and the animal. It cannot tolerate being out of the water and so is just immersed near the surface. Fuji Finepix S602 Bridge camera *f*11.

then forceps are fine but softer, small material would be best moved by the pipette. On the shore use the live-view to set up a stack. You may well find yourself at low tide in the middle of the day with a sun so bright that stacking is difficult. I have used a large dark cloth to cover the top of my head and the back of the camera. You may be able to do it looking through the viewfinder. If all else fails then think about taking material back home. Small amounts of the seaweeds can be put in small bottles of seawater. Take as wide a selection of fringe weeds as possible although only small amounts from the pools. This

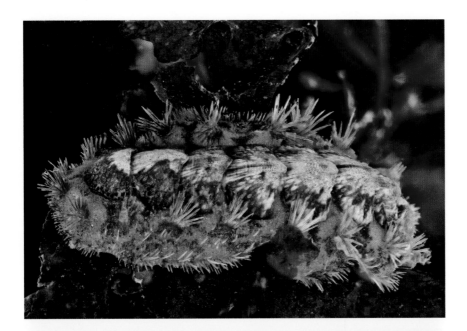

◀ Fig. 9.17
Chiton *Acanthochitona crinita*, 8-image stack, magnification ×1.5. Young one found mid-winter in *Corallina*. Canon 7D, 65mm MP-E, twin macro flash in small observation cell.

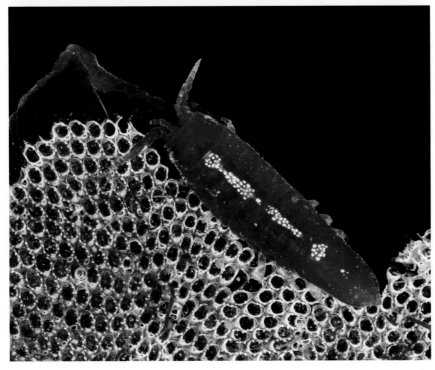

◀ Fig. 9.18
Idotea on sea mat washed into a rockpool. Magnification ×3, 16-image stack using a temporary tack-tank on the seashore.

will increase the chances of finding different things as you are unlikely to see anything until you get them home. A few small plastic tubes, 6–8cm/3in long, will be more than enough.

With the material in a small dish of seawater, tease the weed apart. Whether on the shore or back in the studio monitor the specimens as once they are left alone tentacles from small organisms attached to the weed begin to appear. If there are small

▶ Fig. 9.19
Small Gammarid crustacean on *Corallina*. Note the *Spirobis* white tube worm. Magnification ×4. Canon 7D, 65mm MP-E with twin macro flash ƒ8.

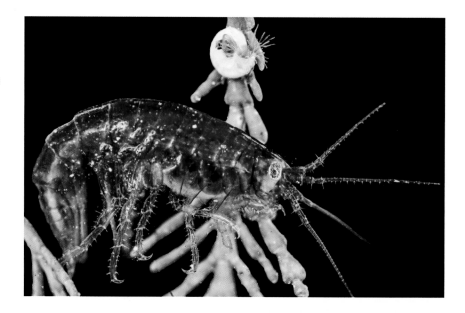

white coils of shells these are *Spirobis*, a species of marine worm. But there are plenty of others like Bryozoans that slowly extend their feeding parts and are beautiful. The problem with some feeders like barnacles and Bryozoans is they keep moving their tentacles around as they collect food. You could try adding some Epsom salts and this might slow them down enough for stacking. Sea slugs and many other organisms will appear. Setting up marine material can be slow as it does take time for some to adjust to the surroundings of the cells and uncoil or expand. Take larger organisms back to the car park and the larger tanks. These need more props like stones and weed to provide a backdrop. If you wish to keep them for more than an hour in a tank they should be transferred to a tank where air is bubbled through; otherwise they should be returned to the shore.

Although there may be plenty of sunlight I tend to use flash in most of these situations as it is more controllable. Move one flash to be above the cell or tank and the other to one side at 45 degrees. If you cannot get a separate one for above, e.g. the cable will not reach, just make sure that when they are 45 degrees they are held above the lens rather than to the side. If tentacles move they are more likely to be frozen by the flash. Slow movements can result in more legs or spines than you would expect. Whilst this may be obvious, like the sea spiders, in some it is less clear. The chiton, *Acanthochitona*, moves its spines around so that in the photograph here there are too many spines appearing in the composite.

Whilst there is plenty of material in rockpools try some close-ups of barnacle-encrusted areas. Dead barnacles leave behind an empty shell which becomes colonized by other life. The 'crazy paving' between barnacles is very picturesque. Any tall outcrops of rock that are shaded from the sun will remain damp when the tide recedes. These are encrusted with a range of organisms like small delicate sponges, anemones and fine seaweeds. Many of these things can only be stacked remotely on the shore as you could not transpose them.

Project 5

POND AND STREAM LIFE

Understanding the subject

You may not have access to the seashore but life in freshwater provides almost as much material to work with and everyone has some suitable habitats nearby. Hunting for the organisms can be a little more time-consuming and the equivalent to seaweed does not have the same variety of animals. Insects are quite dominant, whether as adults or in an earlier stage of development. As well as looking in the water there is an abundance around the edge, out of the water, but the latter will depend on the season: May through to September is the best period for flying insects. Within the water there is always something about. Over the winter many larval forms go into what is called 'diapause', when they stop feeding and can become less active. This is an ideal time to collect samples, return home, photograph them, do stacking and then return them to the water. Many of the insects that are in water all their lives will leave the water as an adult to disperse to other places. I mention this because when you take them home and have them in an observation tank they may try to get out and disperse, especially if you leave them overnight! Pond life can remain in a small tank for twenty-four hours without problems but creatures from running water need oxygen bubbled through to keep them alive. This section is about invertebrate animals as there are laws governing removal of some vertebrates like newts; these would have to be photographed on site.

Method

Plan to do one of two things: either go with the aquatic life in mind or to work on the aerial insects, as they need quite different approaches. For the first, you will need a selection of sampling containers, a fine mesh net on a pole, a large white dish or tray in

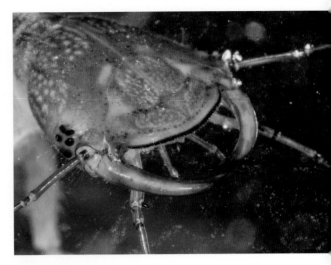

▲ Fig. 9.20
Water Beetle, *Dytiscus* sp. larva head, magnification ×2. Canon 7D, 65mm MP-E macro, twin macro flash, ƒ8.

which to tip the net sample for sorting and a white plastic spoon. A selection of plastic pipettes would be ideal. I have a pond nearby and so usually the photography is done at home and then the material returned later.

For the second, it is about weather and timing. By all means go out on the first fine weather day but the number of insects may be disappointing. With safety in numbers emergence from the water, such as for dragonflies, damselflies and mayflies, is synchronized for mass movement and it takes a few days of good weather for this synchrony to happen. I would be checking the forecast looking for a period of calm, warm weather so on the third day get up early. An hour after dawn is good for the insects to be emerging around the edge. Dragonflies and damselflies are very approachable in low vegetation; look around the reeds and emergent vegetation for nymphs that have climbed up to emerge. Once adults have emerged they spend some days away from the water's edge. At any time seeing pale, fluttering ones means they are fresh that day. As they are soft they will be more reluctant to fly, easier targets for stacking. This is almost as easy as stacking

▶ Fig. 9.21
Lesser Diving Beetle *Acilius sulcatus* adult. Magnification ×1. Canon 7D, 100mm macro twin macro flash, ƒ11 ISO 100.

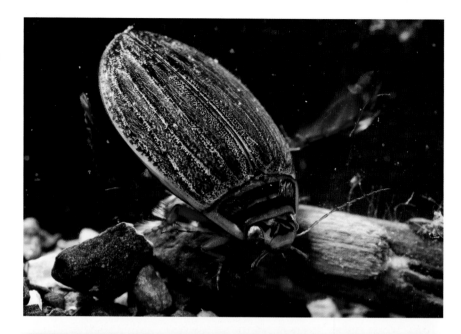

▶ Fig. 9.22
Lesser Water Boatman, *Corixa* sp., magnification ×2.5. Canon 30D, 100mm macro with extension ring, flash, ƒ16 ISO 100.

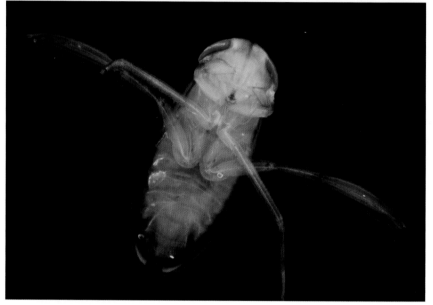

insects that are covered in dew, which will sit tight until the sun dries them. To pursue aerial insects in this way look at the butterfly project above.

For aquatic life a different approach is needed, as organisms need to be caught. Using the net I would choose a particular area of pond weed or reeds and vigorously push the edge of the net through this. Avoid digging into sediments. Rather than sweeping

the net, it is a case of jabbing with it, which knocks organisms into the water. After the knocking process you are scooping through the disturbed water to collect them with the net. Try not to over fill the net with weed and debris. Put clean pond water in the white tray and empty the net into it, washing the net sides of any material. Spend time on the ground working your way through the sample, teasing it

▲ Fig. 9.23
Water Spider, *Argyronet aquatica*. Close-up of cephalothorax;
note the air-bubble covering and ciliates growing on the head.
Magnification ×3. Canon 7D, 65mm MP-E macro. 9-image stack *f*8.

apart with the white spoon. As you find things scoop them up and transfer to a smaller container. Return the sample to the pond or stream. Two or three samples should be enough and cause a minimum of disturbance to the pond. Take a small amount of weed back in a container to help provide a backdrop.

Once at home I sort through the material based on size and what will fit in each observation cell. Working then on similar-sized organisms at a time I prepare the tanks or cells with clean gravel and sand at the bottom. Filtered water helps to eliminate detritus and I have several plastic petri dishes with clean water acting as quarantine areas. The first species, and usually there is a spare of the same species if I can do that, is put in the first dish of clean water while preparing the tank or cell. If possible it will go

in a second one before being put in the cell. Water beetles, dragonfly larvae and water bugs usually would go in tanks with weed present and given time to settle down before photographing. Small larvae need to be contained within a limited area so that they remain extended and flat to the glass. These would have very small, upright cells. Once they are in the cells and photography starts it is a good time to look at backlighting as well. You may also decide that the creature does not look right in the upright cell and would be better laid flat. Flat in a small washer-well gives the opportunity to use wallpaper paste if they are moving a great deal – this slows them considerably.

Project 6

GROUND INVERTEBRATES

Understanding the subject

Even when you are lying down on the ground, look-ing for creatures to photograph in the grounds of a garden, field, woodland or other terrestrial habitat can be a little disappointing, as so many organisms hide away by day or are sufficiently camouflaged as to be overlooked. Insects that live deep down among the leaf litter and in tussocks of grass tend to lack flight which makes observation tanks and cells suitable for photographing them. The best periods to find the material are spring and summer, with May and June being the most productive. Even outside of this period it can be surprising what can be found.

Method

Every month or so I have a good look around the ex-terior of the house. Large numbers of animals climb up the walls and then stop, almost as if caught in the light, and freeze waiting for the night. Harvestman (a type of arachnid), mites, a variety of spiders, even millipedes will be common. Beetles and other insects will be there too. The spiders will be easy to stack *in situ* on a wall unless they have spun a web. That is fine as long as they are facing you and the wind is not causing them to vibrate. Web-making spiders can be popped in an observation cell with a lid. In a cell they will not be affected by any wind suspended in their web which they will start spin-ning quite quickly. They may need some coaxing

▼ Fig. 9.24
Common Earwig, *Forficula auricularia*, magnification ×4, 28-image stack. Canon 7D, 65mm MP-E macro twin flash.

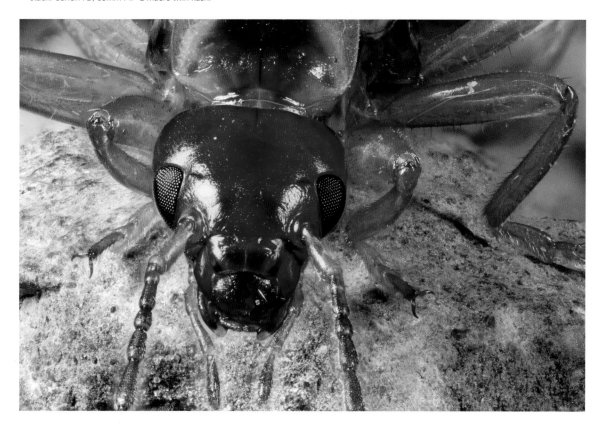

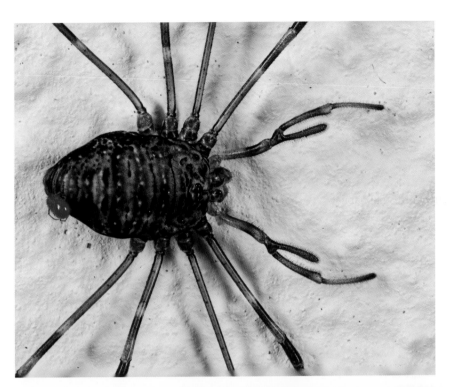

◀ **Fig. 9.25**
Harvestman, *Dicranopalpus caudatus* with mite attached. Magnification ×2, 20-image stack. Photographed on the wall of a house. Canon 30D, 65mm MP-E, twin macro flash ƒ8.

▼ **Fig. 9.26**
Dysdera sp. A very small spider left in a tack-tank to settle before stacking. Magnification ×4. Canon 7D, 65mm MP-E with twin macro flash ƒ8.

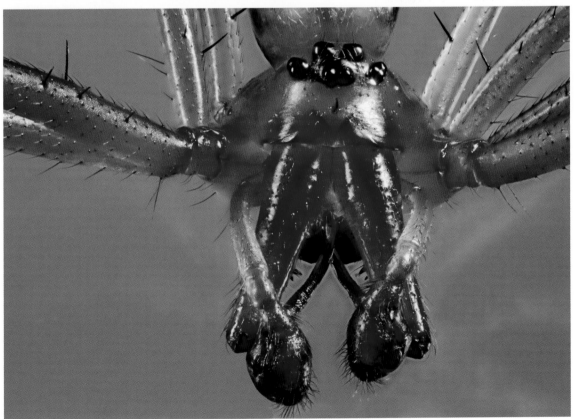

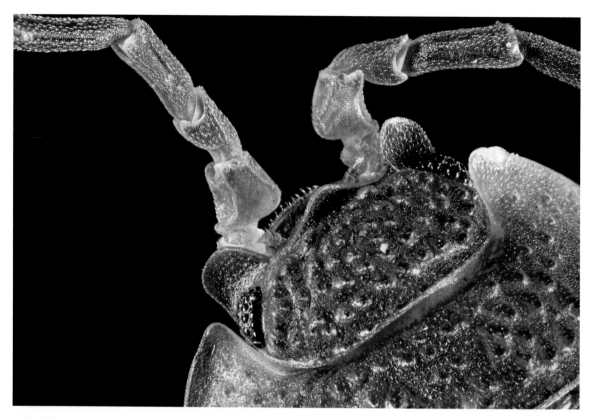

▲ Fig. 9.27
Head of a Woodlouse, *Oniscus* sp., magnification ×3. Canon 7D,
65mm MP-E with twin macro flash ƒ8.

with a fine paint brush to face the right way. With the
tank or cell on a Lab Jack they can be manoeuvred
into position slowly for stacking along an optical
bench. They are not normally affected by flash.

Searching tussocks of grass and other dense, low
growing vegetation can be productive. Have a tube
ready to secure them before transferring to observa-
tion cells. One of the best options is what is called a
'sweep net'. This is really a canvas bag sewn around
a frame to swish back and forth through long grass
and hedgerows. The solid frame knocks the inver-
tebrate down into the bag. After a quick sweep stick
your head in and see what you have. A productive
field can be a-buzz with creatures. Flying insects
quickly reach the top and can be let go but crawl-
ing around the bottom will be any number of bugs,
beetles, grasshoppers and spiders. Another option is

to put a white sheet under bushes and tree branches.
Hit the branch with a smart tap from a stick in May/
June time and it is amazing what falls out onto
the sheet. Just be ready to catch them in a tube to
transfer to a cell.

For nocturnal species try putting pitfall traps
into the ground. These could be jam jars, plastic
yoghurt cartons or any container that can simply be
put in the ground. Dig a hole sufficient to allow the
container to fit, with the soil surface just above the
rim of the container. Push the soil in around it so
that any invertebrate walking along easily falls down
into the container. They need checking first thing
in the morning, as a single predator like a shrew
can pop down and eat everything. This can be the
best way to find ground beetles. They will need the
larger observation tanks with gravel and mosses

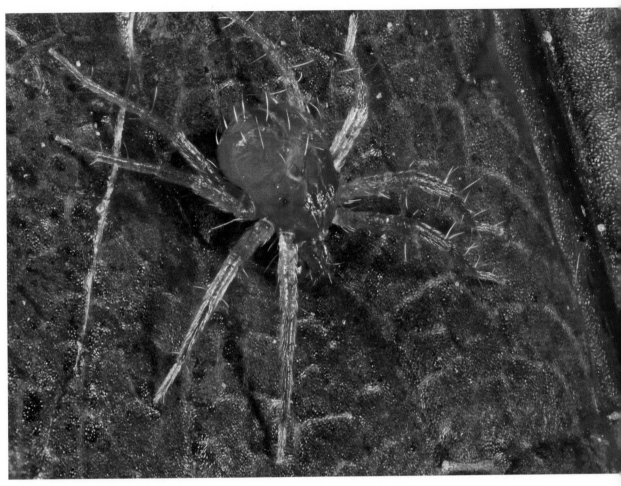

▲ Fig. 9.28
Whirligig Mite *Anystis*, magnification x7 (dead specimen). Canon 7D, 65mm MP-E with extension rings, twin macro flash ƒ8.

to try and keep the beetles in the middle section. These organisms usually emerge at night so keeping the tank dark to begin with may stop them trying to burrow and settle down faster. Hot weather can keep beetles active; cooler conditions will slow them down. It may mean leaving them overnight and early next day when it is cooler they may be more approachable.

▲ Fig. 9.29
Sporangia of the Royal Fern, *Osmunda regalis*. Magnification ×3.
Canon 7D, 65mm MP-E with twin macro flash ƒ8.

Project 7

MOSSES, FERNS AND LICHEN

Understanding the subject

These subjects can be useful material with which to practise stacking techniques. They show amazing diversity in shape and size. All are non-flowering and are typically found in damp conditions although lichens can be found just about anywhere and in places other organisms cannot exist. For example, they live in extremes like deserts, on rocks, air-polluted urban areas and cold habitats. Ferns lack the variety of shape but the reproductive structures, called 'sori', under the fronds make interesting stacks.

Method

To photograph the sori, remove a small piece of the frond, making sure first that there are sori underneath. Very pale ones are likely to be immature. Later in the summer they go brown and the tiny drumsticks, containing spores, appear. Looking at them with a hand lens will tell you if any spores are coming through and the subject is worth stacking. Support the small piece of frond in a clamp, like the crocodile clip supports. I would be using a horizontal optical bench with a blue or green

▲ Fig. 9.30
Shield Fern, *Dryopteris* sp., developing sori under the frond.
Magnification ×2. Canon 7D, 65mm MP-E with twin macro flash ƒ8.

◀ Fig. 9.31
Shield Fern, *Dryopteris* sp.,
expanded sori under the
frond. Magnification ×2.
Canon 7D, 65mm MP-E with
twin macro flash ƒ8. Slightly
cropped. 34-image stack.

▲ Fig. 9.32
Mountain Liverwort, *Marchantia polymorpha*, with spore-bearing
bodies, magnification ×2. Canon 7D, 65mm MP-E with twin macro
flash ƒ8. 44-image stack.

coloured card behind the subject. If you have a heat
lamp or tungsten light that gets warm, shine this on
the fern. It can take between five minutes to some
days, depending on how advanced they are in their
development, but eventually the spore structures
appear and twist backwards. What they are doing is
trying to fire the spores clear of the plant.

Mosses develop beautiful spore-bearing struc-
tures (sporangia) that grow vertically upwards above
the moss. Moss can be photographed in the field or
taken indoors to photograph. They do not have roots
and so if they need to be returned afterwards as
long as they are kept damp they can be pushed back
down into the soil with the other mosses. Always

just take small quantities. Delicate mosses make
good subjects for backlighting (see Fig. 4.1).

Lichens are best photographed *in situ* unless they
are on loose material and easily transported. As we
have seen before, they need diffuse light to show up
their structure clearly. Twigs and branches naturally
fall off trees and these are ideal to collect. They can
easily be set up for stacking.

▶ Fig. 9.33
A leafy lichen *Physcia* showing the black cups for spore production.
Magnification ×5. Canon 7D, diffused twin flash on 65mm MPE
macro lens, ƒ8.

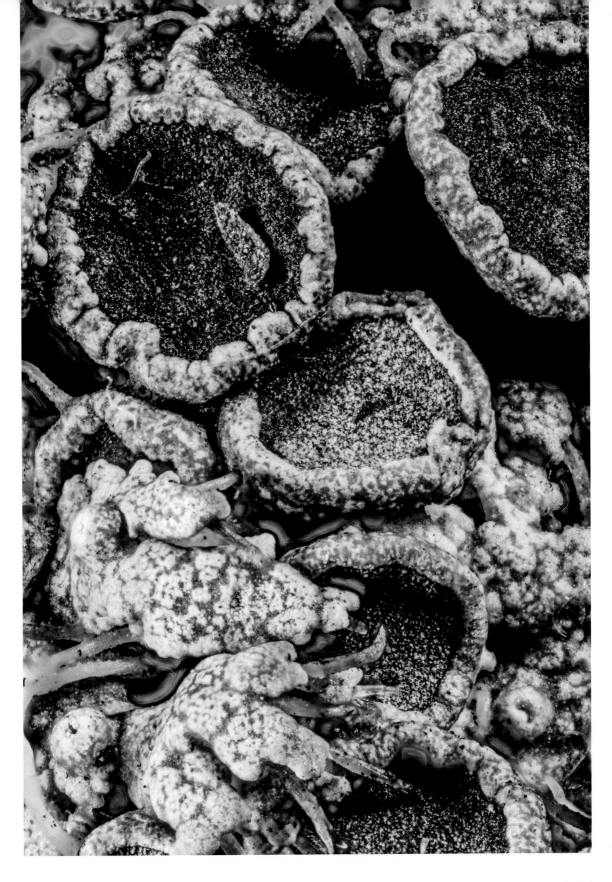

PLANKTON

Understanding the subject

Although a rather specialist area, there is something here for the amateur wishing to take some unusual photos. Whilst most planktonic creatures are microscopic there are some that fit within the realms of this book. Essentially, plankton is the name given to life that drifts in open water that cannot itself determine where it will go. This means that jellyfish fit the description as, although they have a pulsating bell, they do not determine exactly where they are going to end up but drift with the currents. Plankton can be found both in freshwater, like water fleas or *Daphnia*, and in the sea. The latter has the best variety and spectacular shapes. Some organisms live their entire life in the plankton whilst others have a larval stage only. There are two peaks of abundance likely to occur: the spring bloom (March–May) and the autumn bloom (September–October). These

blooms are determined by a disturbance of the water and typically that will be wind. So a few days or a week after a gale expect the plankton density to rise.

Method

A very fine net is almost essential. The mesh size determines what will be retained but as we are thinking of the larger end of the plankton, a 100 microns or 1 millimetre mesh size would be fine. Many plankton nets would be more like 50 microns. Small, basic nets can be purchased, or try making one out of the finest material (silk is perfect!) you can find. If you have access to a boat, the slower the better, then tow it behind at rowing speed for five minutes. Try different areas. Walking along a pier or breakwater, towing the net on the end of a long rope, can produce excellent results at high water.

Due to the fine mesh, water needs to go through slowly as all you are doing is filtering the water through the net. The bottom of the net should end in a hole, which fits tightly to a small bottle. The sample ends up in here. Take a number of samples and then return to a suitable indoor area to start sorting

▶ Fig. 9.34
Tomopteris helgolandica,
a planktonic marine worm,
magnification ×1.5. Backlit
in a dish of seawater. Canon
30D, 100mm macro with
extension tube.

▲ Fig. 9.35
A marine copepod, possibly a
Sapphirinid, magnification ×6,
3-image stack. In wallpaper
paste made with seawater
in a cavity slide. Canon 60D,
65mm MP-E macro with
extension tube, twin macro
flash.

◄ Fig. 9.36
Zooea larva of a swimming
crab, *Necora* sp. In wallpaper
paste made with seawater
in a cavity slide. Canon 7D,
bellows fitted with Minolta
12.5mm micro lens, *f*2, ring
flash under stage.

▲ Fig. 9.37
Marine copepod adult with egg sac. Canon 7D, bellows fitted with
Minolta 12.5mm micro lens, ƒ2, ring flash under stage.

through it. Plankton does not last more than a day
and so needs dealing with immediately. Using the
hand lens, see if you have anything large enough
to put in a small cell or the dish we saw earlier with
washers glued in the base. Jellyfish maybe too large
but comb jellies are a close relative and are like a
clear jelly ball the size of a small acorn covered in
lines of beating hairs. If the light is just right you will
get diffraction patterns. Marine worms are not like
their terrestrial counterparts but show a vast diver-
sity of beautiful shapes, colour and size. Some are
completely transparent.

For very active organisms I would use Epsom
salts or wallpaper paste made up in filtered seawater
and placed in small wells in dishes. I prefer to use
backlighting. The camera will be switched to the
vertical on the optical bench with the lens aimed
down onto the specimen on a stage. Beneath that
will be an LED ring light. It will then be stacked.

▲ Fig. 9.38
An Asilid robber fly, having caught a red shield-bug, dropped to
the ground to eat it. A black ant, having seen this, rushed in and
attacked the robber fly, biting its leg. The robber fly then flew
away. In all, the action lasted under ten seconds. This shows the
importance of always being prepared by having your 'default' setting
for a photograph. Practise these settings of aperture, ISO, shutter,
lens, manual focusing and prepared flash on the camera so you are
ready for any action that unfolds. Eight photos taken, this was the
seventh, 1/250th sec. ƒ8, ISO 125 Canon 7D, 100mm macro, twin
macro-flash and a bit of luck.

Further Information

Websites

Stacking software
Helicon Focus: www.heliconsoft.com
Zerene Stacker: www.zerenesystems.com/cms/
 stacker/softwaredownloads
CombineZM and CombineZP – the domain keeps
 changing but try: www.hadleyweb.pwp.blueyon-
 der.co.uk/CZM/News.htm and www/hadleyweb.
 pwp.blueyonder.co.uk/CZP/News.htm
PhotoAcute Studio: www.photoacute.com/studio/
Picolay: www.picolay.de
TuFuse: www.tawbaware.com/tufuse.htm

Other software
Topaz Labs: www.topazlabs.com
Control my Nikon:
 www.controlmynikon.com/cmn.html
Pentax control: www.pktether.com
FastStone Image Viewer: www.faststone.org

Equipment
SRB adapters for lenses and cameras:
 www.srb-griturn.com
Microscope slides/cover-slips/chemicals:
 http://stores.ebay.co.uk/Magnacol
Cognisys StackShot: www.cogisys-inc.com/stack-
 shot/stackshot.php.
 (This equipment is currently undergoing signifi-
 cant developments. Check their website for the
 latest details.)

Moth traps
Watkins and Doncaster: www.watdon.co.uk
Bioquip natural history: www.bioquip.net
Anglian Lepidopterist Supplies: www.angleps.com
Natural history equipment and information:
 www.nhbs.com

Other
The Quekett Microscopical Club: www.quekett.org
The place to learn about all things in close-up,
 including field meetings, weekend field courses,
 equipment fairs and lectures.
UK Tidal Information: www.tidetimes.org.uk/all